science is beautiful

BOTANICAL LIFE

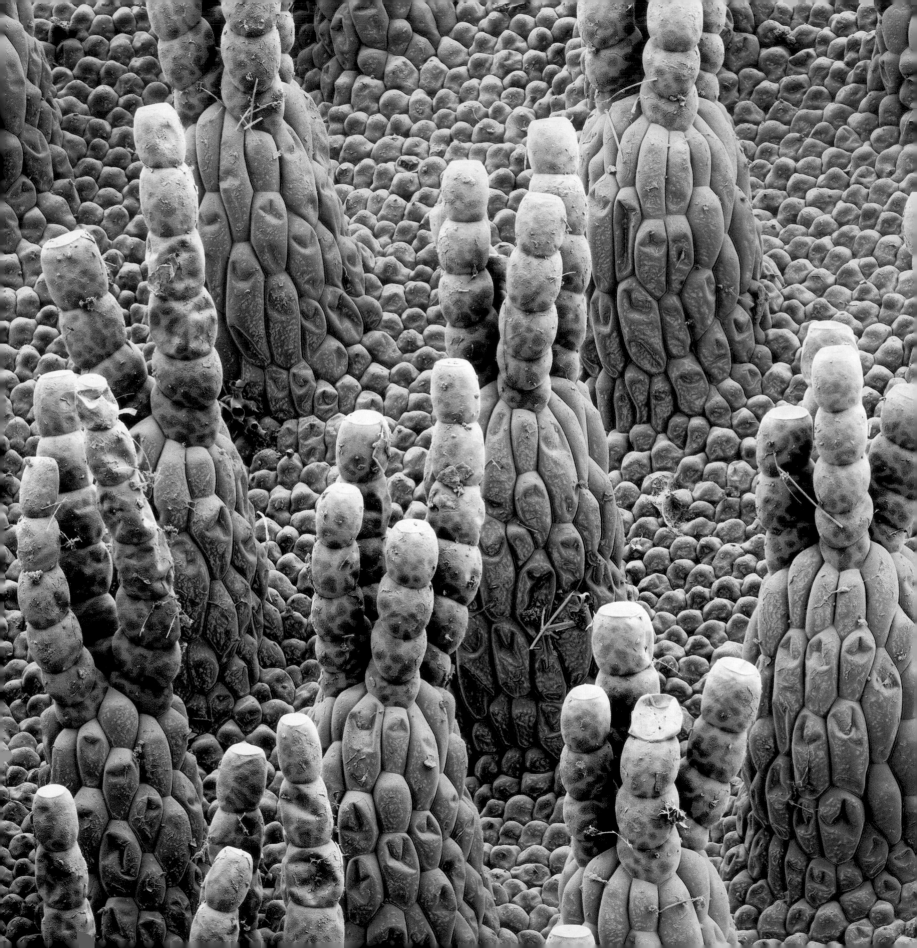

science is beautiful

botanical life

UNDER THE MICROSCOPE

Colin Salter

BATSFORD

First published in the United Kingdom in 2018 by
Batsford, an imprint of Pavilion Books Company Limited
43 Great Ormond Street
London WC1N 3HZ
www.pavilionbooks.com

ISBN: 9781849944816

A CIP catalogue record for this book is available from the British Library.

10 9 8 7 6 5 4 3 2 1

Reproduction by Misson, Hong Kong
Printed by 1010 Printing International Ltd, Hong Kong

This book can be ordered direct from the publisher at the website:
www.pavilionbooks.com, or try your local bookshop.

Previous page: Surface of a water fern (scanning electron micrograph)
The Azolla water fern is a floating plant that does not anchor itself in
the soil. Instead it sprouts roots in all directions from the cone-like cells
seen in this image. The roots draw nutrition from the water. It spreads
not by seeds but by splitting into smaller pieces as it grows. Because it
locks up atmospheric nitrogen it has found a use as a fertilizer in the rice
fields of India.
(Magnification x70 at 10cm wide)

Right: Chicory pollen grain (scanning electron micrograph)
Each plant's pollen is distinctive, and botanists rely on microscopic
examination of pollen to classify and identify plants. This identification is
of particular use to forensic scientists, archaeologists and palaeontologists.
Pollen is produced by the male of seed-producing plant species; when it
finds the ovary of a suitable female plant it generates sperm cells. Some
plants are self-pollinating, in which case the pollen travels to the ovary of
the same flower.
(Magnification x1500 at 10cm wide)

Contents

Introduction

In the first two books in this series, *Science Is Beautiful: The Human Body* and *Science Is Beautiful: Disease and Medicine*, we've looked in great detail at how the human body works, what can go wrong and how to put it right. We live in magnificently complex machines. The capacity of our bodies to maintain and repair themselves is amazing, as is the skill of our medical professions in patching us up when our bodies no longer can.

With this volume we turn our attention to the plant world, a world populated by very different but equally complex organisms. We go from a single species, Homo sapiens, to over a quarter of a million, to which we owe our very existence. They were here before us; the spread of prehistoric forests absorbed carbon from the atmosphere and made the air breathable for us and other species to evolve as we have done. Plants regulate our environment and their own. With them the world is in equilibrium, and we destroy their habitats at our peril, be they local wetlands or distant rainforests.

We owe plants more than just the air that we breathe. By trial and error, or perhaps by instinct, our ancestors discovered which plants were good to eat, which had healing properties and which were useful for shelter, clothing or something else. The long, wide leaves of the cabbage palm are effective roofing materials, and some cultures also stitch them into service as ceremonial dress. The spiky leaves of the pineapple have been used in papermaking, while the canes of Malaya's *Calamus* vines, otherwise known as rattan, are used for everything from corporal punishment to furniture

Plants in medicine

We've touched on the medicinal use of plants in earlier volumes of *Science Is Beautiful*. Many animals know instinctively what plants to eat when they are ill, and no doubt evolving humans had the same unconscious knowledge. Plants were the first pharmacy, and herbal therapy the first medical science, the principal approach to medication from prehistoric times until the nineteenth century.

The pharmaceutical industry of the modern world has developed drugs that go far beyond the herbal medicine cabinet. Most are synthetically produced; but some plants used in traditional medicine are now being shown by chemical analysis to contain compounds well suited to the treatment of the ills for which they were prescribed. Anti-inflammatory aspirin, as is well known, is derived from the leaves and bark of the willow tree. The humble dandelion contains pharmaceuticals known to reduce blood pressure and inflammation and act as a diuretic. Studies are under way to establish the dandelion's efficacy in slowing cancer cell growth and the progress of Alzheimer's disease.

For now, plant medicine remains largely on the fringes of conventional health practice. The billion-dollar drugs corporations have no interest in encouraging the use of herbal remedies that are more freely and cheaply available than their own. Social pressures in the scientific age have also led to a dismissal of plant-based treatments. For example, penal

attitudes towards the recreational or spiritual use of cannabis have delayed research into its medicinal advantages. But it has been shown to provide effective relief against pain and nausea and neurological conditions such as multiple sclerosis.

Plants in food and drink

The fruit, vegetables and grains that we eat today are all the product of thousands of years of domestication – farmers sowing seeds in rows instead of simply gathering the plants in the wild, then selecting the species that were biggest or best to eat and cross-breeding species for greater productivity.

And now we are genetically modifying plants for even higher yields. It remains a controversial development; humanity is 'playing God' and fast creating new species that might otherwise have evolved naturally, but over thousands of years. Although we may not fully understand the consequences of releasing such creations into the environment, they do answer a need. As the world's population rises and inhabits more and more of the world's surface, there is less and less land for agriculture. We need more food, but have less ground to grow it on. Our fields, orchards and greenhouses simply have to become more productive. Perhaps as a reaction to the introduction of GM crops, the 'grow your own' movement is undergoing a revival, whether it be herbs on your kitchen windowsill or guerrilla gardening in abandoned urban lots. If you can't grow your own, foraging is an increasingly popular alternative. Once you are confident about identifying edible wild species, they are there for the taking – as long as they are not under legal protection, and you really are sure that, for example, it is a tasty *Daucus carota* (wild carrot) and not a lethally poisonous but very similar *Conium maculatum* (hemlock).

The plant's perspective

Whether as meal, medicine or material, we humans have much to thank the plant world for. Beyond these practical applications, we've also learned to domesticate plants purely for their beauty in our gardens. But look at it from the plant's point of view. Their usefulness and attractiveness are not for our benefit. Plants, like all living things, have evolved with only two things in mind: staying alive and perpetuating the species. This book celebrates how they approach these twin problems of survival.

Most plants stay alive thanks to their roots and leaves. Roots draw water and some nourishment from the soil in which they grow, or in the case of the Azora water fern, from the water in which it floats. From the roots a specialized system of cellular channels hoists the water to where it is needed. That may not seem so clever in a dandelion, for example – but imagine carrying the water you need vertically up the 380 feet (116 metres) or so to the topmost branches of a Californian redwood. Leaves

have to be nourished so that they can play their part in the health and growth of a plant. They contain extraordinary units called chloroplasts, which conduct the business of photosynthesis. Photosynthesis is the use of sunlight to extract carbon from the atmosphere and convert it into useful carbohydrates, which are distributed throughout the plant by further channels, helping it to grow.

While leaves and roots maintain a plant's health and growth, perpetuation of the species is down to flowers, which are the plant's reproductive organs, male or female or both. It is here that nature has introduced the most extraordinary variety of techniques for ensuring the fertilization and distribution of seeds. Flowers must somehow ensure the successful meeting of sperm-producing pollen and egg-producing ovary. They often enlist the help of the insect world, and use everything at their disposal – shape, colour, scent, nectar and even markings invisible to the human eye – to attract the right pollinator to the right part of the flower.

Sowing the seed

A fertilized egg becomes a seed, and the flower's next task is to disperse its seeds as far and wide as possible. Rooted as it is, it relies on other more mobile forces to transport its potential offspring – gusting winds, passing animals, flowing waters. To get the seed where it needs to be, a plant may use a parachute, grappling hooks, a catapult or mere gravity. Or it may produce a fruit tempting enough for an animal to eat, allowing the undigested seeds to pass in its faeces at a later date.

Among the most ingenious, or haphazard, methods of dispersal must surely be that of the cup-shaped bird's nest mushroom. The nest contains little coin-like capsules of spores, and to disperse them the mushroom depends on the remote chance of a heavy raindrop landing in the cup at just the right angle. When it does so with enough force, the raindrop propels the capsules up the sides and out through the air to land up to three feet (one metre) away like a reverse version of tiddlywinks.

Is this evidence of intelligent design or of absurd complication in the random lottery of evolution? Either way, this book looks beneath the surface of botany at some of the inventive solutions that plants have devised to overcome the everyday problems they face. Close up, their microscopic ingenuity is a whole world of scientific wonder. And science, like a flower, is beautiful.

A brief note about how these pictures were made may be helpful. You'll see alongside each one a note of what sort of micrograph it is. A micrograph is simply a graphic image of microscopic detail, and there are several different ways of producing one. The pictures in this book were acquired by one of two technological marvels.

Light micrographs

A light micrograph is produced by a light microscope. This is the traditional microscope, the one invented in the sixteenth century, which uses lenses to magnify a specimen visible under natural or artificial light. When light strikes an object, it is reflected by the surfaces of that object according to the colour, texture and angle of those surfaces. That reflected light reaches the eye, either directly or (in this case) through the lenses of a light microscope. The light is gathered on light-sensitive cells inside the eyeball. The brain processes the information gathered by these cells, information about shape and size as well as colour and texture, in an activity better known to us as sight. The light microscope sees more or less what the human eye sees; it simply magnifies it.

Fluorescent light can also be used to show up unseen detail. Specific components within biological samples can be stained with fluorescent chemicals, which are visible in particular narrow wavelengths of light. The result is a fluorescence light micrograph.

The microscope became a tool for scientific study in the late seventeenth century, and remains the simplest, most low-tech, low-cost way to look at small things. It has changed little, in essence, in the four hundred years since its invention. The greatest innovations have been in the kind of light used to view specimens. For example a polarized light source placed behind a biological sample can reveal particular patterns of colour and structure in the same way that polarized sunglasses can.

Electron micrographs

At the start of the twentieth century scientists began to develop a high-tech alternative to the light microscope. The first electron microscopes appeared in the 1930s. Instead of beams of light, they use a stream of electrons fired from an electron gun. Instead of lenses they use electromagnets, which can bend beams of electrons in the same way that

glass lenses bend light. If the electron beam is dense enough, it becomes possible for the first time to see things in greater detail than with mere light – in other words, to see things that are not visible to the naked eye. There are two kinds: the transmission electron microscope (TEM) and the scanning electron microscope (SEM). As its name suggests, the electrons from a TEM are transmitted – that is, they pass right through the material being studied. Because they pass through it, they are affected by it, just as light passing through stained glass is affected. It is the way in which the electrons are affected that builds up an image of the material, just as sunlight streaming through a stained-glass window lets us see the full colourful work of the window's designer. The TEM's image is collected on the far side of the material, either by camera or by a fluorescent screen.

By contrast the electrons from an SEM do not pass through the specimen. The SEM fires electrons that scan the specimen in a grid pattern. They interact with the atoms in the material, which then emit other electrons in response. These secondary electrons may be emitted in many directions depending on the shape and composition of the surface. They are detected; and by combining information from these secondary electrons with details of the original electron scan, a scanning electron micrograph is built up.

Because their electrons have to pass through the material, TEMs can only work with very thin samples of material. SEMs can deal with much bulkier material and the resulting images can convey depth of field. TEMs are however capable of greater resolution and magnification. The numbers are unimaginable, but TEMs can reveal details less than 50 picometres (50 trillionths of a metre) in width and magnify them over 50 million times. SEMs can 'see' details one nanometre (1000 picometres) in size and magnify them by up to half a million times. By comparison, an ordinary light microscope only shows detail larger than around 200 nanometres (4000 times larger than the TEM) and provides useful, undistorted magnification only up to 2000 times (25,000 times less than the TEM).

Most of the micrographs you will see in this book are enhanced with additional colour, sometimes called false colour. This makes it easier to see what is being illustrated, and prettier too. Beautiful as they are, most plants are not the multicoloured works of art you see here, at least not internally. But they are works of extraordinary complexity, marvels of botanical engineering with impressive techniques for surviving and reproducing. You will never look at fruits, flowers and vegetables in the same way again.

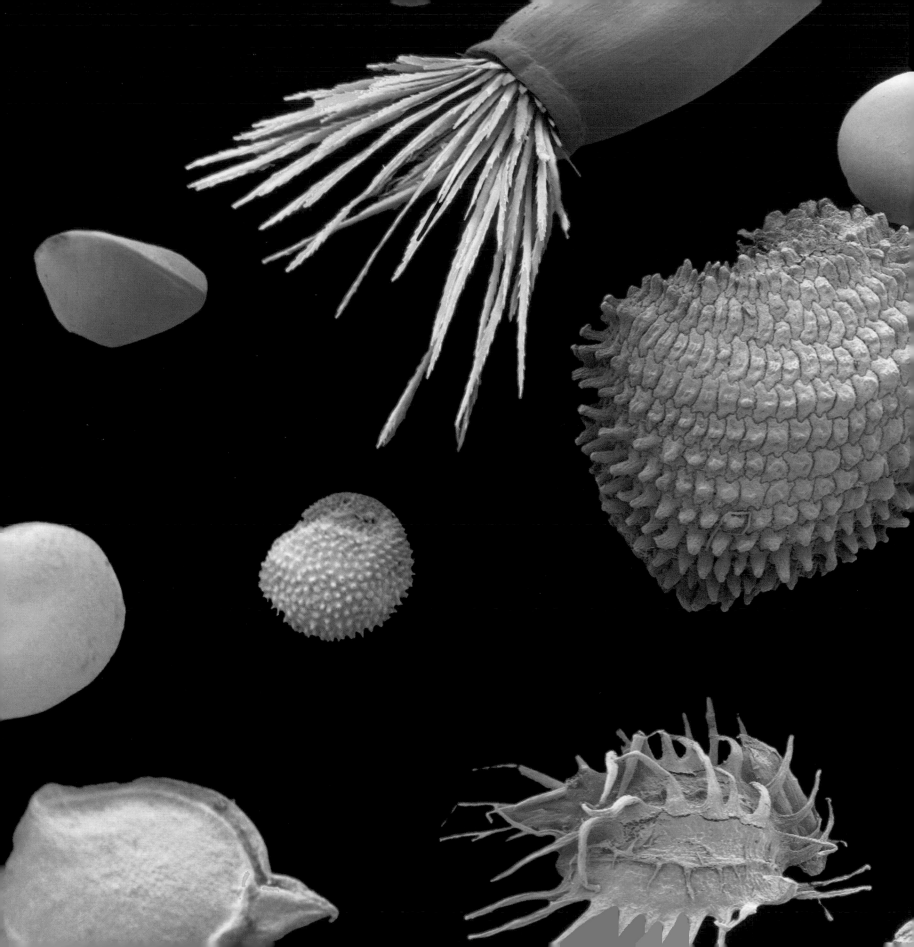

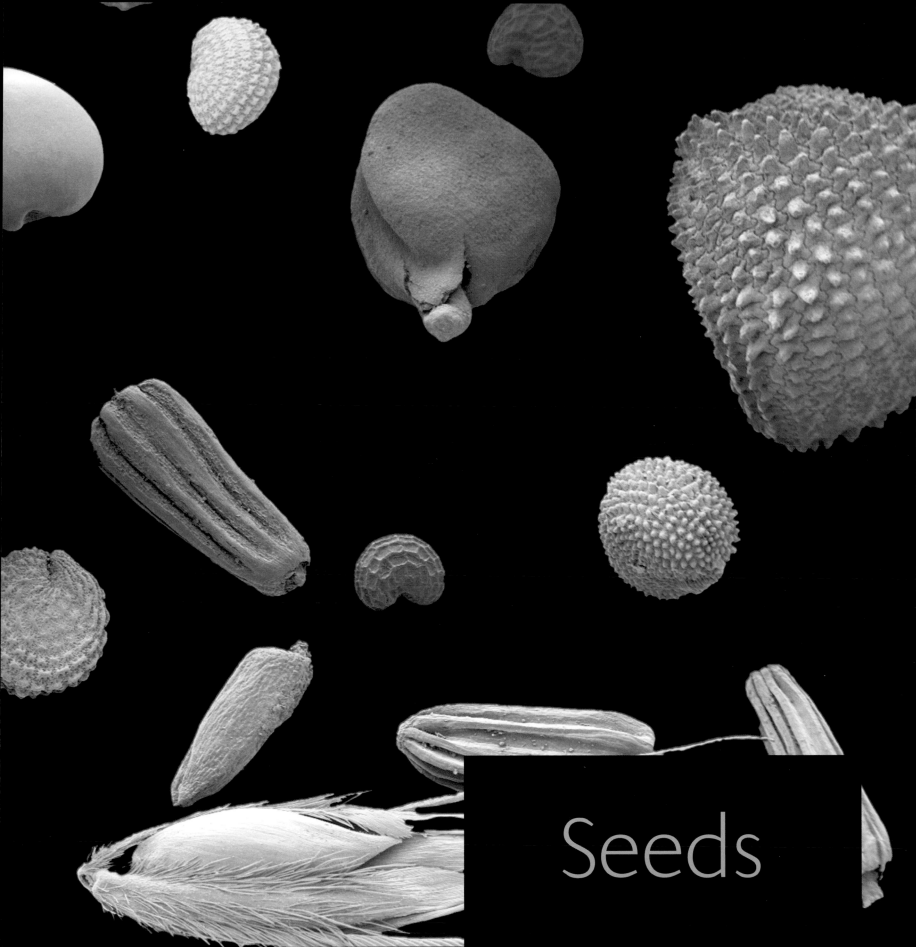

Seeds

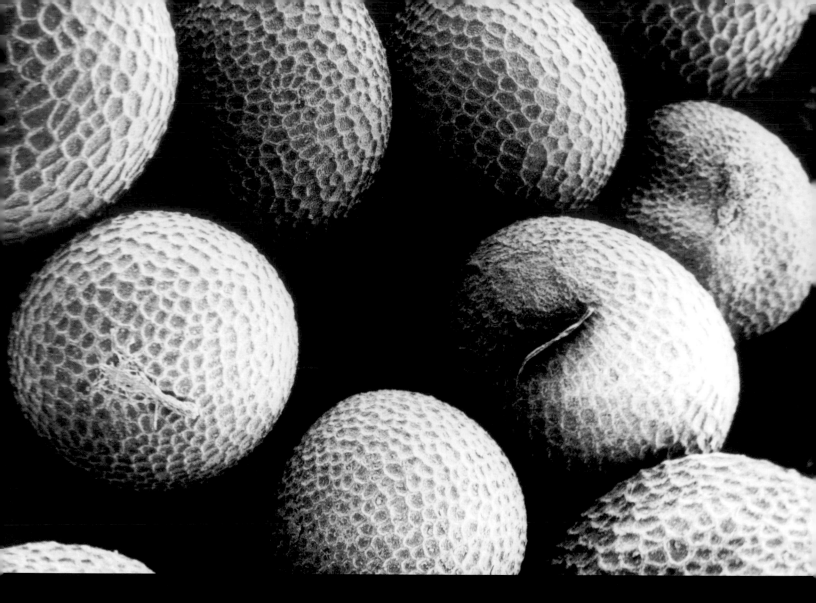

Previous page: Mixture of flower and grass seeds (scanning electron micrograph)

Seeds come in all shapes and sizes. Not all plants produce them, and those that do fall into two categories. The seeds of angiosperms, plants that bear flowers and fruits, are enclosed in a hardened shell. Gymnosperms (from the Greek for 'naked seeds'), which include conifers, have no such shell. This artificially coloured image shows a variety of angiosperm seeds from a commercially available wild meadow mixture that includes flowers and grasses. (Magnification x200 at 10cm wide)

Above: Mustard seeds (scanning electron micrograph)

Many of us were introduced to botany as children by growing seedlings from mustard seeds on wet blotting paper. They germinate easily in cold air and are native to many temperate regions of the earth. The three varieties of mustard plant are all members of the Brassica family, which also includes cabbage, broccoli and cauliflower. The 1mm-diameter seeds, high in vitamins and minerals, are ground to powder and mixed with water or vinegar to make table mustard. (Magnification x25 at 10cm wide)

Right: Bur-clover burr (scanning electron micrograph)

Seeds have evolved many ways of improving their chances of dispersal, for example by wind or through an animal's digestive system. The bur clover's seed is wrapped in a shell of sharp hooks called a burr, which attaches itself to the fur of an animal attracted to the plant's edible leaves. The animal moves away and eventually shakes the burr off elsewhere, ensuring a broad geographical spread for the clover. The burr was the inspiration for the Velcro hook-and-loop fastener. (Magnification x5 at 10cm wide)

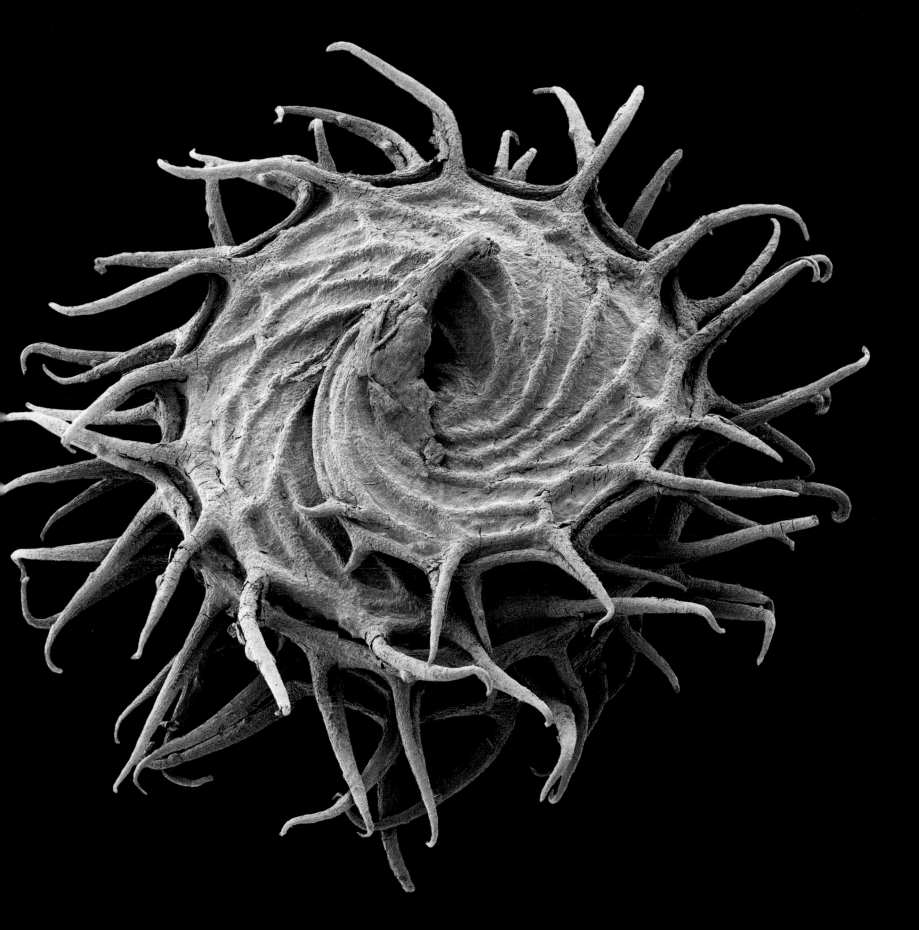

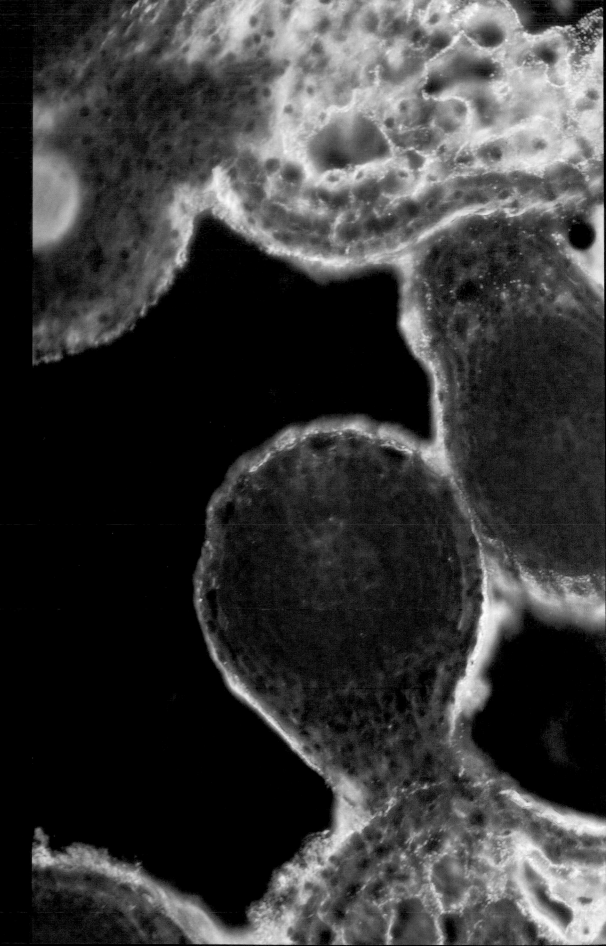

**Poppy ovary with developing seeds
(light micrograph)**
The dotted red line in this colour-enhanced
image is the inner lining of one of many
placentas in a poppy. The lining contains eggs
(ovules), which in this case have been fertilized
by poppy pollen. The red balloons emerging
from it are seeds – embryonic poppies,
surrounded by a protective coat (here in
yellow-green). They will eventually break free
of the lining and fill the swollen seed head of
the poppy until it bursts and scatters them.
(Magnification unknown)

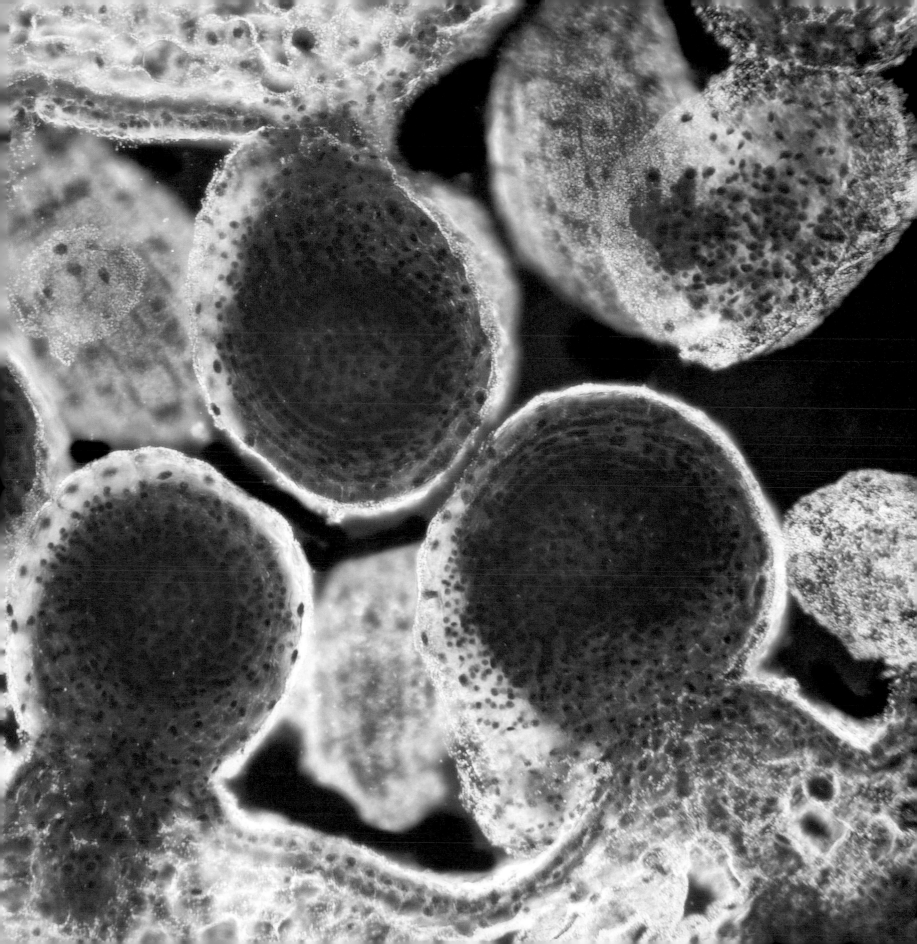

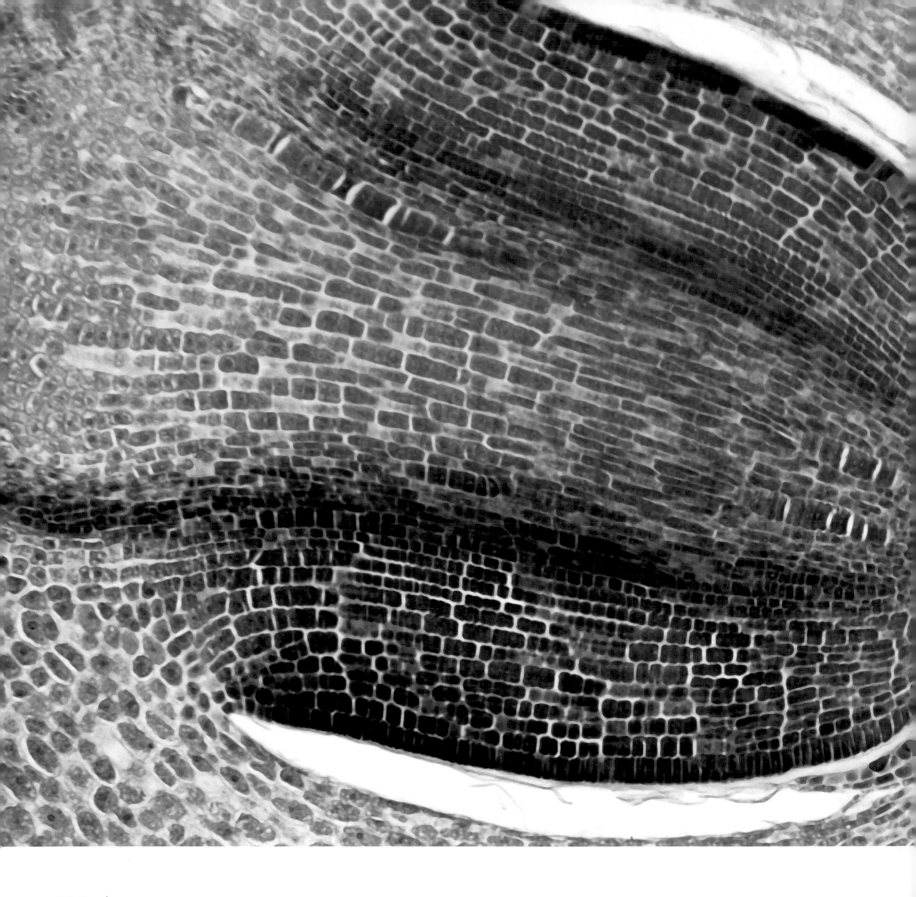

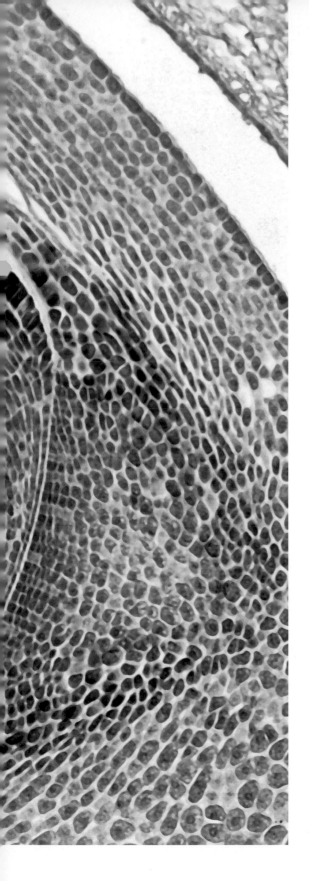

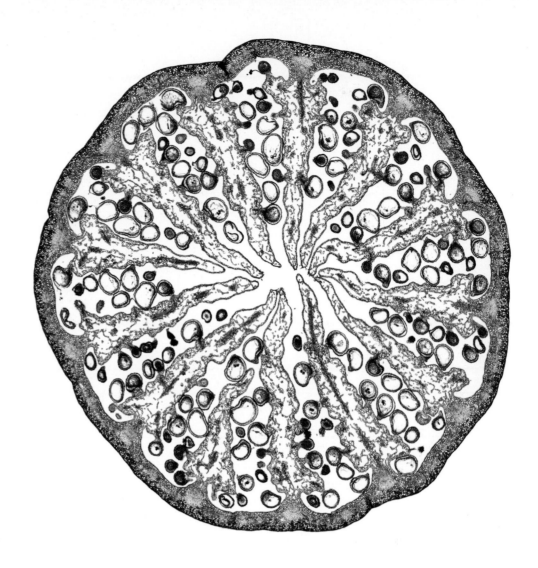

Left: Maize seed (light micrograph)
This cross section of a maize seed shows the
very early stages of germination. At bottom
right the radicle stretches out: from it the roots
of the new plant will develop. Expanding in the
opposite direction, the hypocotyl swells once
the roots are established, lifting the head of
the seed above ground. From there the stem,
the embryonic leaves (called cotyledons) and
finally the first true leaves will start to grow.
(Magnification x50 at 10cm wide)

Above: Poppy seed head (light micrograph)
Within the tough outer wall of a poppy head,
here seen in cross section, thirteen tongue-
like barriers, called septa, run towards the
centre, not quite meeting in the middle. From
these placenta-lined walls the poppy's ovules
develop – the small red circles in this image.
The fertilized ovules become seeds inside some
of them: you can see the endosperm, the
nutritional material that will feed the embryo
of a new poppy.
(Magnification x5 at 10cm wide)

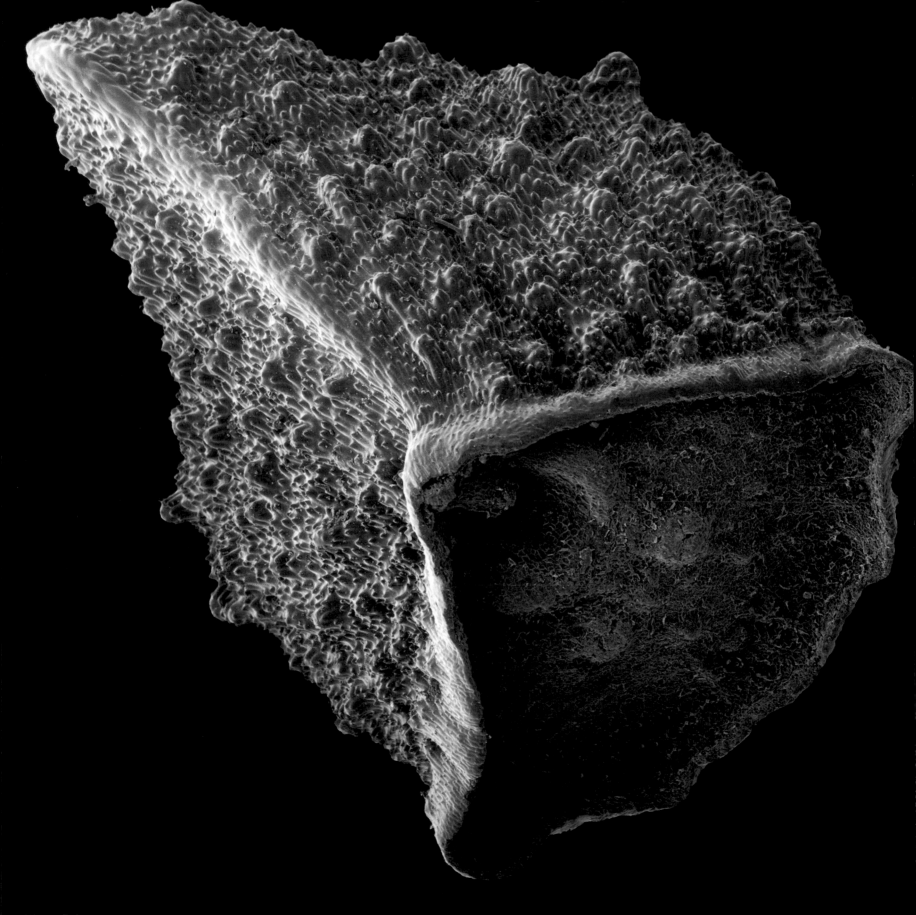

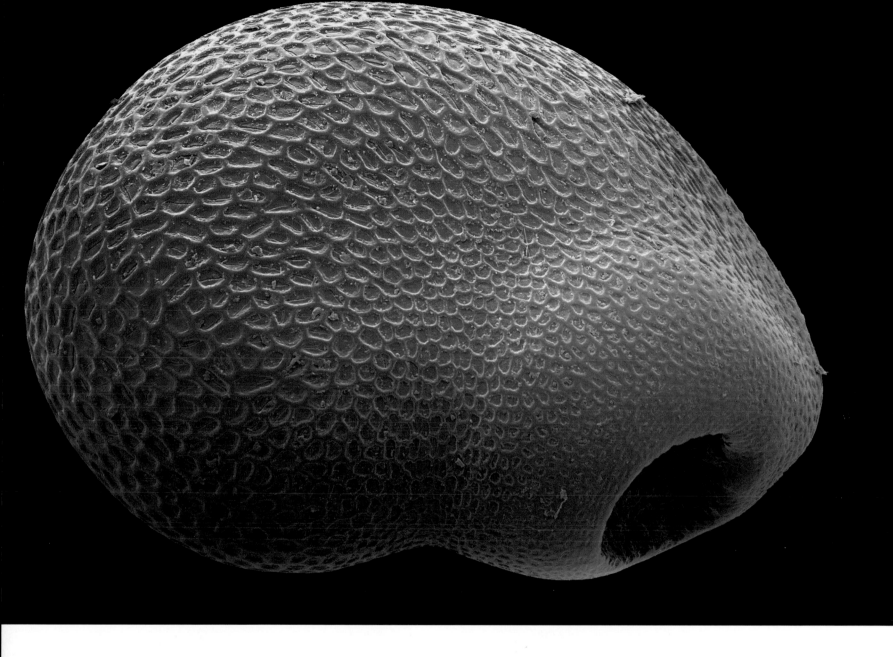

Left: Borage seed (scanning electron micrograph)

Some seeds are flat, some are round; some, like this borage seed, seem designed to pierce the ground on which they fall. Borage seed oil contains high amounts of gamma-linolenic acid, a fatty acid also found in the oils of evening primrose and blackcurrant. Herbalists prescribe borage oil for a wide range of complaints including diabetes, rheumatoid arthritis and heart disease; but there is little scientific evidence to confirm its efficacy. (Magnification x580 at 10cm wide)

Above: Cactus seed (scanning electron micrograph)

Cacti form a large family of plants called the Cactaceae. Most of them are well adapted to extremely hot, dry conditions; their leaves for example have evolved as spines, reducing the surface area from which precious moisture might evaporate. Their seeds are also protected, growing from ovaries buried deep in the fleshy stem below the flower. They are dispersed in the dung of animals that have eaten the plant. (Magnification x830 at 10cm wide)

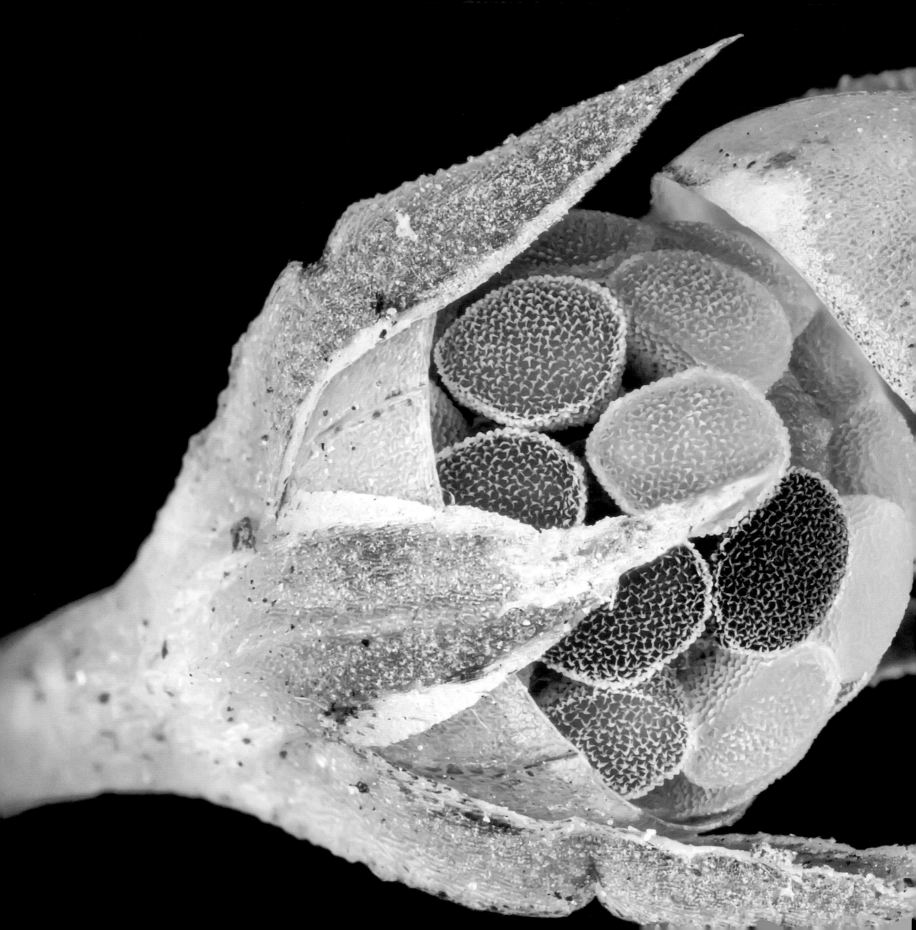

Pimpernel seed capsule (light micrograph)
The scarlet pimpernel is also called the shepherd's weatherglass because its petals close up when bad weather is coming. When its seeds are ripe the top of the capsule flips open to release its contents on to the soil. The name means 'little pepper' and it is highly toxic when taken internally by livestock and humans. It has some insect-repellent properties. Its German name, *Gauchheil*, means 'idiot-cure', a reference to its use in some herbal traditions to treat mental illness. (Magnification x40 at 10cm wide)

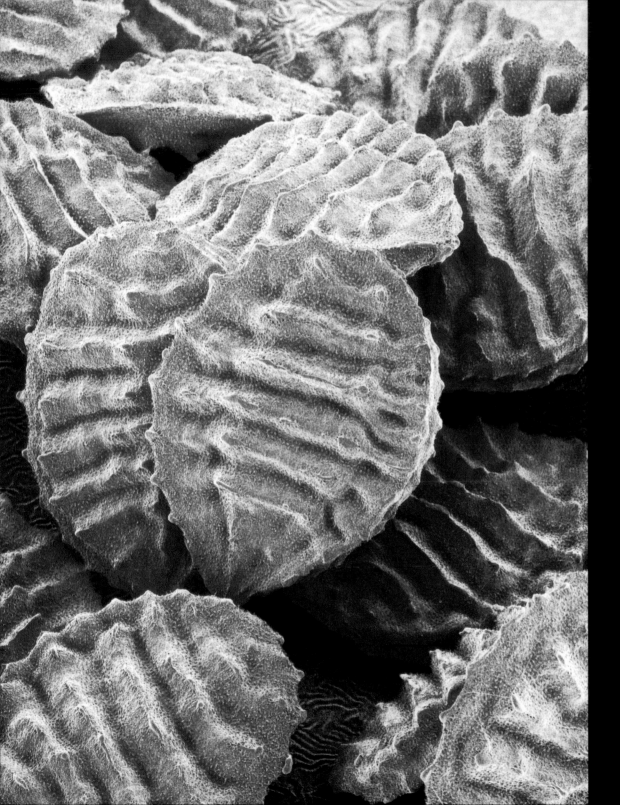

**Left: Wood sorrel seeds
(scanning electron micrograph)**

The humble wood sorrel, carpet of the forest floor, is unrelated to its namesake herb, but tastes like it. The flowers, seeds and leaves all contain oxalic acid and are refreshing to eat, with a mild lemony flavour. There are some 800 species around the world, and Native Americans north and south have long used the plant for food and medicine. Some sorrels including the New Zealand yam and the Colombian oca are grown for their turnip-like tuberous roots.
(Magnification unknown)

**Right: Chickweed seed grain
(light micrograph)**

Common chickweed is considered a pest by gardeners and farmers because its pretty white, starlike flowers are quickly followed by a profusion of seeds. If unchecked it forms a thick mat of foliage that stifles grass and crops. However it is also a crop in its own right, rich in iron and delicious in salads. It is a staple ingredient of the rice porridge traditionally eaten on 7 January for the Japanese Festival of Seven Herbs, Nanakusa No Sekku.
(Magnification x40 at 10cm wide)

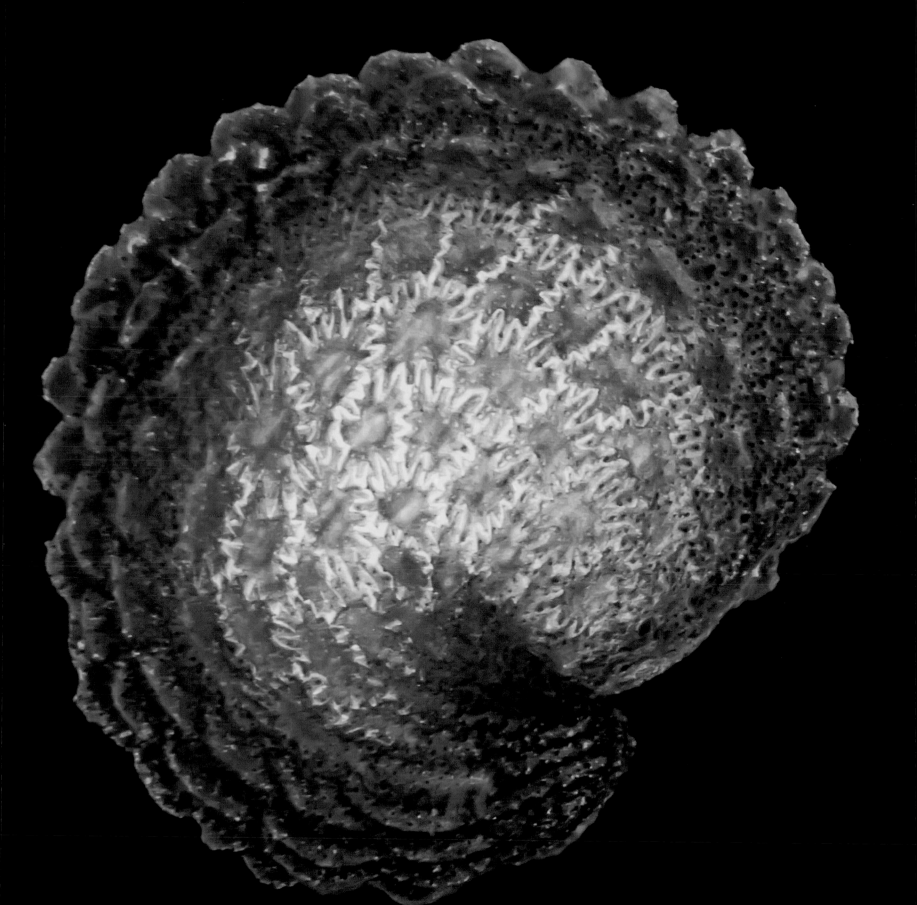

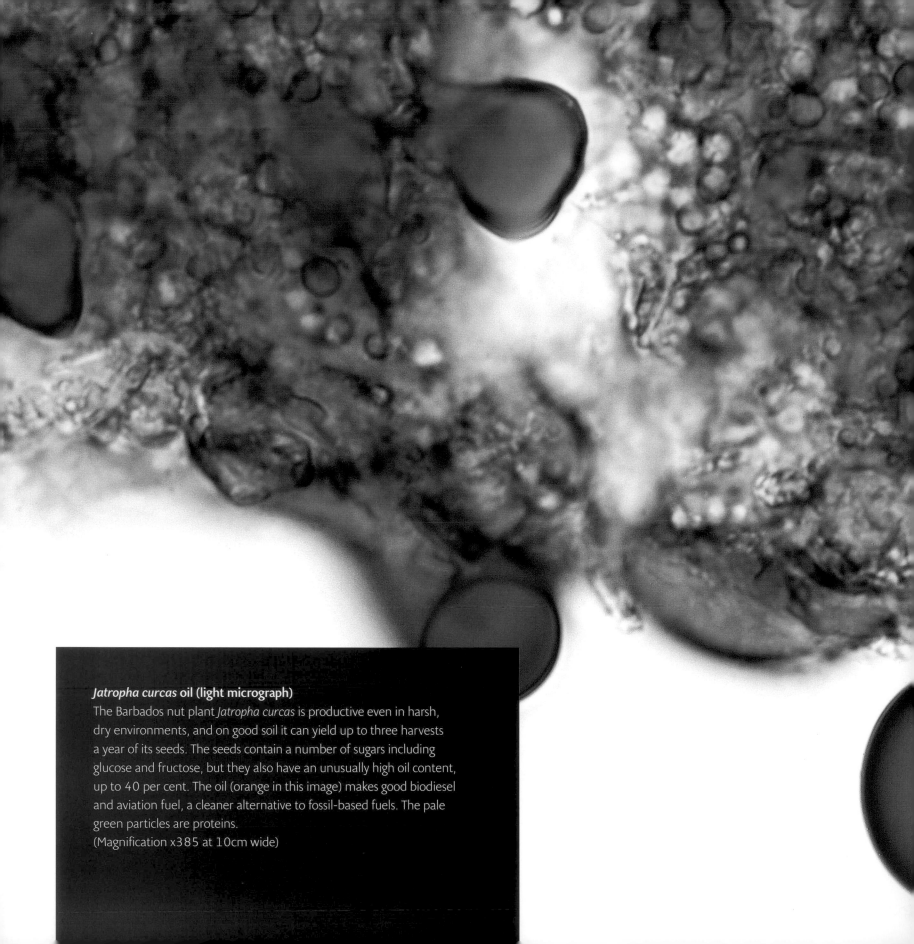

***Jatropha curcas* oil (light micrograph)**
The Barbados nut plant *Jatropha curcas* is productive even in harsh,
dry environments, and on good soil it can yield up to three harvests
a year of its seeds. The seeds contain a number of sugars including
glucose and fructose, but they also have an unusually high oil content,
up to 40 per cent. The oil (orange in this image) makes good biodiesel
and aviation fuel, a cleaner alternative to fossil-based fuels. The pale
green particles are proteins.
(Magnification x385 at 10cm wide)

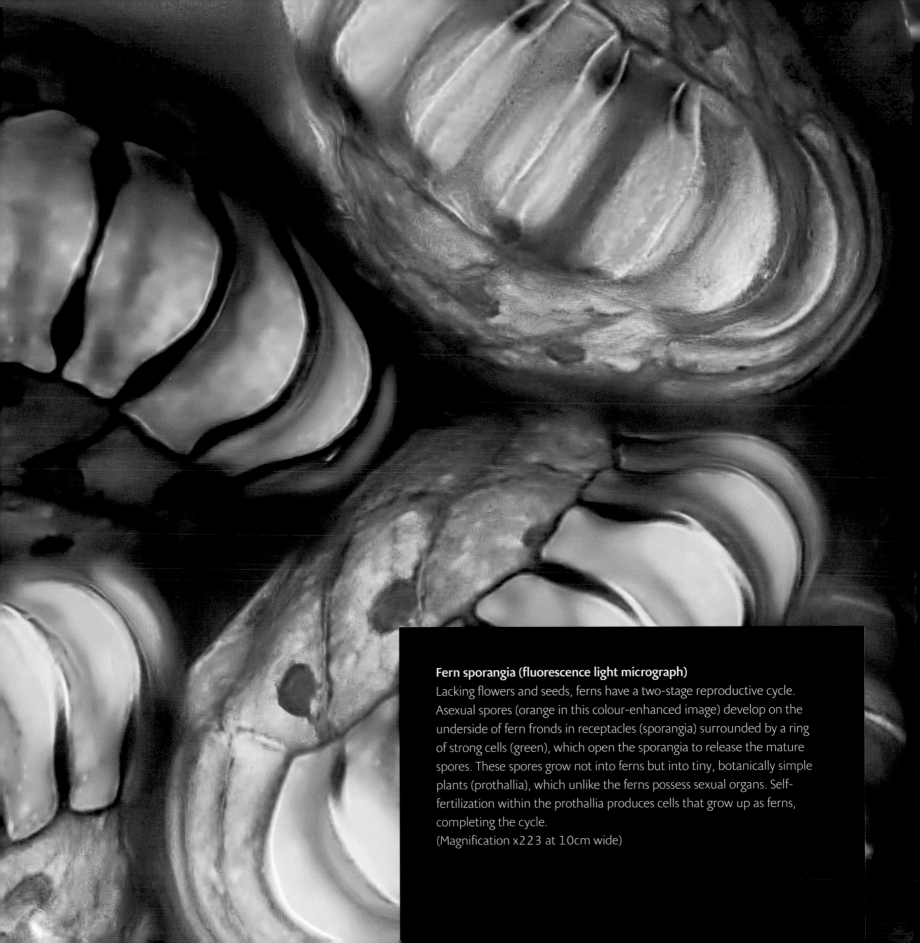

Fern sporangia (fluorescence light micrograph)
Lacking flowers and seeds, ferns have a two-stage reproductive cycle.
Asexual spores (orange in this colour-enhanced image) develop on the
underside of fern fronds in receptacles (sporangia) surrounded by a ring
of strong cells (green), which open the sporangia to release the mature
spores. These spores grow not into ferns but into tiny, botanically simple
plants (prothallia), which unlike the ferns possess sexual organs. Self-
fertilization within the prothallia produces cells that grow up as ferns,
completing the cycle.
(Magnification x223 at 10cm wide)

Above: California poppy seeds (scanning electron micrograph)
Poppy seeds are sown when the fruit of the plant, the seed capsule, splits in half. The seeds are scattered around the parent plant, which is why poppies tend to grow in large drifts of colour in fields and verges. The California poppy was adopted as the state flower in 1903; one poppy reserve near Los Angeles is completely covered in the orange blooms every year. An extract from the plant has a mild sedative effect. (Magnification x18 at 10cm wide)

Right: *Nigella* seed (scanning electron micrograph)
The tiny black teardrop seeds of *Nigella* (here artificially coloured) give the plant its name – derived from the Latin for 'little black'. They develop in swollen pods from which they fall as the pods dry out. Thus, although the plant is an annual, it appears to return every year in the same place. The seeds are widely used in cooking, and their pungent flavour gives the plant a variety of common names including black cumin and fennel flower. (Magnification x1000 at 10cm wide)

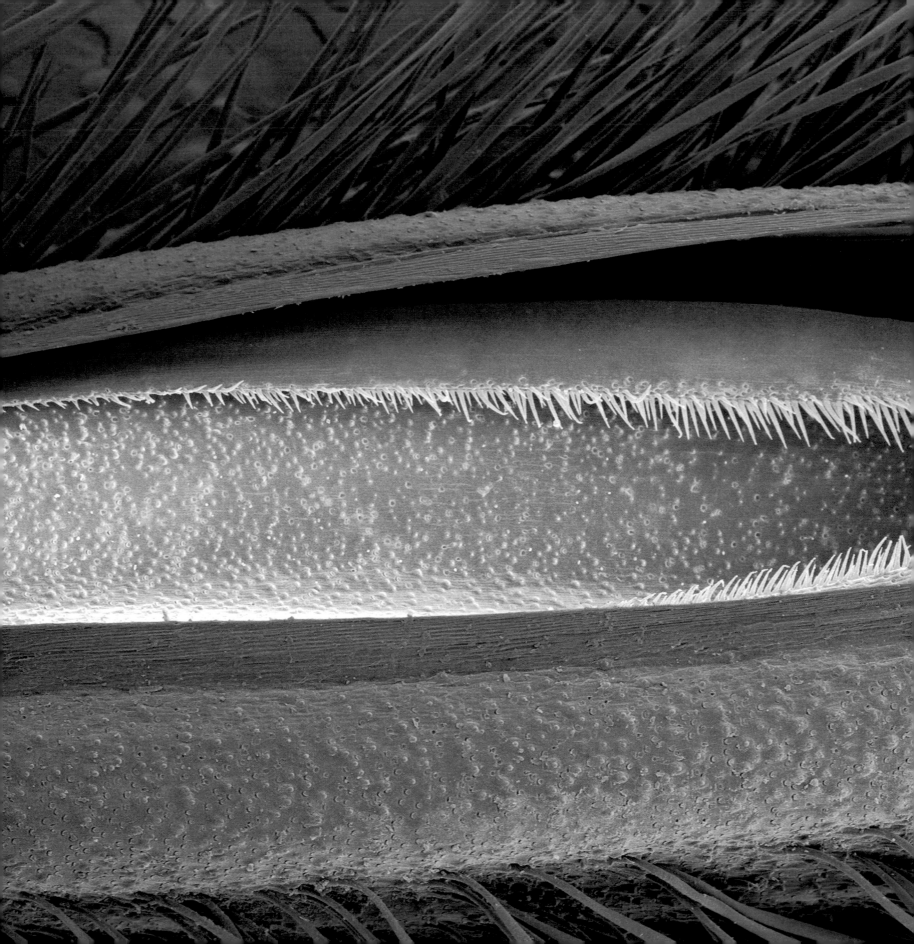

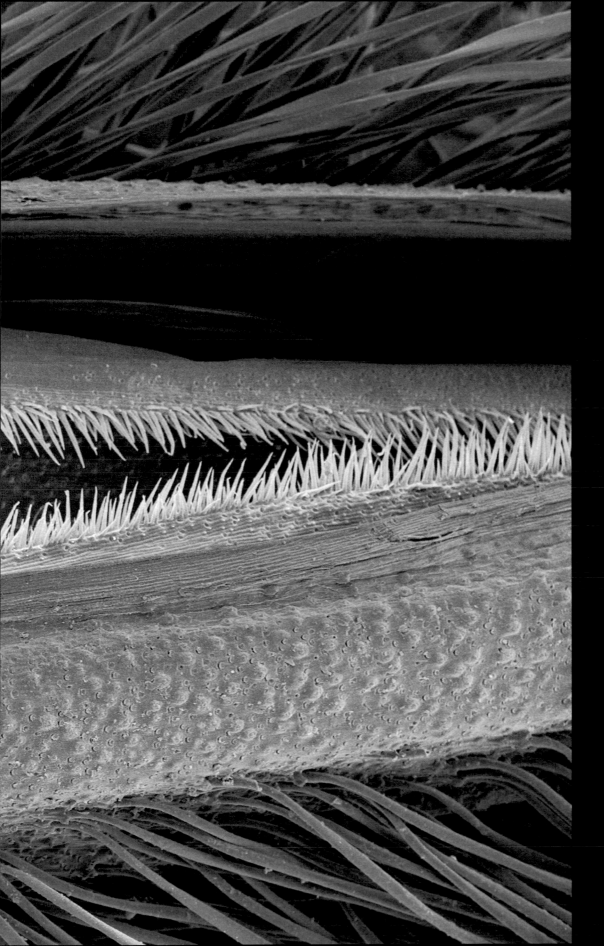

Elm tree seed (scanning electron micrograph)
This image shows a fertilized elm ovary
unfurling to become a thin green disc
containing a small seed. Clusters of discs
gradually turn brown on the tree until
the winds of autumn shake them free.
The relatively large surface area acts as a
sail, carrying the tiny seed at its heart as
far as the wind will take it. Seeds like this
with sails that rely on the wind for dispersal
are called samaras – sycamore seeds are
another example.
(Magnification x12.5 at 10cm wide)

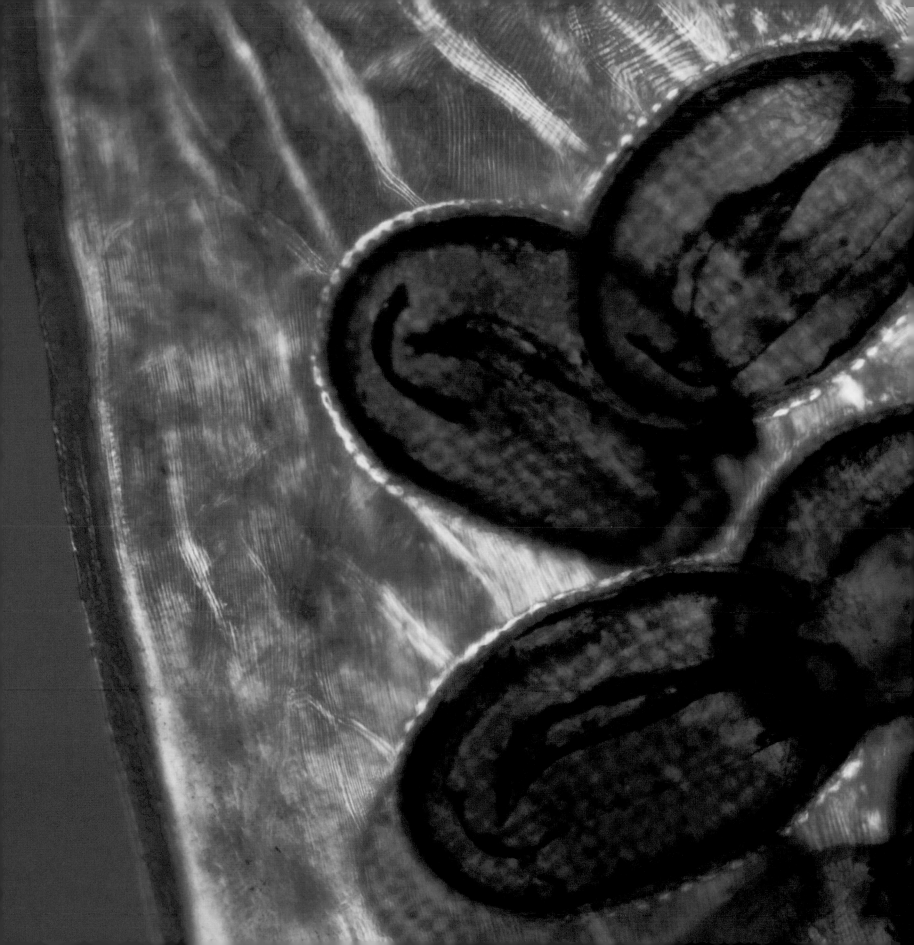

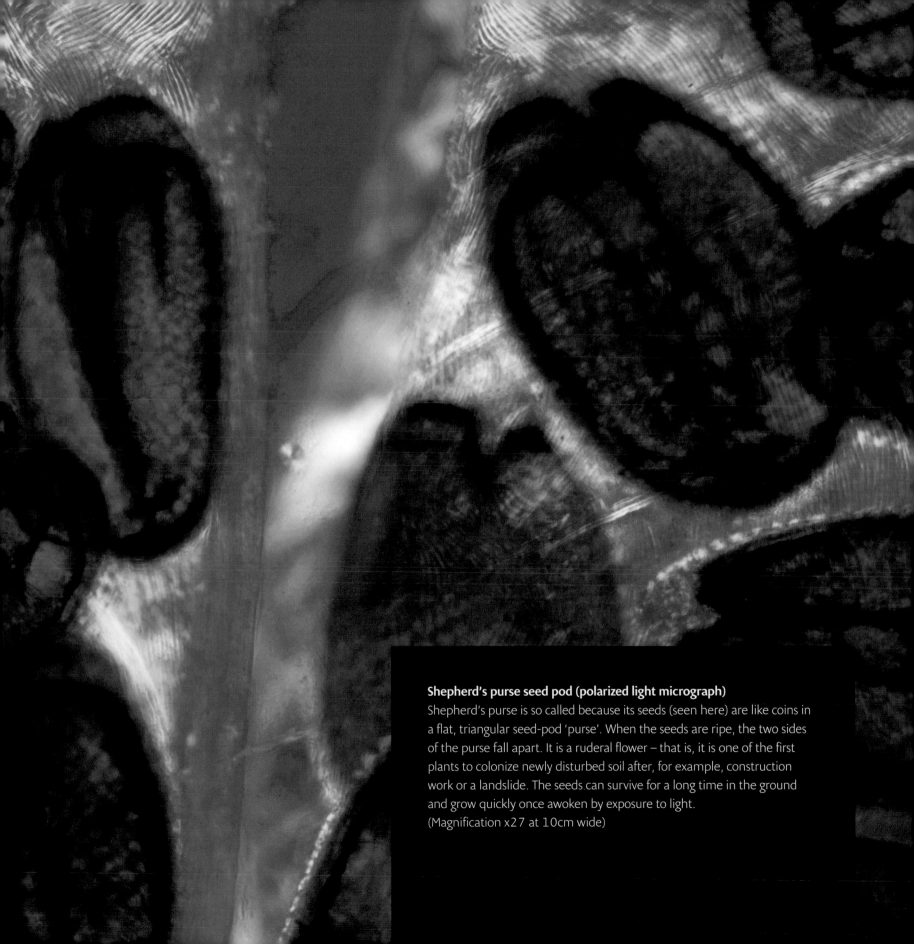

Shepherd's purse seed pod (polarized light micrograph)
Shepherd's purse is so called because its seeds (seen here) are like coins in a flat, triangular seed-pod 'purse'. When the seeds are ripe, the two sides of the purse fall apart. It is a ruderal flower – that is, it is one of the first plants to colonize newly disturbed soil after, for example, construction work or a landslide. The seeds can survive for a long time in the ground and grow quickly once awoken by exposure to light.
(Magnification x27 at 10cm wide)

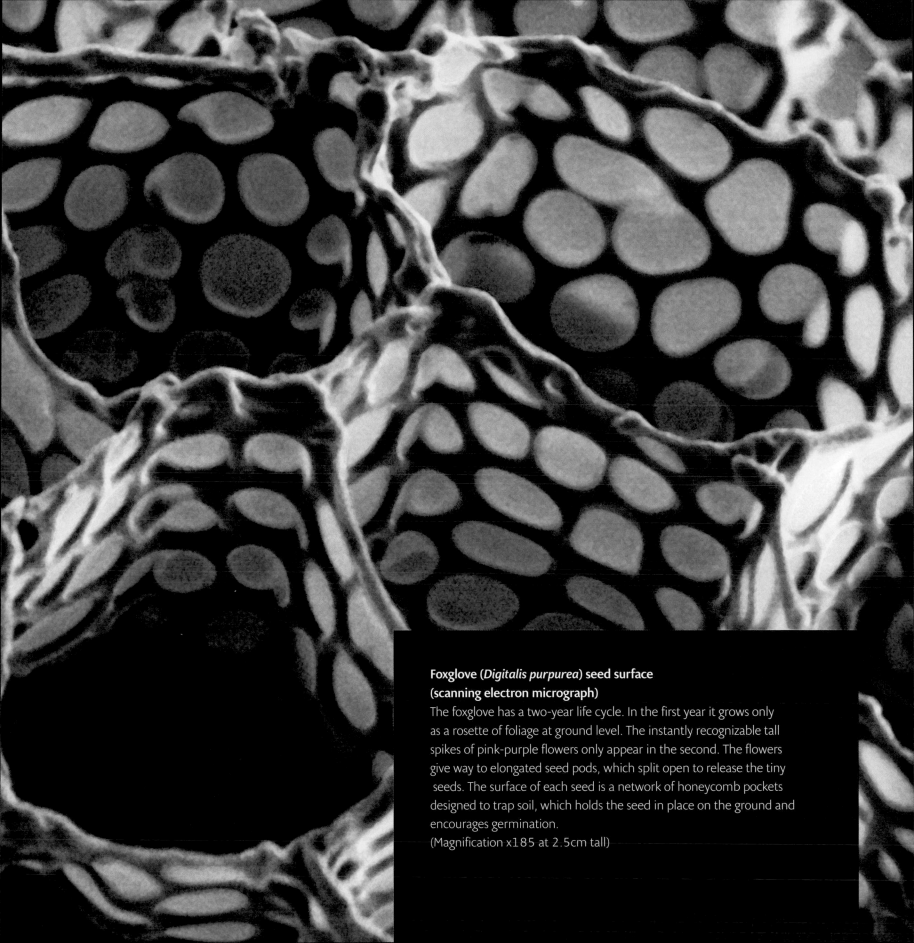

**Foxglove (*Digitalis purpurea*) seed surface
(scanning electron micrograph)**
The foxglove has a two-year life cycle. In the first year it grows only
as a rosette of foliage at ground level. The instantly recognizable tall
spikes of pink-purple flowers only appear in the second. The flowers
give way to elongated seed pods, which split open to release the tiny
 seeds. The surface of each seed is a network of honeycomb pockets
designed to trap soil, which holds the seed in place on the ground and
encourages germination.
(Magnification x185 at 2.5cm tall)

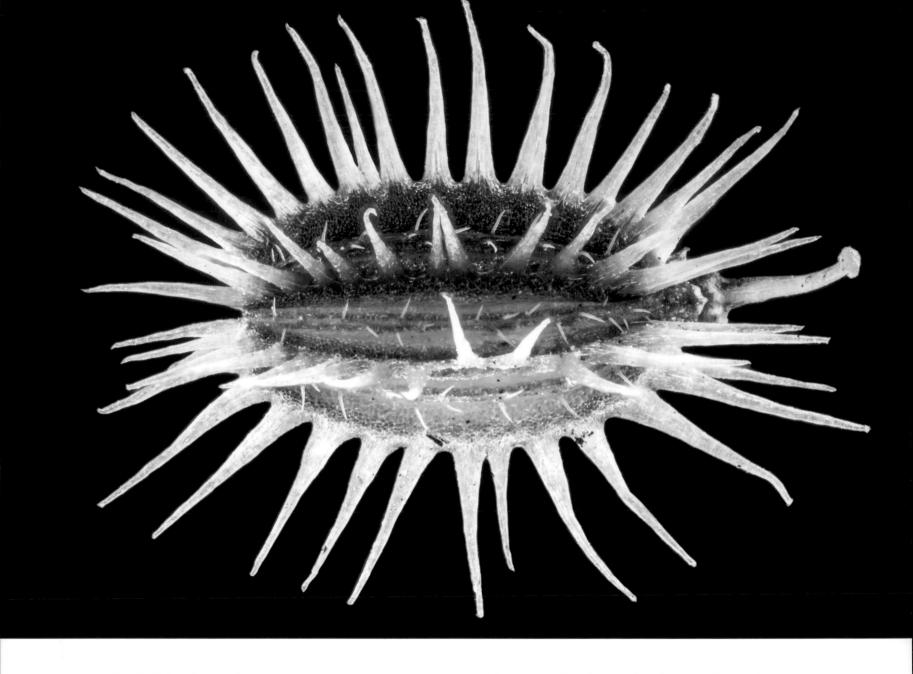

Carrot seed grain (light micrograph)

The wild carrot is sometimes known as Queen Anne's lace. Its white flowers grow in a cluster atop a two-foot (60cm) stem, looking from above like a circle of lace. A single red flower at the centre, which attracts pollinating insects, is supposedly the blood from Anne pricking her finger with a needle. The flower head curls into a ball as the seeds mature. When it detaches it rolls along at the mercy of gravity and wind, helping to disperse the seeds, which can survive for five years in the soil.
(Magnification x40 at 10cm wide)

Right: Redwood seeds (scanning electron micrograph)

The two Californian redwood species are the largest trees in the world, 30 feet (9m) wide and 300 feet (100m) high. For such a tall tree, its cones are small, about an inch (2.5cm) long. Beneath each scale of the cone lie about five seeds, which fall out when the mature cone opens up. Survival rates of seedlings are very low, but mature trees, some over 2000 years old, are extraordinarily resilient to climate change and natural disasters.
(Magnification x55 at 10cm wide)

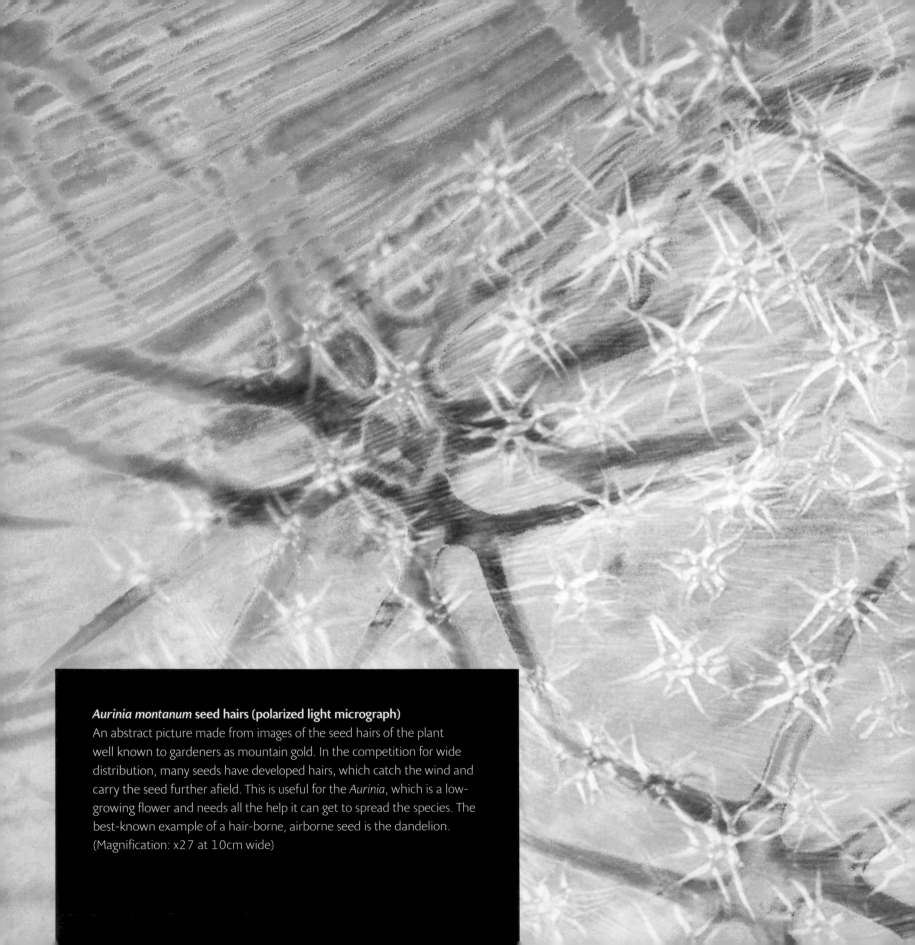

***Aurinia montanum* seed hairs (polarized light micrograph)**
An abstract picture made from images of the seed hairs of the plant
well known to gardeners as mountain gold. In the competition for wide
distribution, many seeds have developed hairs, which catch the wind and
carry the seed further afield. This is useful for the *Aurinia*, which is a low-
growing flower and needs all the help it can get to spread the species. The
best-known example of a hair-borne, airborne seed is the dandelion.
(Magnification: x27 at 10cm wide)

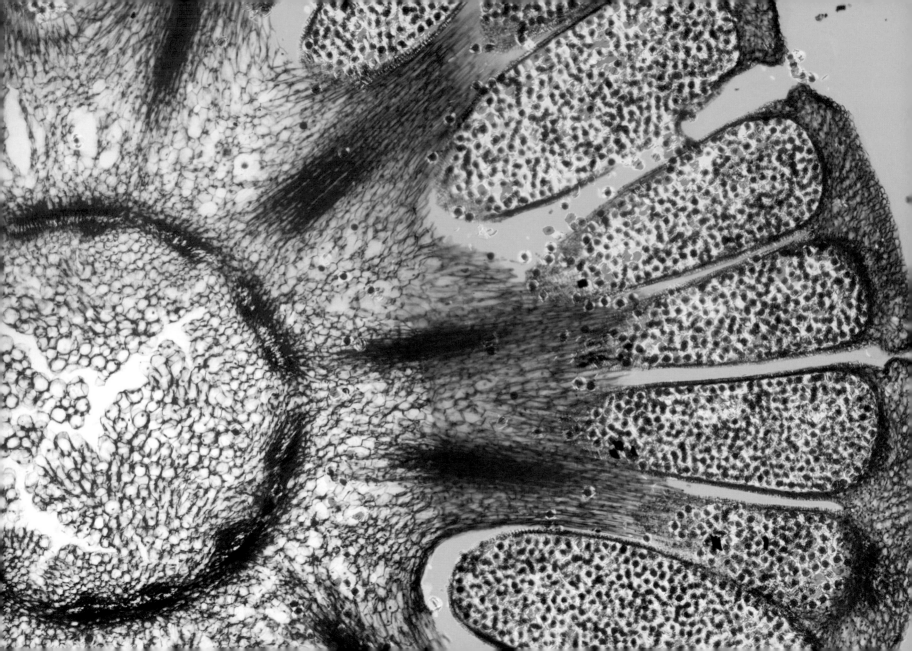

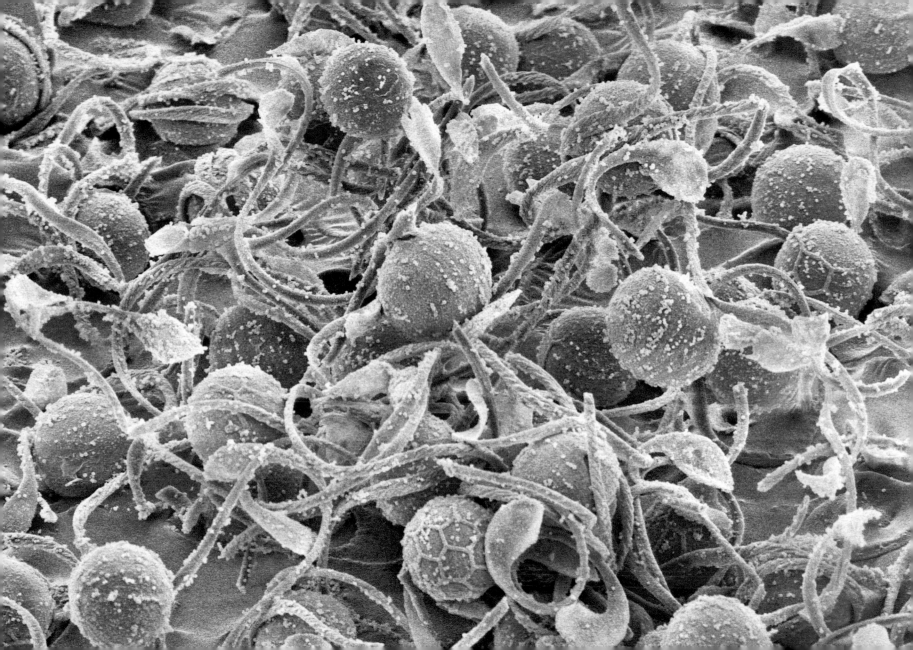

Germinating seed (scanning electron micrograph)
Left to right, the development stages of a typical seedling. The
first thing to emerge from the seed is the radicle, the shoot
from which the plant's roots will form. These, the fine hairs in
the second image, supply the seed with nutrients for its early
growth. Whichever way up the seed lands, the growth of the
radicle is dictated by simple gravity. Finally an embryonic stem
(plumule) emerges above ground, bearing one or two basic leaves
(cotyledons) to start the process of photosynthesis.
(Magnification x5 at 10cm wide)

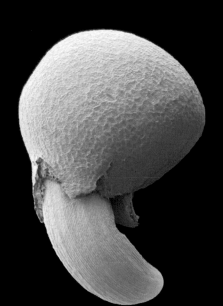
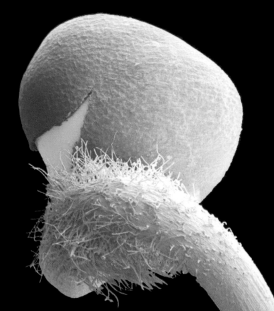

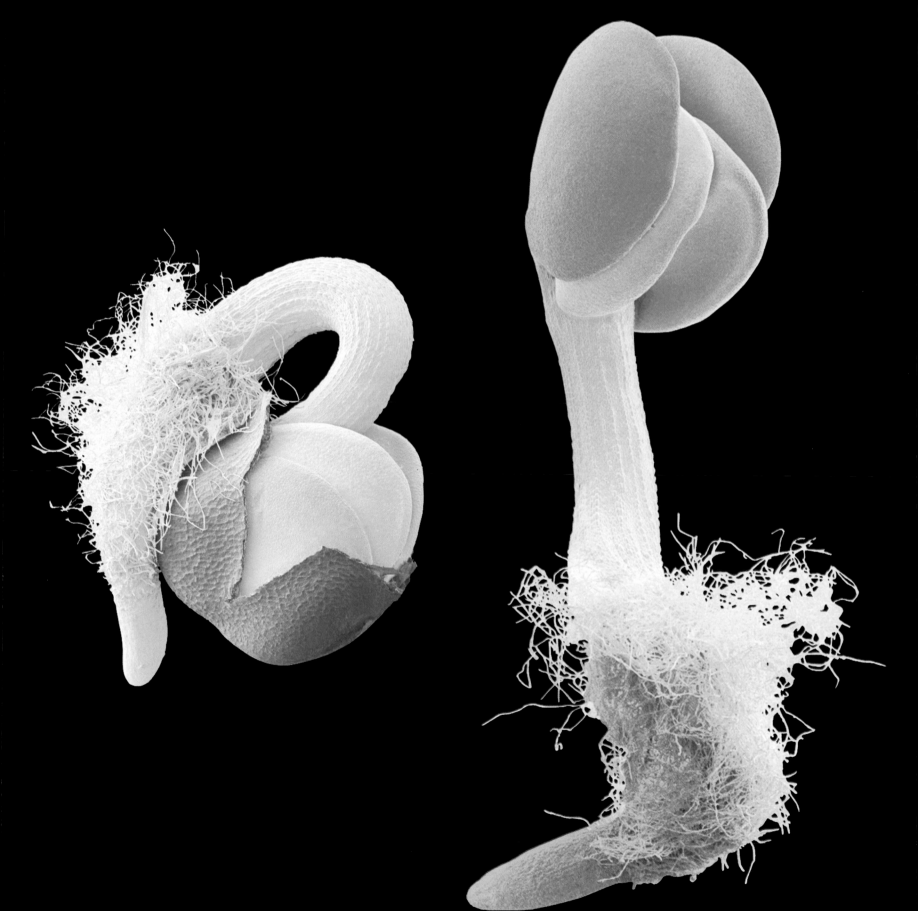

Above: Egyptian cotton fibres (light micrograph)

Cotton thread is spun from the white fibres that form cocoon-like soft shells (bolls) around the seeds of the cotton plant. They are composed almost entirely of cellulose, with a natural springiness that binds them together after spinning. Egyptian cotton is made from a cultivated species, *Gossypium barbadense*, derived in fact from a Peruvian native plant, which yield longer, silkier fibres than common cotton. Its Latin name refers to Barbados, the first English colony to export Egyptian cotton to Europe. (Magnification x75 at 10cm wide)

Right: Dandelion *pappus* (scanning electron micrograph)

The dandelion is another plant that relies on the wind to disperse its seeds. Each of hundreds of seeds in the seed head is attached to a small parachute (*pappus*), seen here from above, of radiating fine hairs. When the wind catches the *pappus*, it pulls the seed away from the head. Hanging below the *pappus* like an invading soldier, the seed glides gently to earth some distance away. Gardeners consider the plant a pest, although every part of it is edible. (Magnification x53 at 10cm wide)

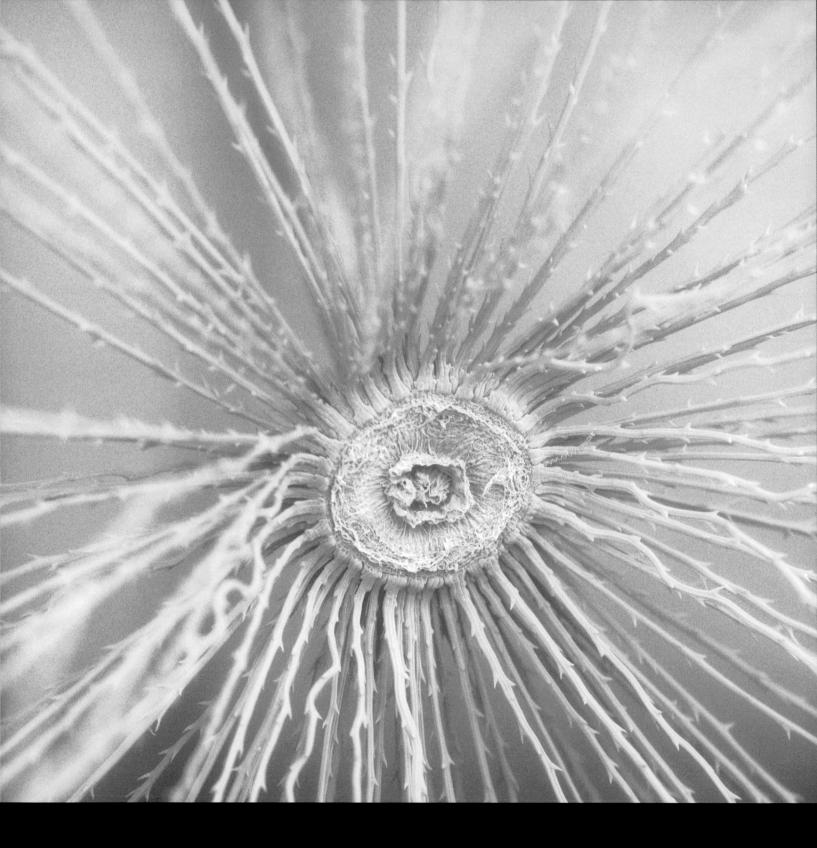

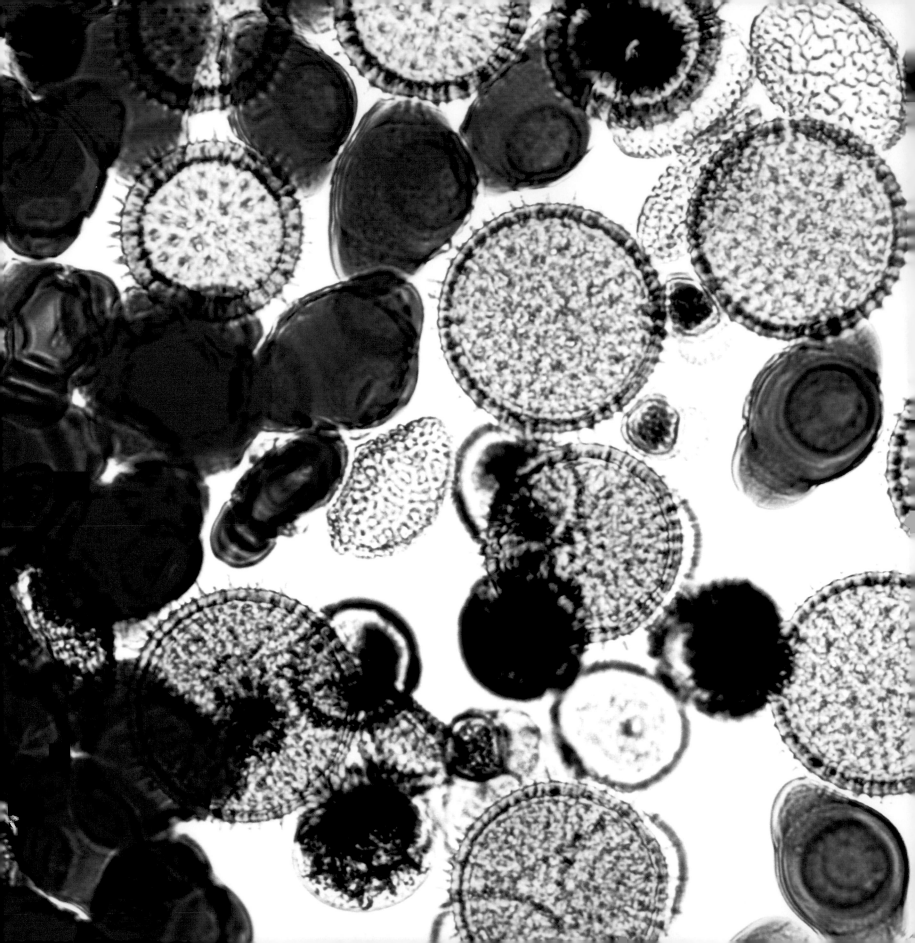

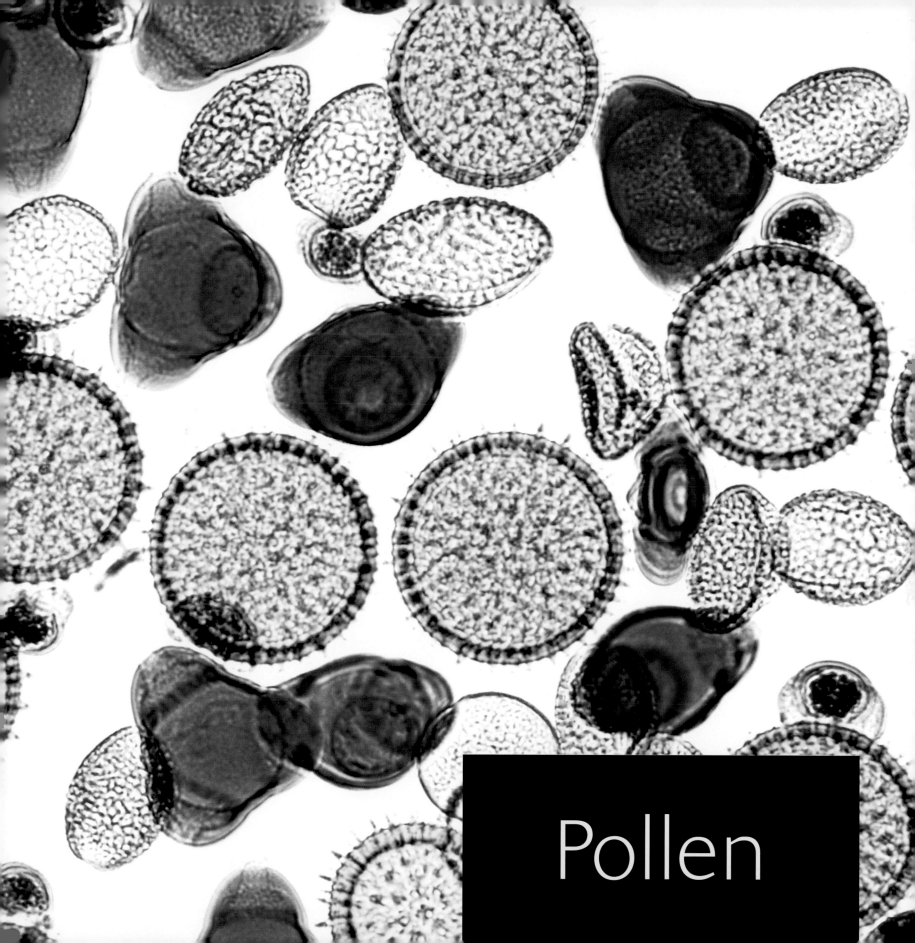

Pollen

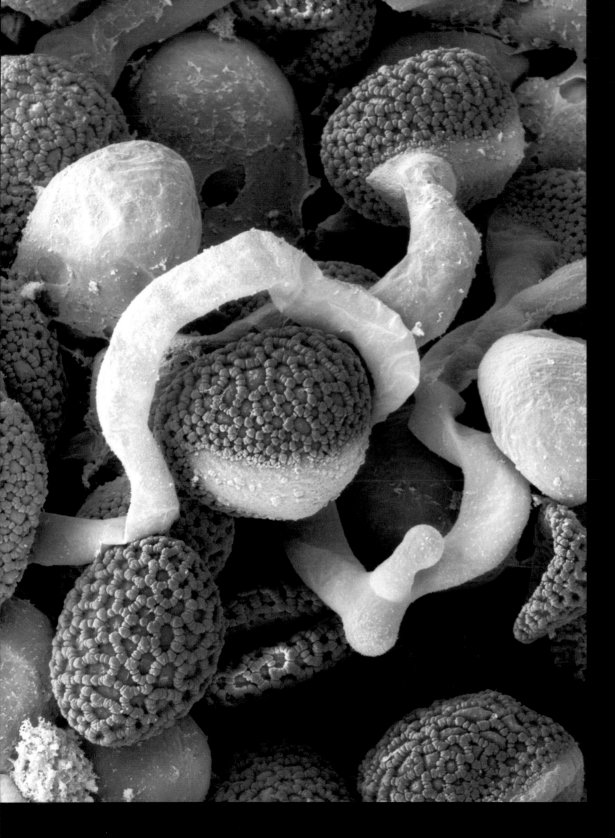

Pollen, which produces the sperm cells
necessary for fertilization of flowering plants,
falls into one of two classifications – monocot
or dicot. Monocot pollen has a single furrow
or pore on its surface, dicots three. Many
differences between plants are related to the
two types of pollen. For example, the stems of
monocot seedlings carry only one embryonic
leaf (cotyledon), dicots two; monocots produce
flower parts in multiples of three, dicots in
multiples of four or five.
(Magnification x30 at 3.5cm wide)

**Left: Asiatic lily stigma detail
(scanning electron micrograph)
Right: Lily pollen
(scanning electron micrograph)**

Many plants reproduce sexually through the
meeting of pollen (male) and stigma (female).
Lily pollen has a complex pattern of ridges
and recesses (seen here left and right), which
it is thought may catch the wind and assist
dispersal in the absence of pollinating insects.
The sticky stigma in the female flower traps
the pollen and triggers its germination: the
white filaments on the left are sperm tubes
extending from the captured pollen in search
of the female's ovary.
(Left: Magnification x418 at 10cm wide)
(Right: Magnification x465 at 10cm wide)

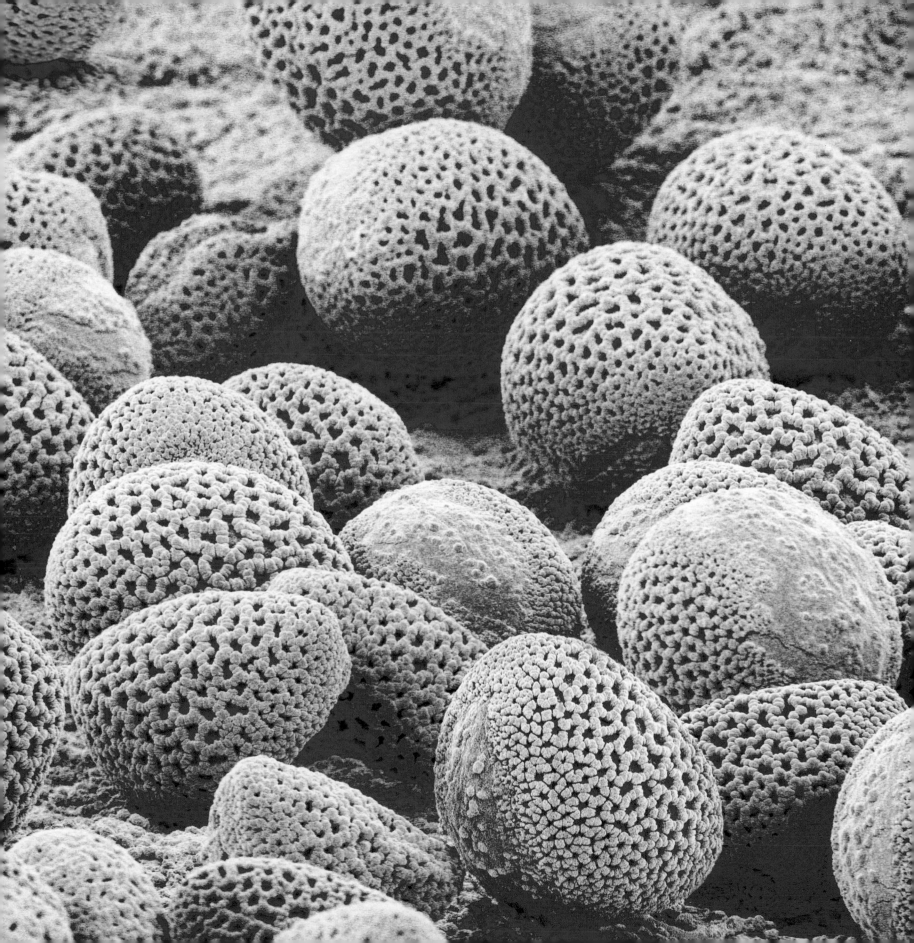

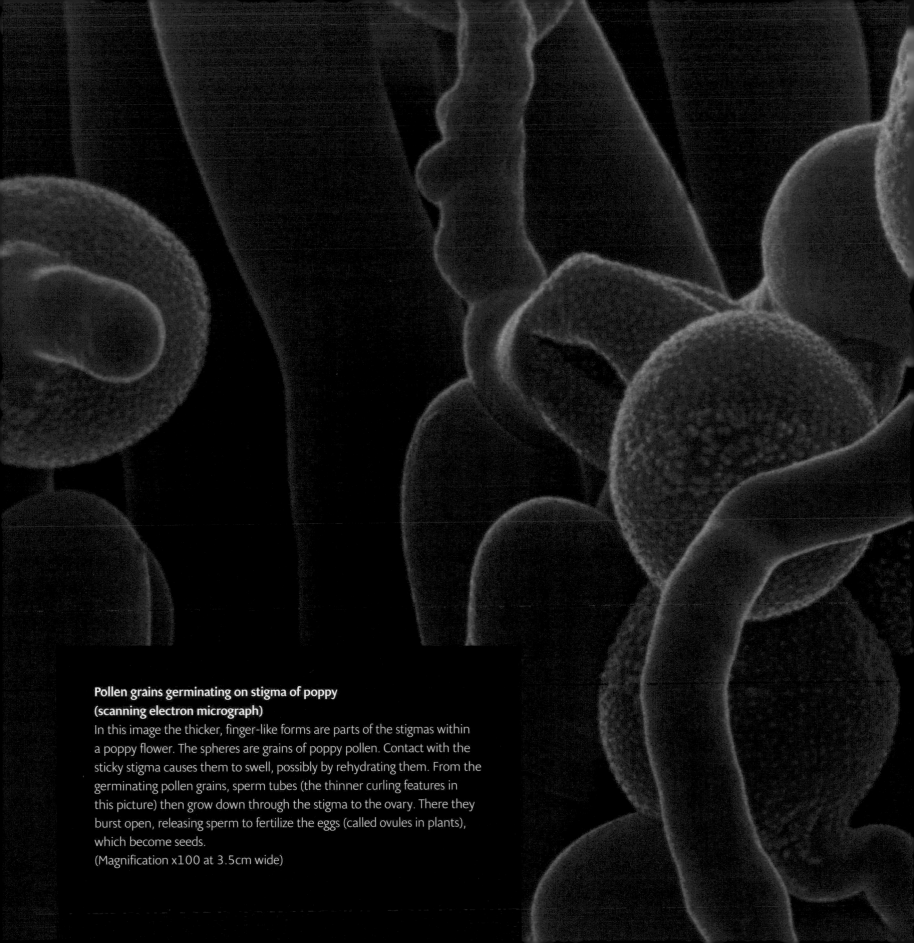

Pollen grains germinating on stigma of poppy
(scanning electron micrograph)
In this image the thicker, finger-like forms are parts of the stigmas within
a poppy flower. The spheres are grains of poppy pollen. Contact with the
sticky stigma causes them to swell, possibly by rehydrating them. From the
germinating pollen grains, sperm tubes (the thinner curling features in
this picture) then grow down through the stigma to the ovary. There they
burst open, releasing sperm to fertilize the eggs (called ovules in plants),
which become seeds.
(Magnification x100 at 3.5cm wide)

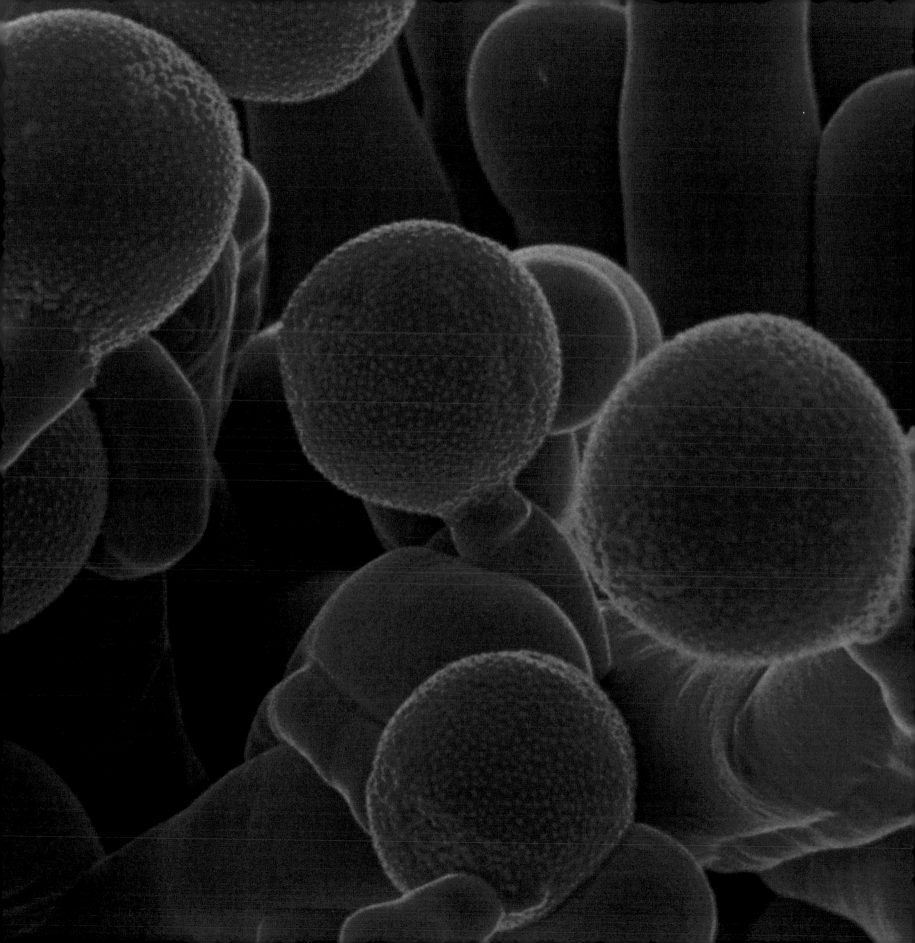

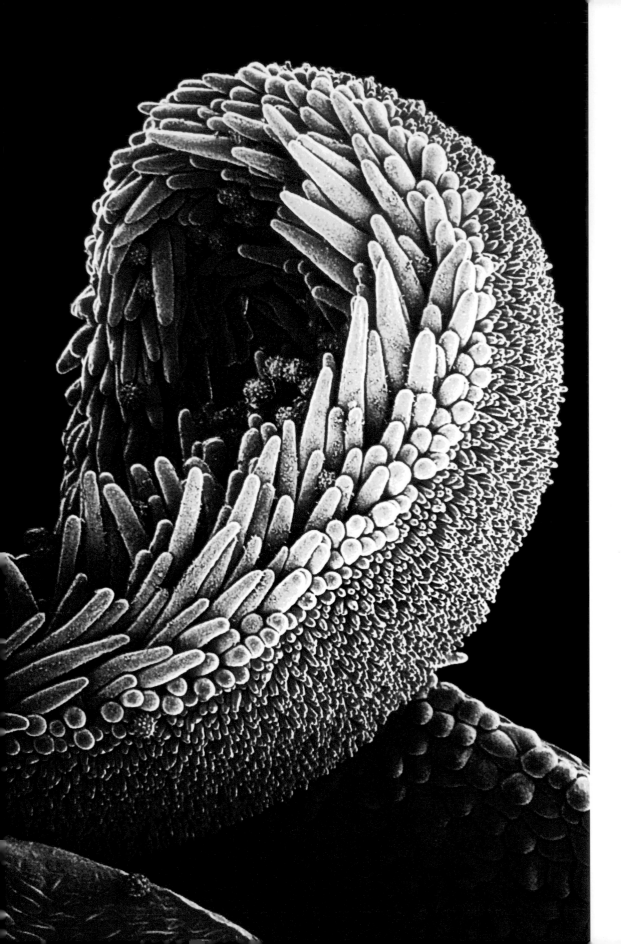

Left: Sunflower pollination
(scanning electron micrograph)
What we think of as a sunflower is really a
flower head of two different types of bloom.
The round inner mass of the head is a cluster
of small fertile florets called disc flowers, which
become the seeds used in oil production and
as snacks. The large outer 'petals' are actually
sterile flowers called ray flowers, whose petals
have fused together. The yellow rods seen here
are the hairs (trichomes) on a floret's stigma.
The trichomes on one side of the stigma are
covered in pollen grains (here pink).
(Magnification x67 at 6cm wide)

Right: Morning glory pollen
(scanning electron micrograph)
These orange spheres are the pollen of the
common hedgerow species morning glory,
captured by the flower's stigma (here in
yellow). The stigma is the outer end of a
flower's female reproductive organ (called
a pistil). Below the stigma is the stem (style)
and below that the ovary in which the pollen
fertilizes the eggs (ovules), which then develop
into an embryonic new plant, the seed.
Morning glory is also known as bindweed
because several stems of it wind themselves
together like rope.
(Magnification x52 at 7cm wide)

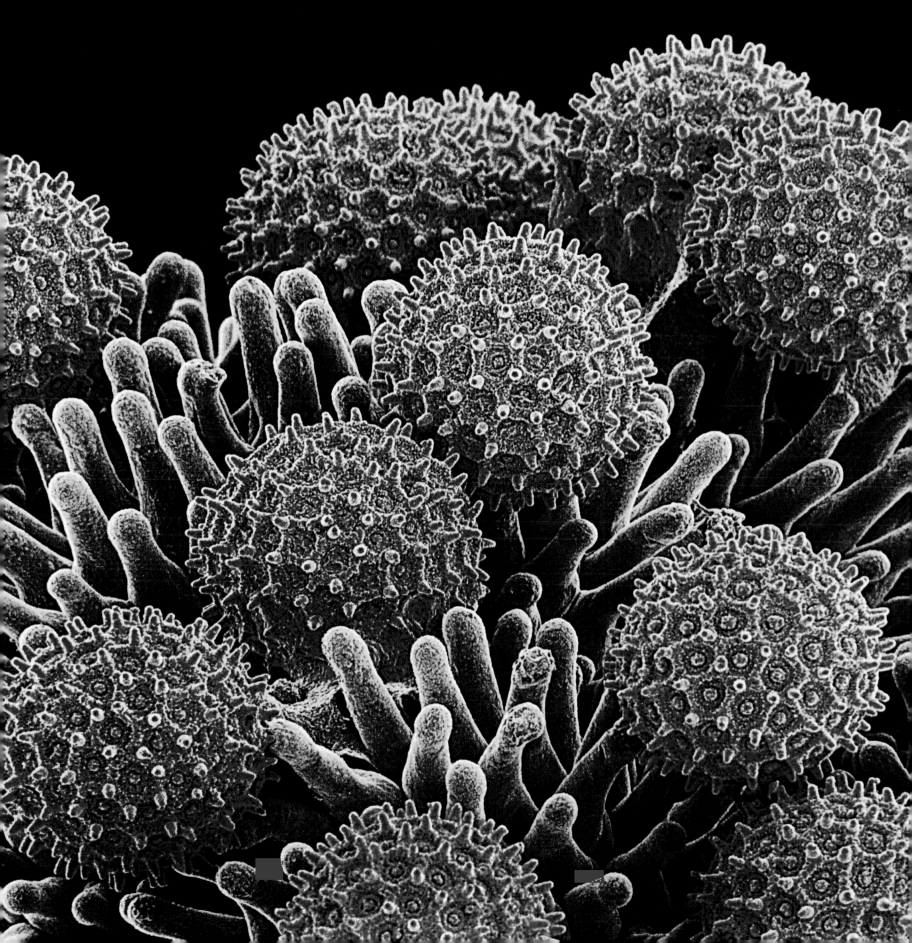

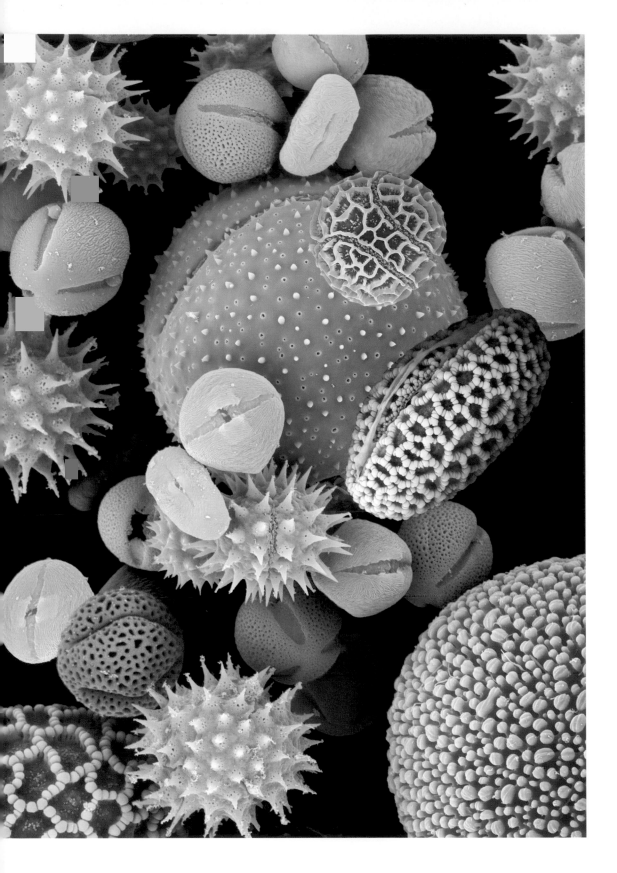

**Left: Pollen grains
(scanning electron micrograph)**
In the microscopic world of pollen there is a great variety of size and shape. Here you can see a selection including sunflower (*Helianthus annuus*, densely spiked spheres); morning glory (*Ipomoea purpurea*, large sphere bottom left with a pattern of beaded compartments); hollyhock (*Sidalcea malviflora*, large pale green sphere at centre with small spikes); lily (*Lilium auratum*, large oval mid-right); narrow-leaved evening primrose (*Oenothera fruticosa*, orange and green lemons with three furrows); and caster bean (*Ricinus communis*, small yellow ovals top and centre).
(Magnification x570 at 10cm tall)

Right: Geranium pollen (scanning electron micrograph)
The male reproductive organs of a flower are called stamens. Each consists of a stem (the filament), terminating in a pollen-producing element (the anther). The anther contains a number of compartments (microsporangia) in which spores develop into pollen grains. The plant may take advantage of wind, gravity or a passing animal to distribute them. Here you can see pollen (pink) on a geranium anther (brown), about to be released in search of a receptive female organ (the pistil).
(Magnification unknown)

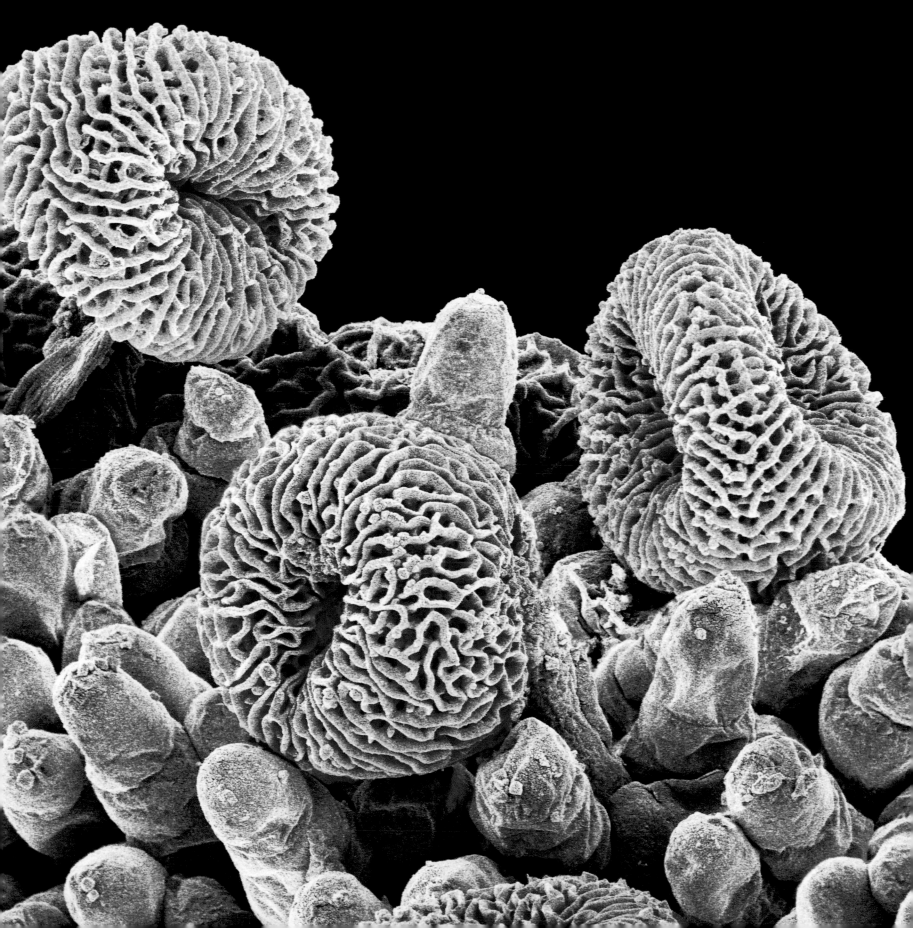

**Autumn hawkbit pollen
(scanning electron micrograph)**

The autumn hawkbit is sometimes known as the fall dandelion, because its flower is similar to, but appears later in the year than, the common dandelion. Although it is not related, its pollen is also similar to the dandelion's, with an intricately spiked surface pattern (called an exine). The spikes are designed to hook on to the fur of a passing animal; but here the pollen grains (yellow) are attached to the fibres (white) at the base of the hawkbit flower. (Magnification x400 at 10cm wide)

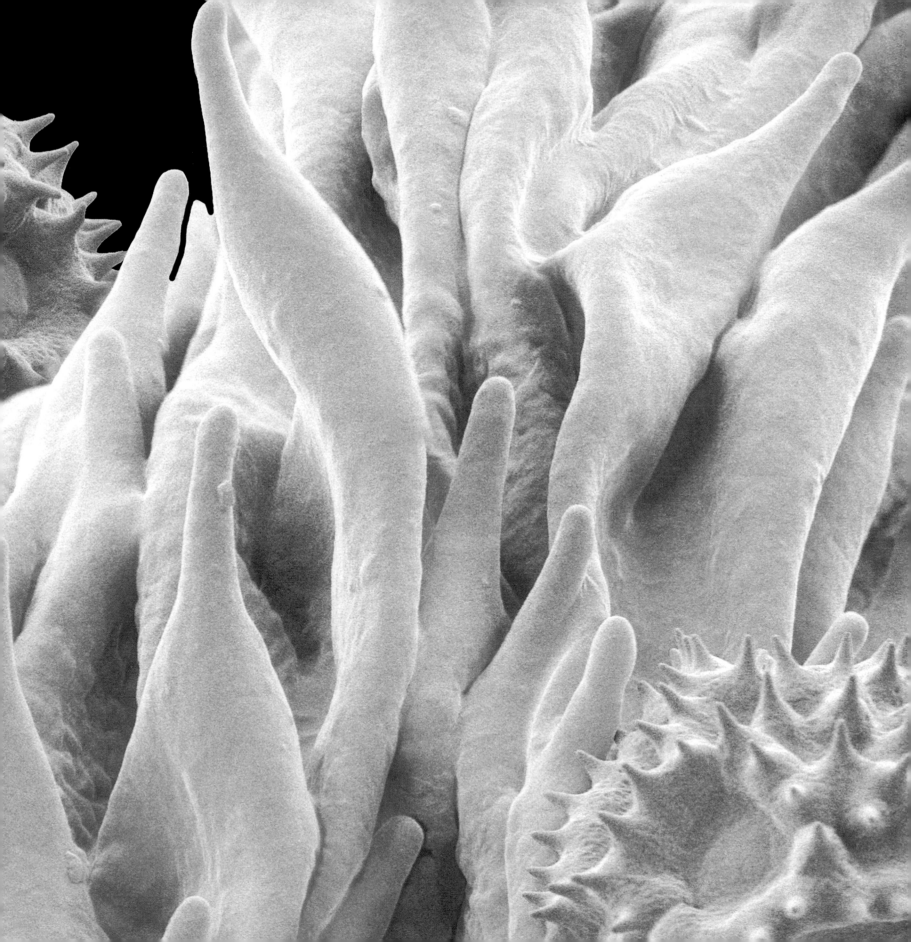

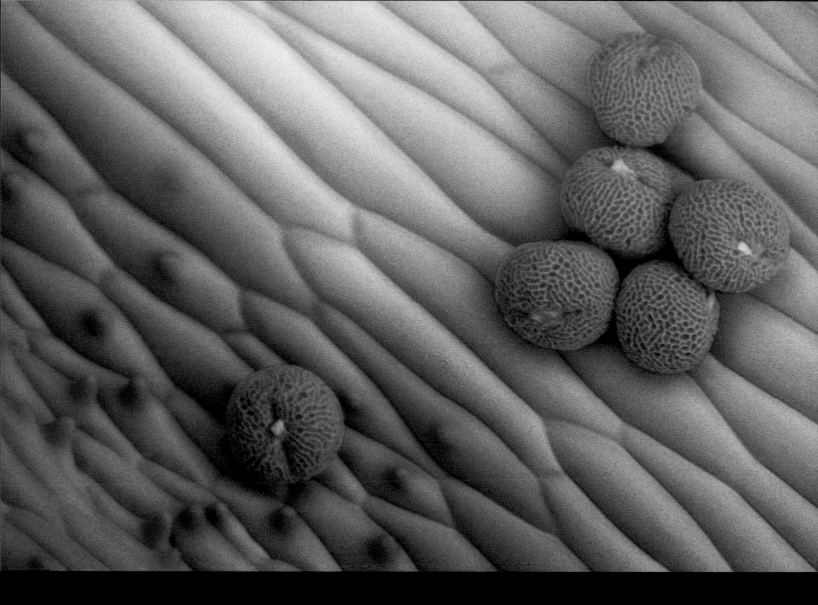

Above: *Pelargonium citronellum* **petal and pollen grains (scanning electron micrograph)**
Plants sometimes acquire scent to deter predators or encourage pollinators. The scent of the scented pelargonium is from oil held in its leaves and released by rubbing or lightly squeezing them: *P. citronellum*, seen here, smells of lemons. Besides naturally occurring varieties, many new forms and scents have been bred through cultivation. Pelargoniums are known as storksbill in the US and, confusingly, as geraniums in the UK. True geraniums are a separate family of flowers commonly called cranesbill in the UK.

Right: *Aquilegia* **pollen grains (scanning electron micrograph)**
You can clearly see the triple furrows on this *Aquilegia* pollen, which identify it as a dicot plant. Monocots, by comparison, have only one. All flowering plants are either one or the other and the groups differ in other respects as well. For example, dicots have a central taproot from which other roots grow, whereas the roots of monocots spring directly from the base of the plant. Above ground, the veins of monocot leaves are arranged in parallel lines; but in dicot leaves they are branched.
(Magnification x2200 at 10cm wide)

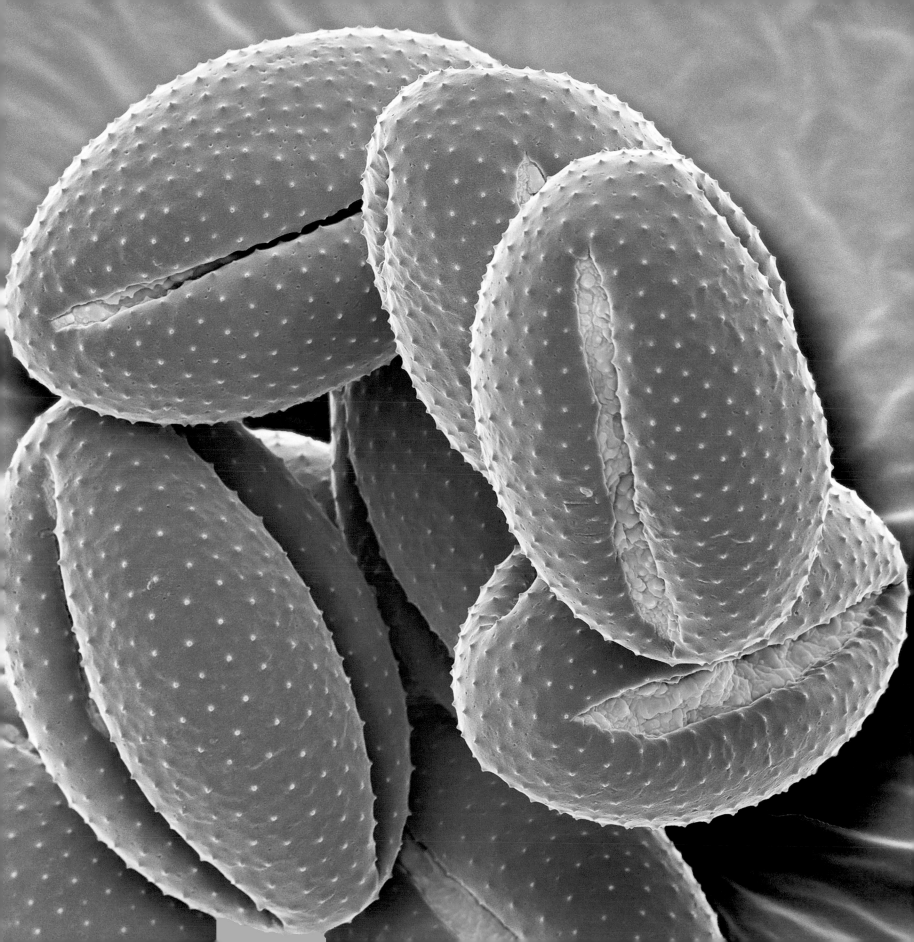

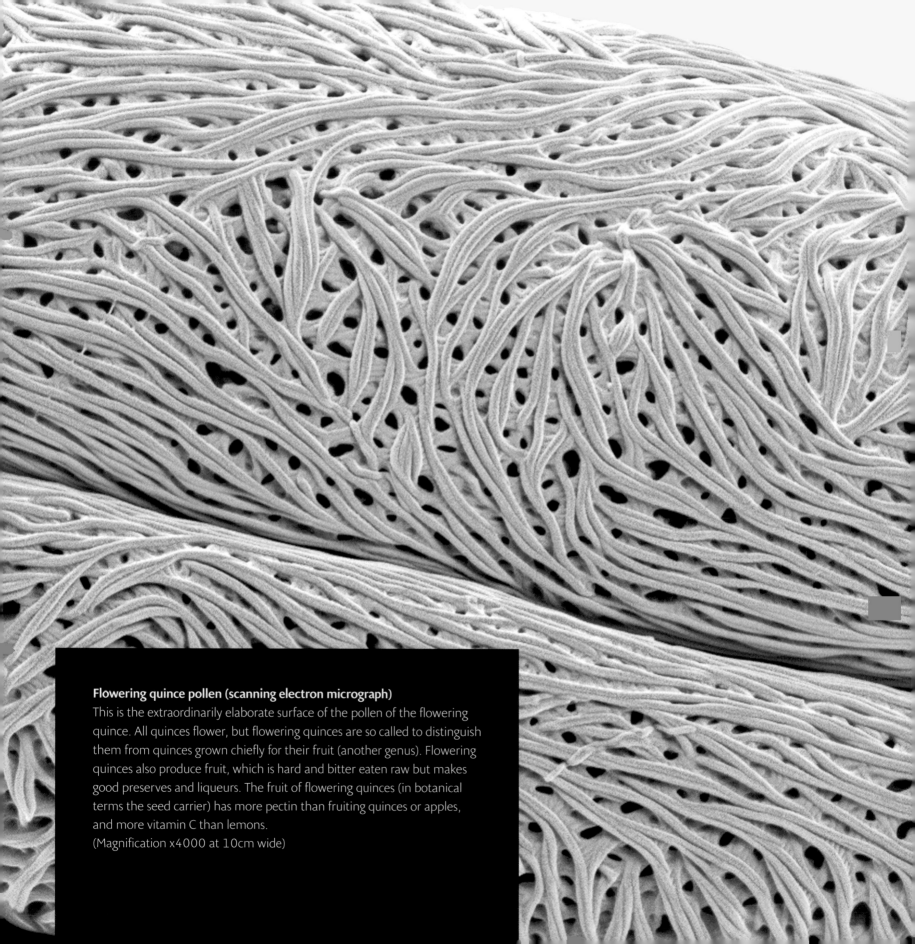

Flowering quince pollen (scanning electron micrograph)
This is the extraordinarily elaborate surface of the pollen of the flowering quince. All quinces flower, but flowering quinces are so called to distinguish them from quinces grown chiefly for their fruit (another genus). Flowering quinces also produce fruit, which is hard and bitter eaten raw but makes good preserves and liqueurs. The fruit of flowering quinces (in botanical terms the seed carrier) has more pectin than fruiting quinces or apples, and more vitamin C than lemons.
(Magnification x4000 at 10cm wide)

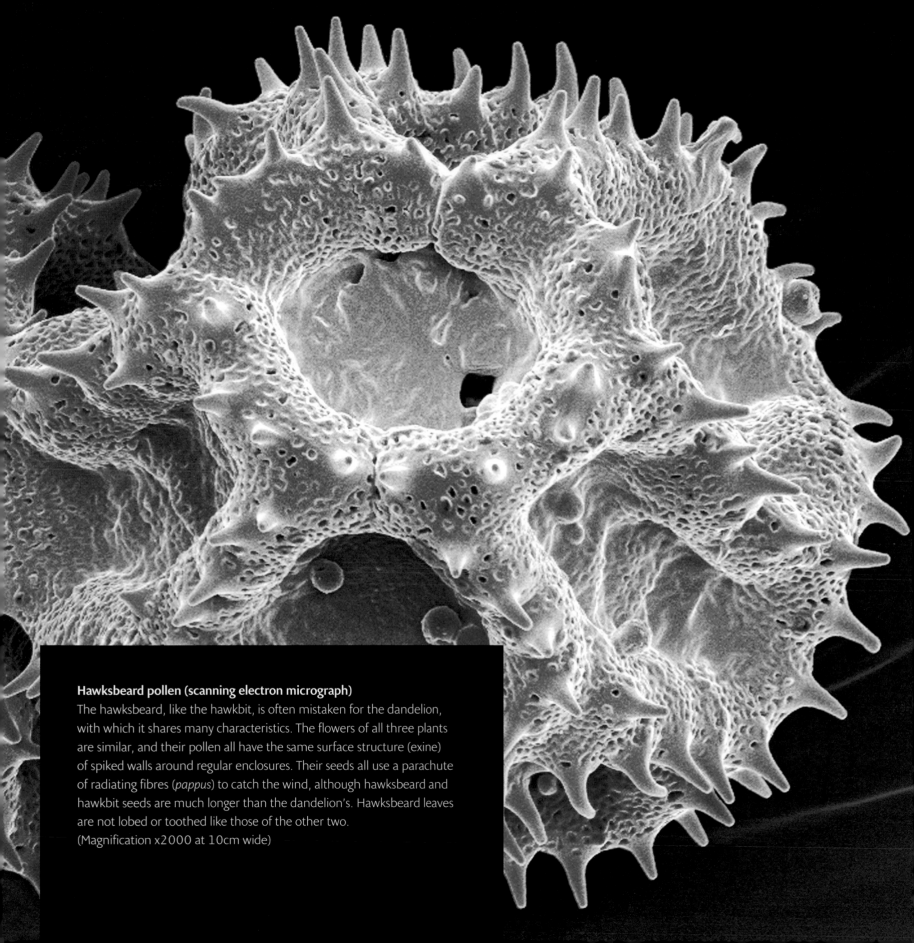

Hawksbeard pollen (scanning electron micrograph)
The hawksbeard, like the hawkbit, is often mistaken for the dandelion, with which it shares many characteristics. The flowers of all three plants are similar, and their pollen all have the same surface structure (exine) of spiked walls around regular enclosures. Their seeds all use a parachute of radiating fibres (*pappus*) to catch the wind, although hawksbeard and hawkbit seeds are much longer than the dandelion's. Hawksbeard leaves are not lobed or toothed like those of the other two.
(Magnification x2000 at 10cm wide)

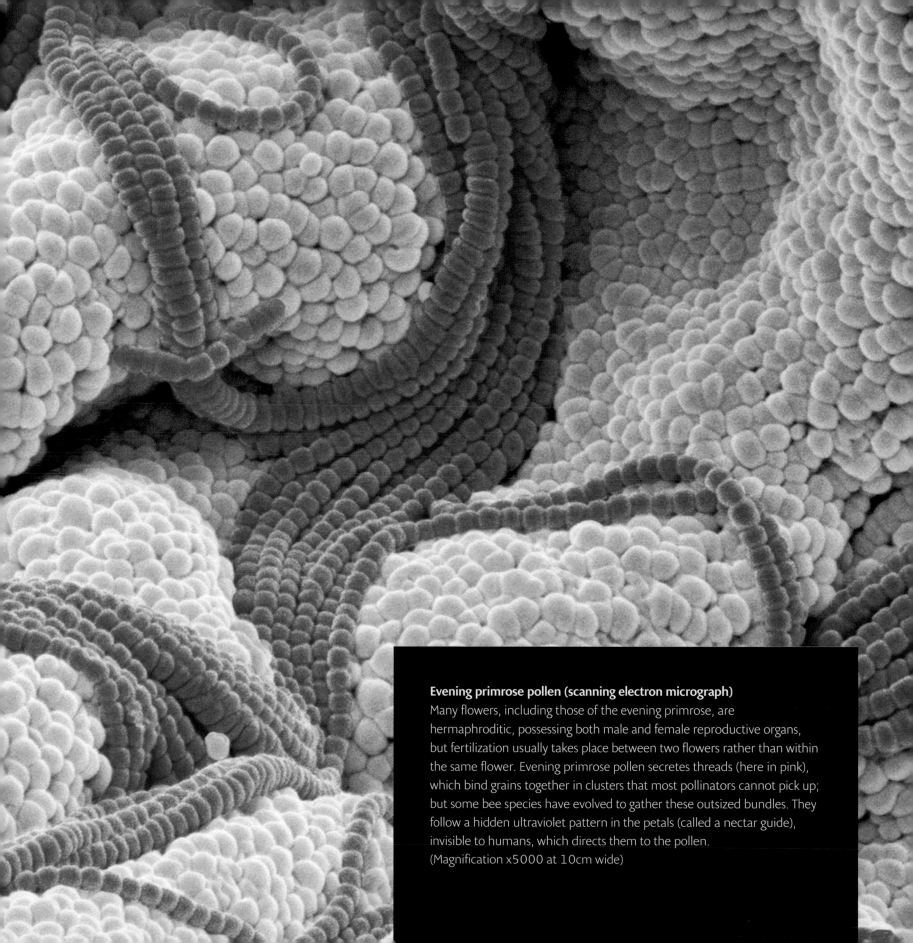

Evening primrose pollen (scanning electron micrograph)
Many flowers, including those of the evening primrose, are hermaphroditic, possessing both male and female reproductive organs, but fertilization usually takes place between two flowers rather than within the same flower. Evening primrose pollen secretes threads (here in pink), which bind grains together in clusters that most pollinators cannot pick up; but some bee species have evolved to gather these outsized bundles. They follow a hidden ultraviolet pattern in the petals (called a nectar guide), invisible to humans, which directs them to the pollen.
(Magnification x5000 at 10cm wide)

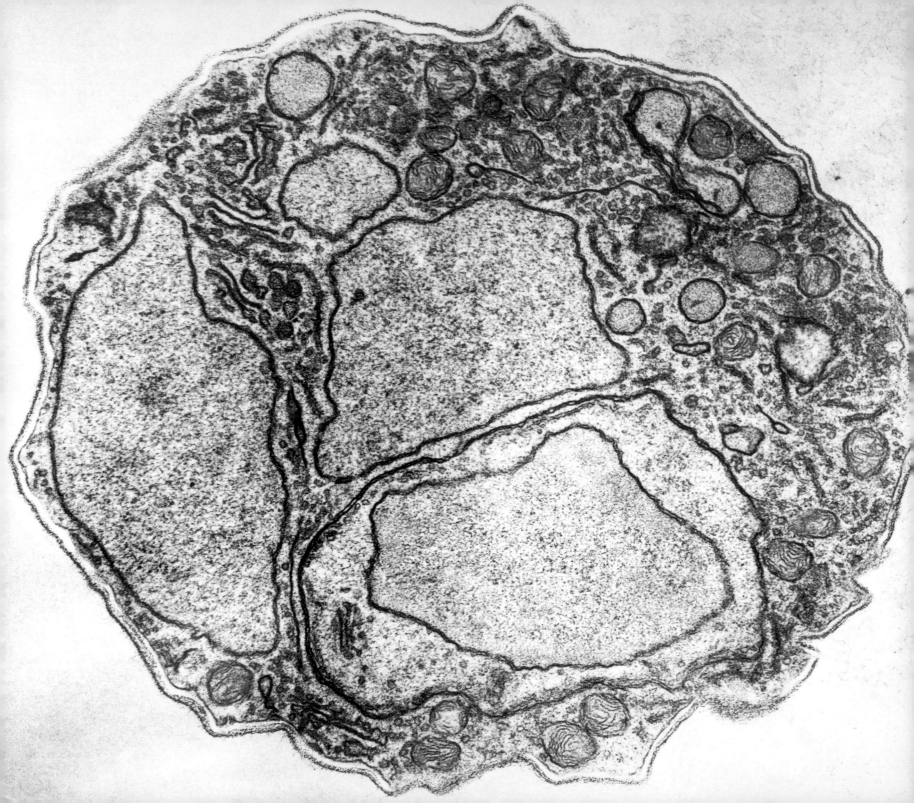

**Left: Pollen tube of African violet
(transmission electron micrograph)**
Once the male pollen has been transferred to
a female stigma, it extends a tube, which
tunnels down through the stigma and style
until it finds the ovary. There the tube releases
sperm, which fertilizes the eggs in the ovary's
placenta lining. The pollen tube of maize can
be up to 12 inches (30cm) long. This image
shows a cross section of the rather shorter
tube of African violet pollen.
(Magnification x5000 at 10cm wide)

**Right: Lily anther
(transmission electron micrograph)**
In this image the yellow discs are embryonic
pollen grains (spores) growing in the male
reproductive organ (anther) of a lily. Of
the surrounding anther cells, the thin
innermost ring is the tapetum, which provides
nourishment for the developing spores. The
outer ones are starch cells. When the pollen
grains are fully mature, the anther will rupture
to release them for pollination. Lily pollen is
highly toxic to cats, in which it can cause acute
kidney failure.
(Magnification x85 at 10cm tall)

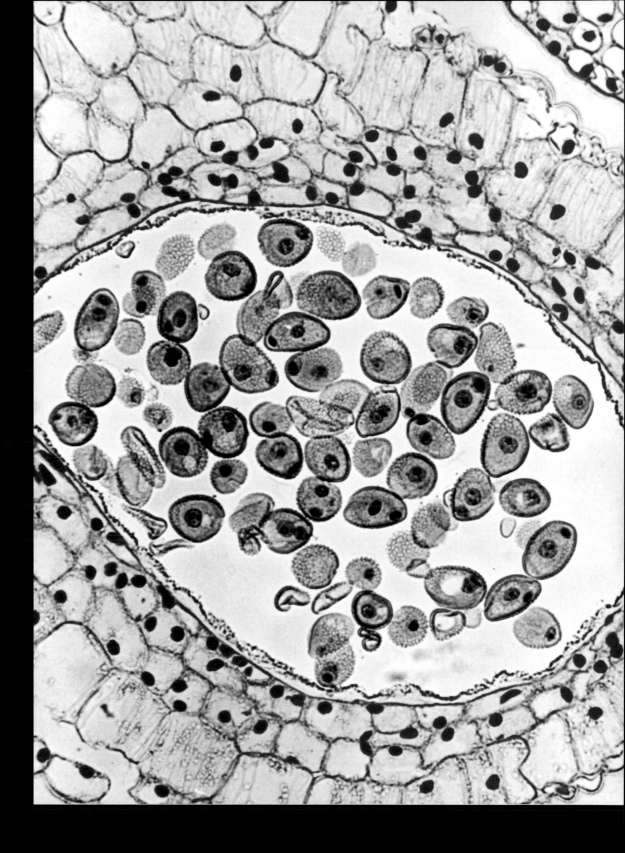

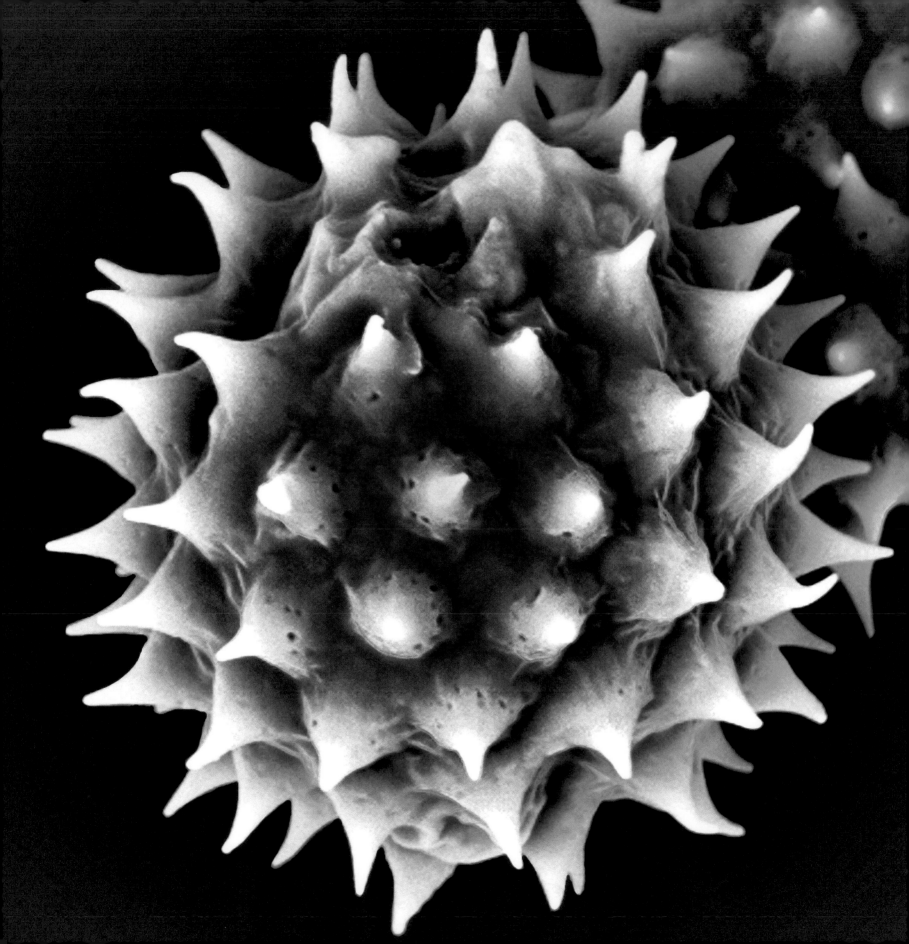

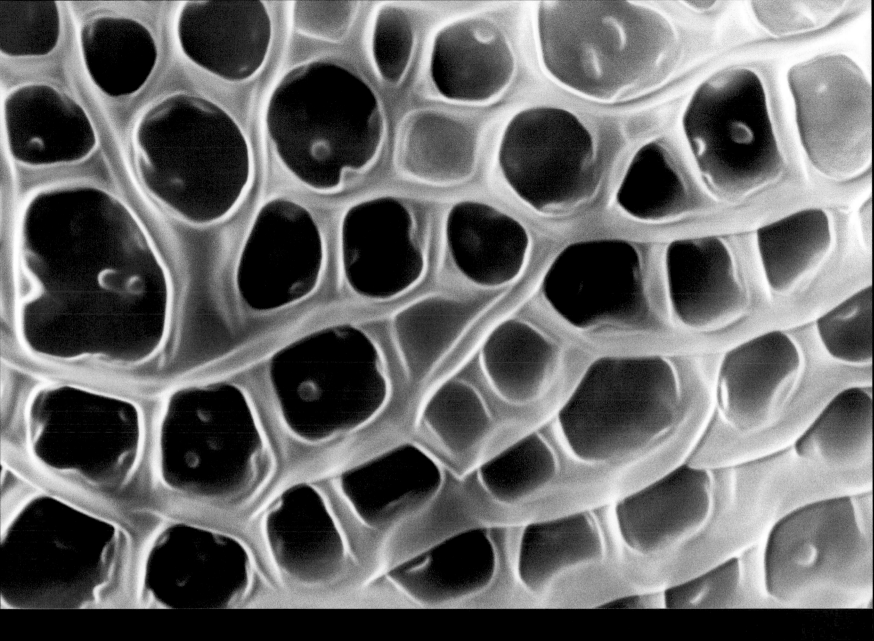

Left: Daisy pollen (scanning electron micrograph)
Daisies form a vast family of plants going back around ninety million years and currently numbering about 33,000 species. One of their distinguishing features is the pollen-producing anthers. In most flowers the anther and the stigma are separate, but in daisies the anthers grow around the stem of the stigma (called a style) as a sort of tube. Pollen sticks to the style, and as the style grows, it forces the pollen out of the enclosing tube, towards the ovary.
(Magnification x5000 at 10cm wide)

Above: Lisianthus pollen (scanning electron micrograph)
Although pollen is vital to the life cycle of plants that generate it, it is not always welcome to humans. Many are allergic to certain types of pollen. Flower arrangers also curse it, for ruining the appearance of surrounding leaves and petals. To combat this, a Japanese seed company has developed pollen-free lisianthus blooms. The flowers no longer grow the stamens from which the pollen is produced, and the cut flowers last a week longer than those with stamens.
(Magnification x7000 at 10cm wide)

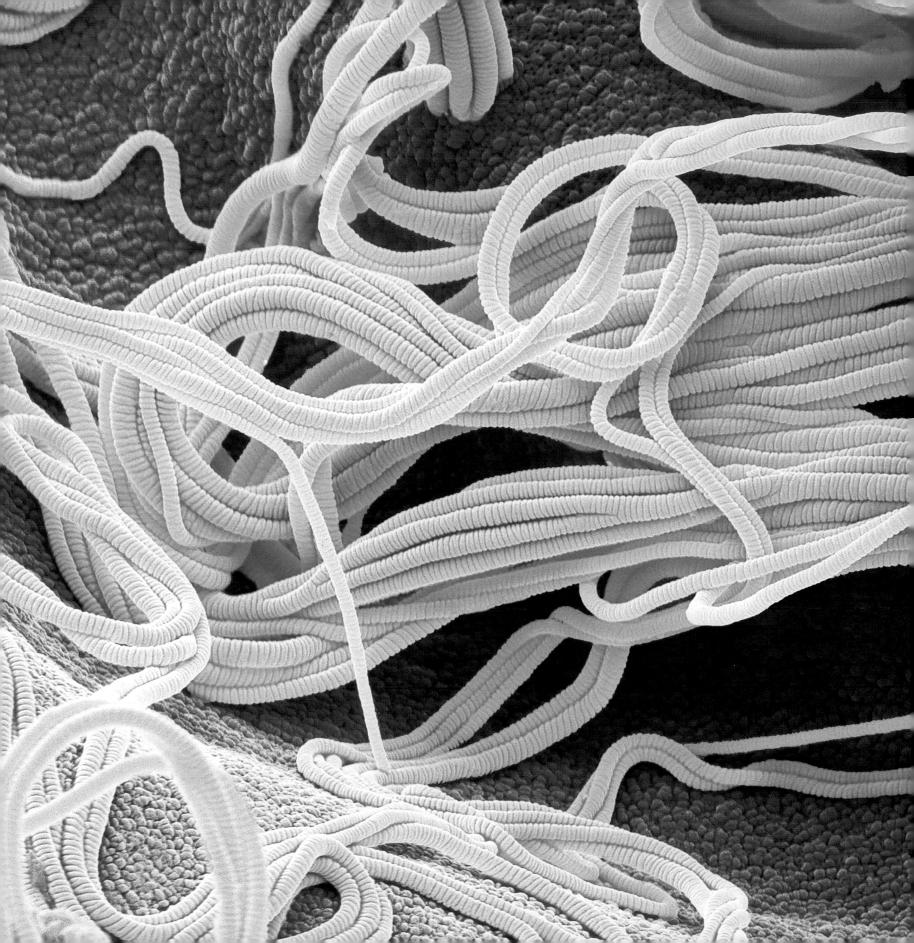

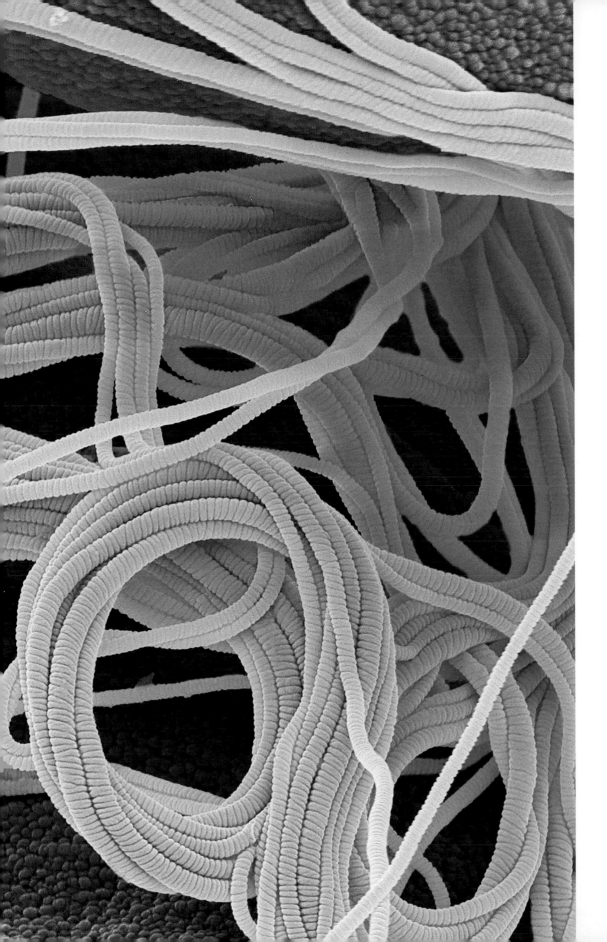

**Toad lily pollen
(scanning electron micrograph)**
The pollen of the spectacular toad lily produces these fine threads, which bind pollen grains together. It's not clear why: it may restrict the number of insect species that can pollinate the plant, or it may actually assist in attaching the pollen bundles to any visiting pollinator. The stems (styles) that support the toad lily's showy stigma are lined with glands. From these are produced sticky droplets, which may encourage pollinating insects to stop by. (Magnification x5000 at 10cm wide)

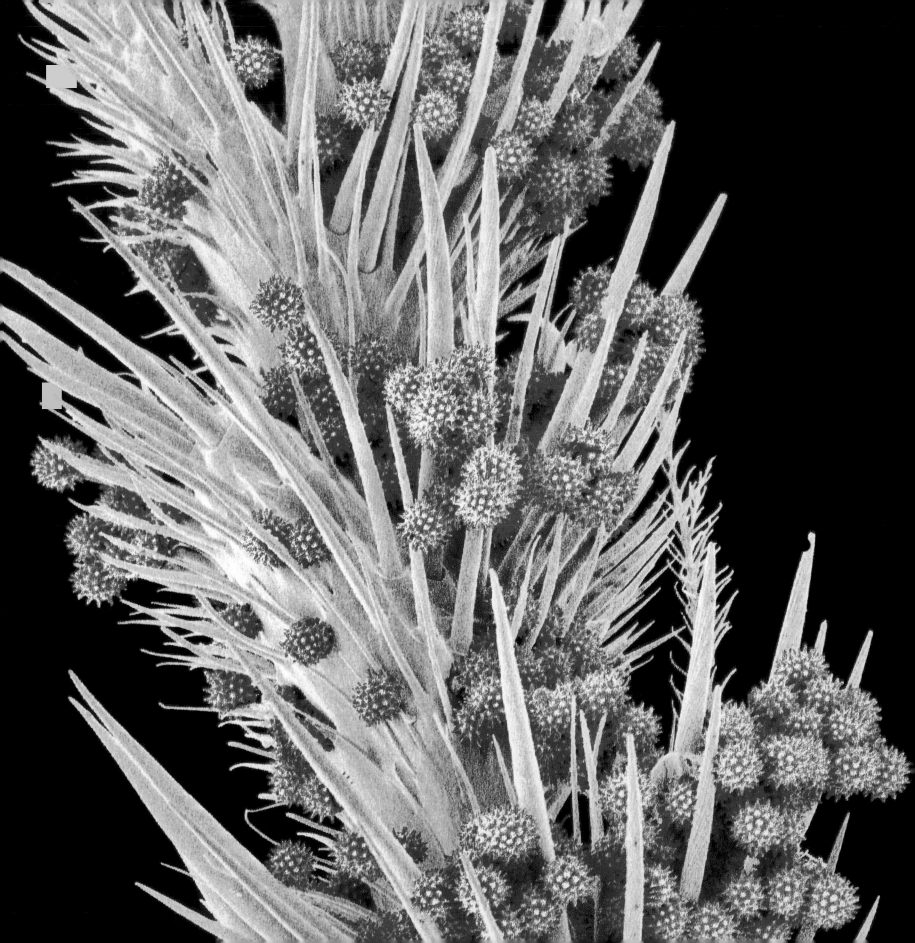

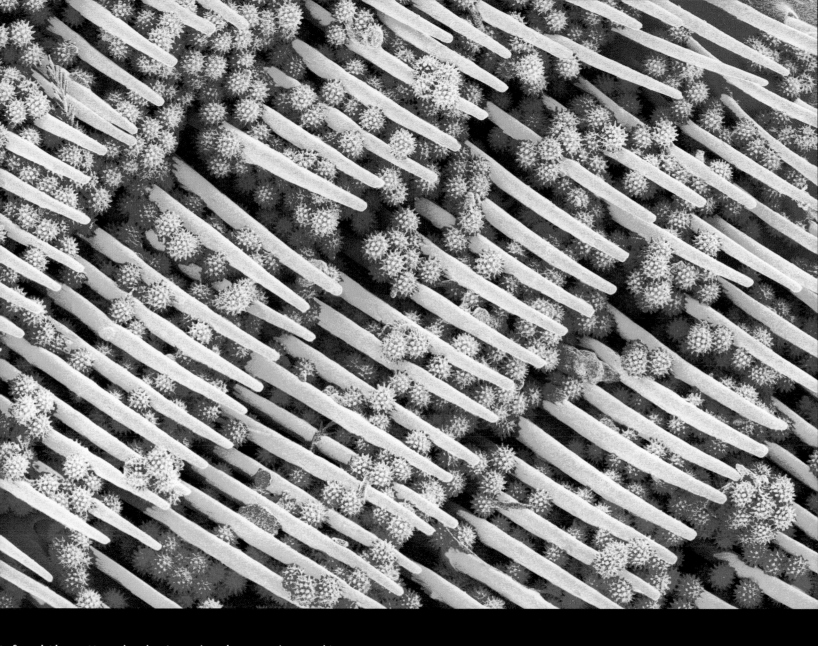

Left and Above: Honeybee leg (scanning electron micrograph)
A bee has six legs, each covered in tiny hairs ideal for gathering the pollen
that the bee needs to feed its larvae. On the left you can see, in extreme
magnification, that even the hairs have hairs, and these images also give

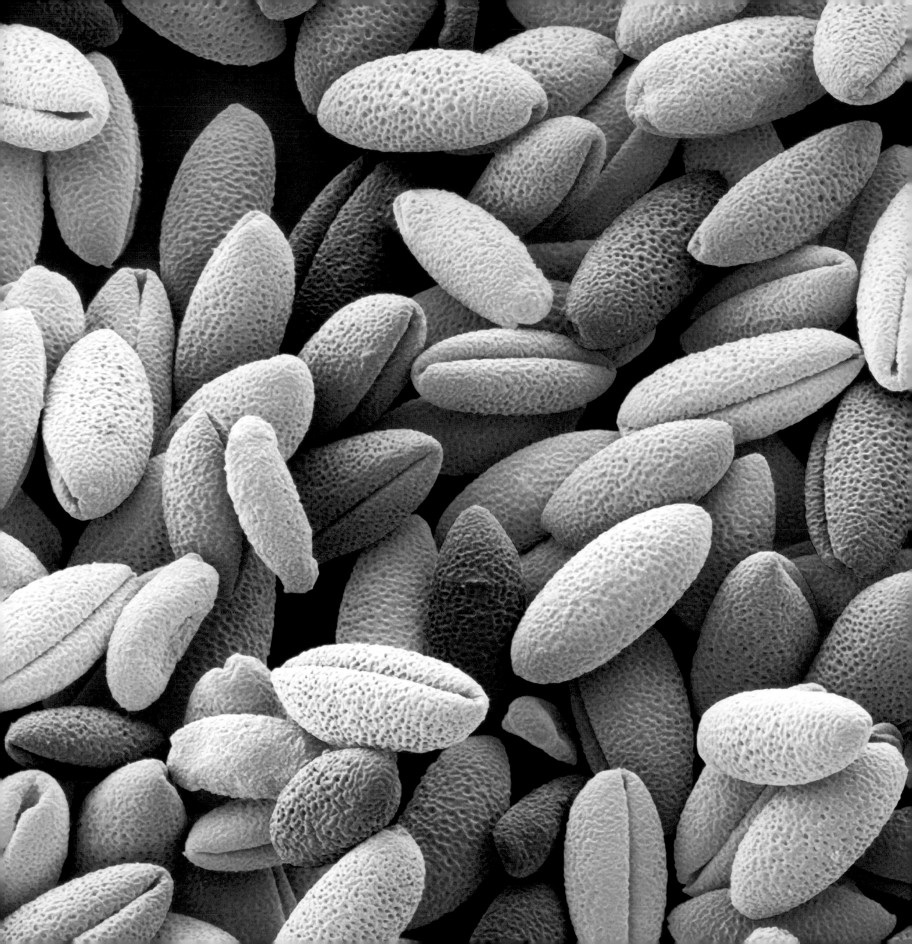

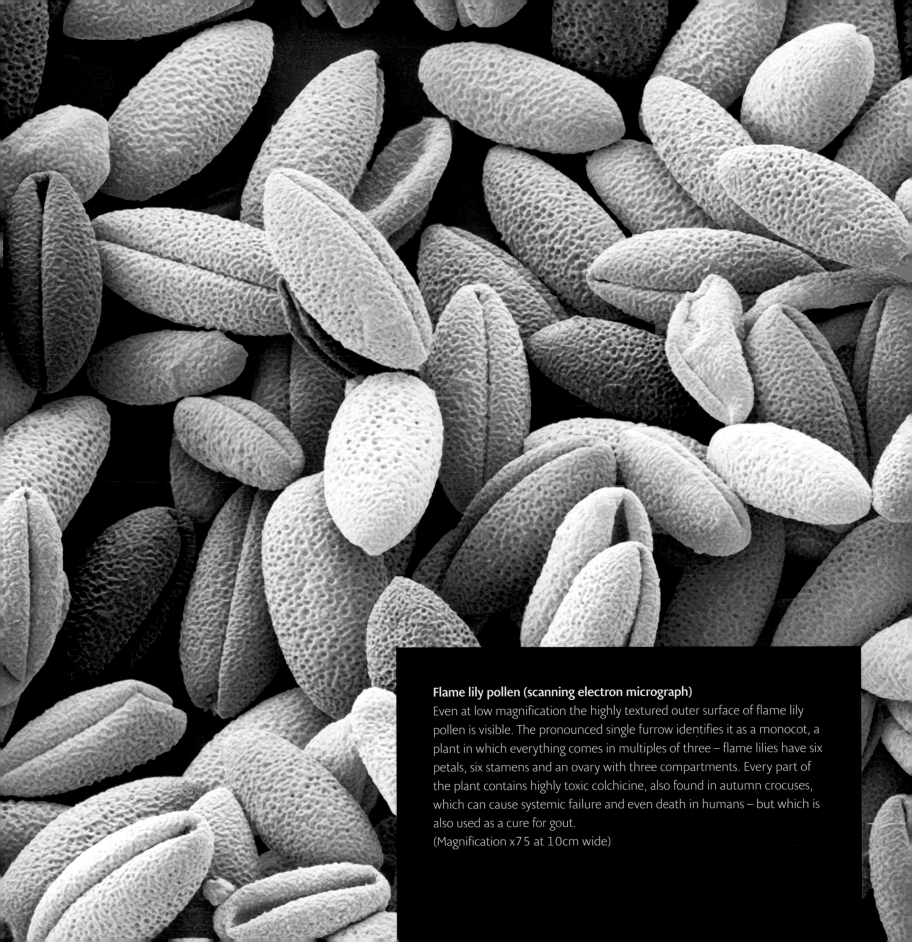

Flame lily pollen (scanning electron micrograph)
Even at low magnification the highly textured outer surface of flame lily
pollen is visible. The pronounced single furrow identifies it as a monocot, a
plant in which everything comes in multiples of three – flame lilies have six
petals, six stamens and an ovary with three compartments. Every part of
the plant contains highly toxic colchicine, also found in autumn crocuses,
which can cause systemic failure and even death in humans – but which is
also used as a cure for gout.
(Magnification x75 at 10cm wide)

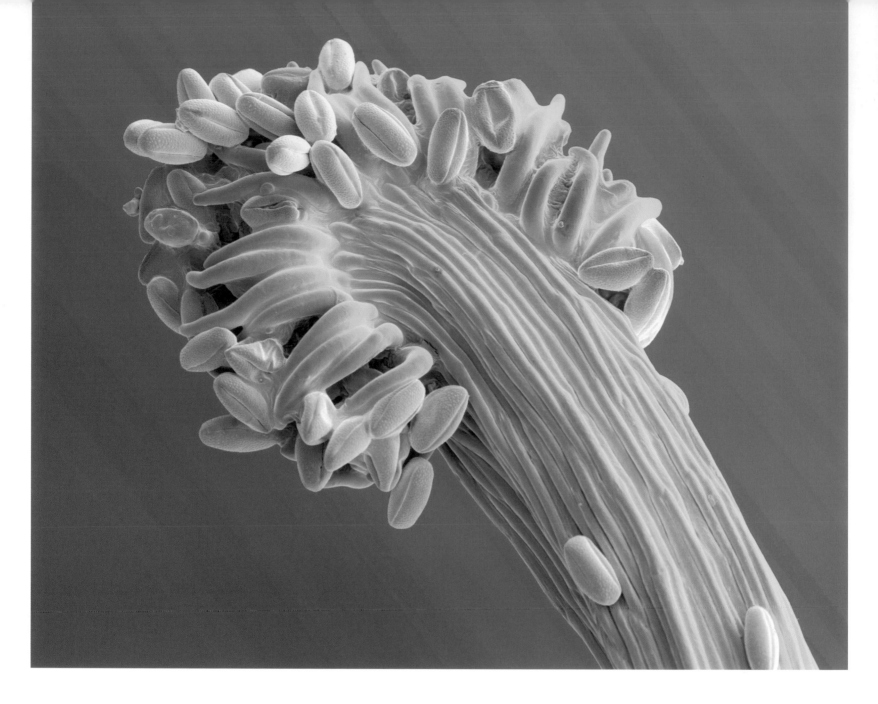

Above: Gorse stigma with pollen grains (scanning electron micrograph)
This is a false-colour image of gorse pollen grains (yellow) attached to the hair-like stigma of the plant's pistil (green). There's an old saying, 'when gorse is out of blossom, kissing is out of fashion'; in other words almost never: gorse can flower for up to ten months of the year in a temperate climate. Its pollen, actually brick red, is tough on sufferers of allergic rhinitis (hay fever), but a valuable resource for bees and beekeepers. (Magnification x250 at 10cm wide)

Right: Lavender pollen grain (scanning electron micrograph)
Here you see a single grain of pollen on part of a petal of French lavender. Lavender gets its name from the Latin word *lavare*, meaning 'to wash', and the herb was used to sweeten the smell of Roman laundry. Honey made predominantly from the pollen of French lavender has a pronounced floral scent, which is highly prized. The essential oil widely used today to aid restfulness and sleep comes from the leaves of the plant. (Magnification x2476 at 10cm wide)

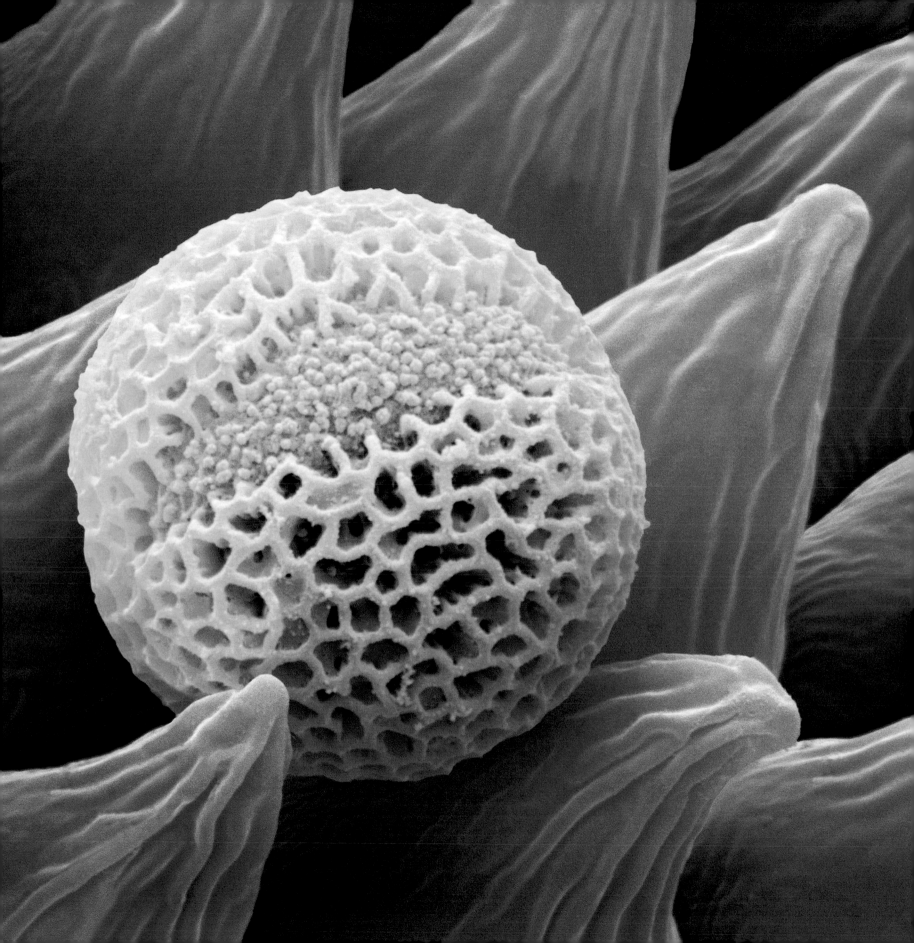

Above: Iris pollen (scanning electron micrograph)
The iris's lower petals make an ideal landing stage for pollen-laden bees. To get to the nectar that attracts it a bee then must force its way past an overhanging stigma, depositing its fertilizing load of pollen as it does so. Continuing towards the nectar, it then squeezes beneath an anther, collecting new pollen. The new load is at the front of the bee, so it won't leave any on the stigma as it exits backwards before taking off for the next iris.
(Magnification x1600 at 10cm wide)

Right: Aubergine pollen grain (scanning electron micrograph)
This view of one end of a grain of aubergine (eggplant) pollen shows clearly the three furrows that indicate that the plant is a dicot. Seeds from dicot species will always produce a seedling with a taproot and two embryonic leaves (cotyledons), unlike those of monocots. Some people are allergic to aubergine pollen, and the plant contains a high level of histamines, although most of the allergens are destroyed in the act of cooking. The aubergine is closely related to the potato and the tomato.
(Magnification x4300 at 10cm wide)

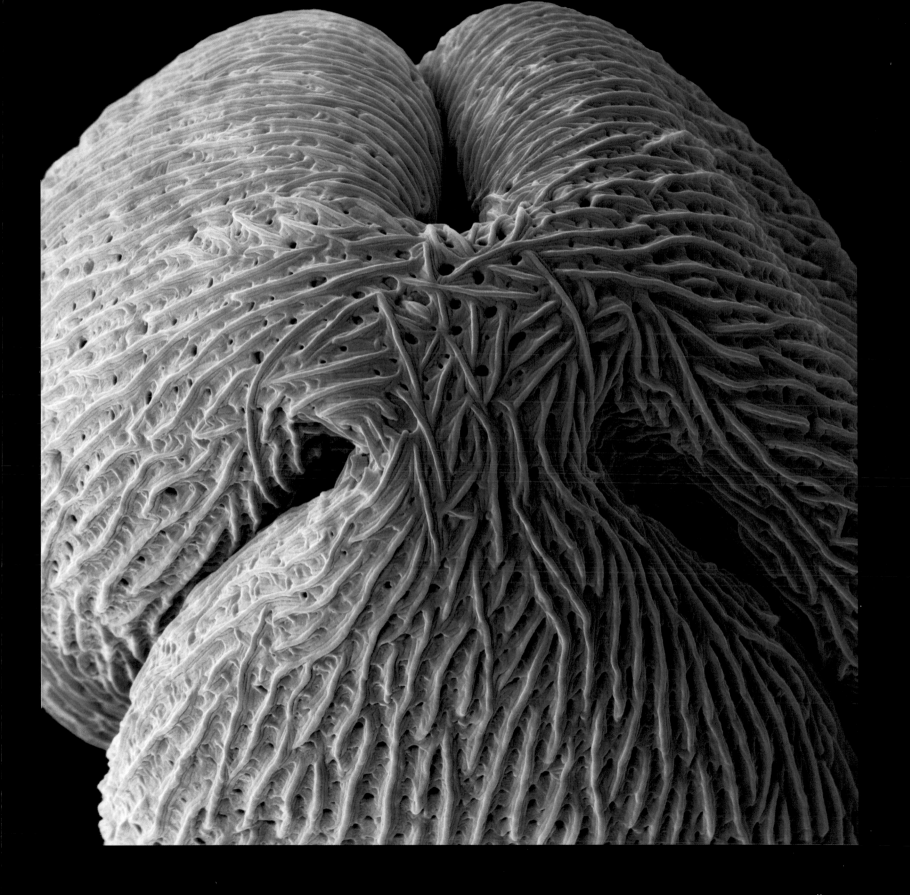

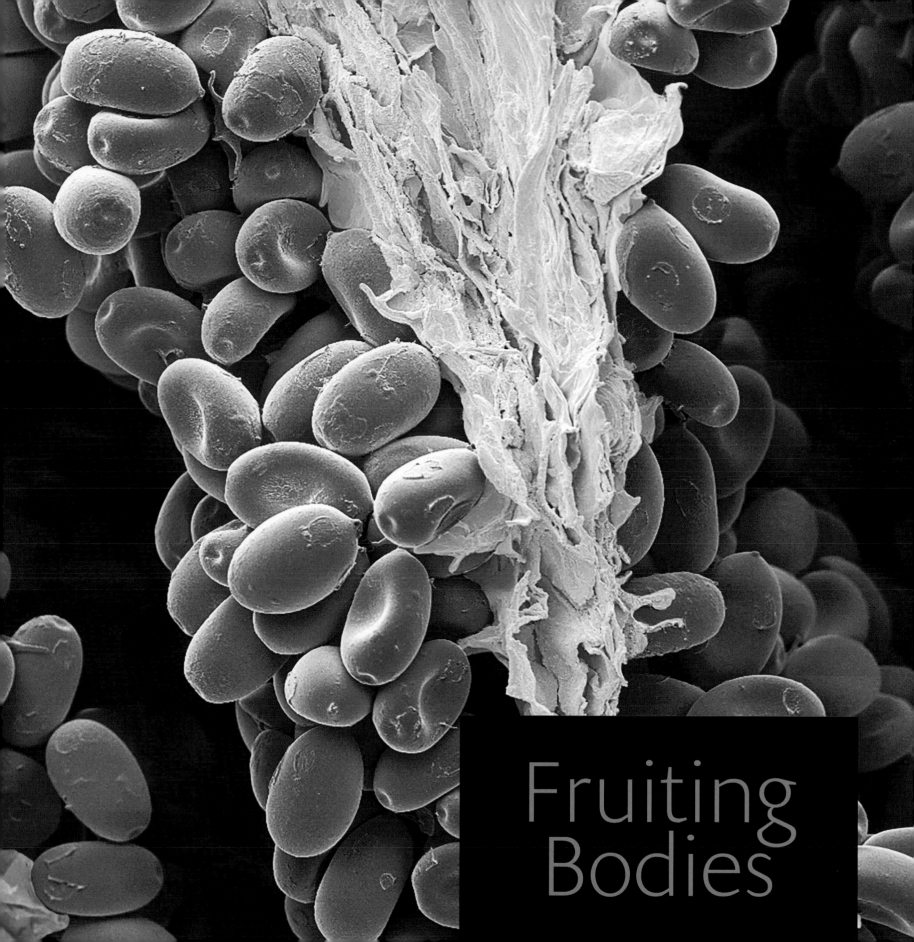

Fruiting
Bodies

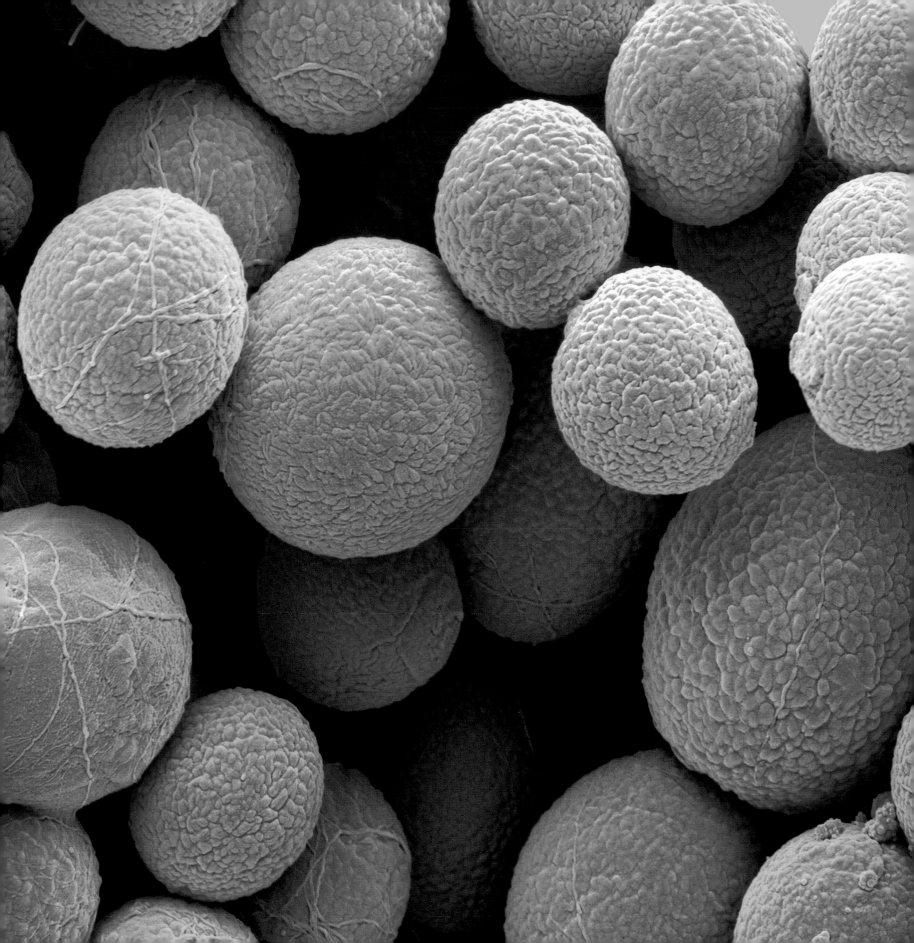

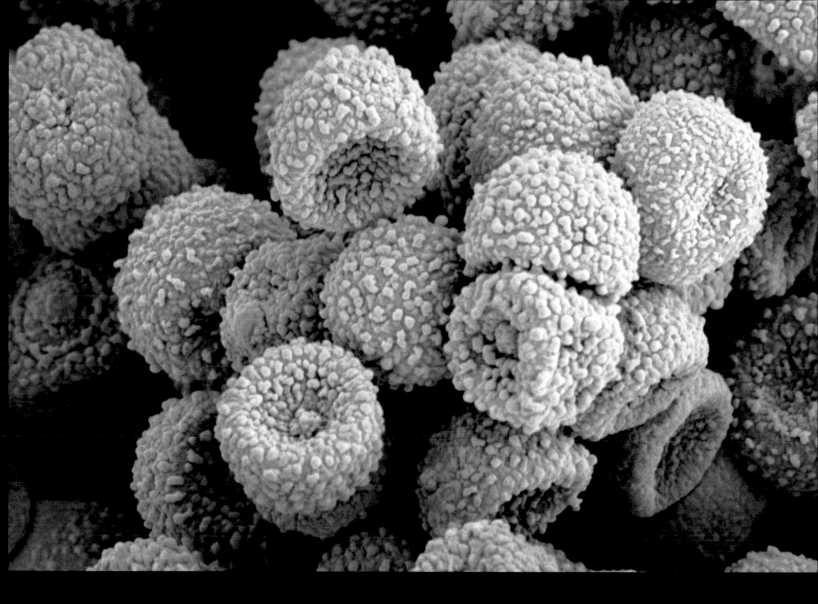

**Previous page: *Pholiota* mushroom spores
(scanning electron micrograph)**

Most of us think of mushrooms as plants in their own right. But they are only the fruiting bodies of much larger fungal organisms growing underground. As the fruit or seed head contains seeds, the mushroom contains spores, from which the next generation of the fungus will grow. In this artificially coloured image the papery divisions are the gills beneath the cap of a *Pholiota* mushroom, covered in pink spores.

(Magnification x500 at 10cm wide)

Left and Above: Bread mould conidia (scanning electron micrograph)

Fungus doesn't only grow in the earth. These two pictures show the spores of two different fungi that have made bread their home. The botanical name (conidia) comes from the Greek word for 'dust' and the spores look like a dusting of fine powder to the naked eye. The fruiting body from which they come may be less than a millimetre in size, and the spores themselves are attached to a network of even finer stems called conidophores.

(Left: Magnification x3000 at 10cm wide)
(Above: Magnification unknown)

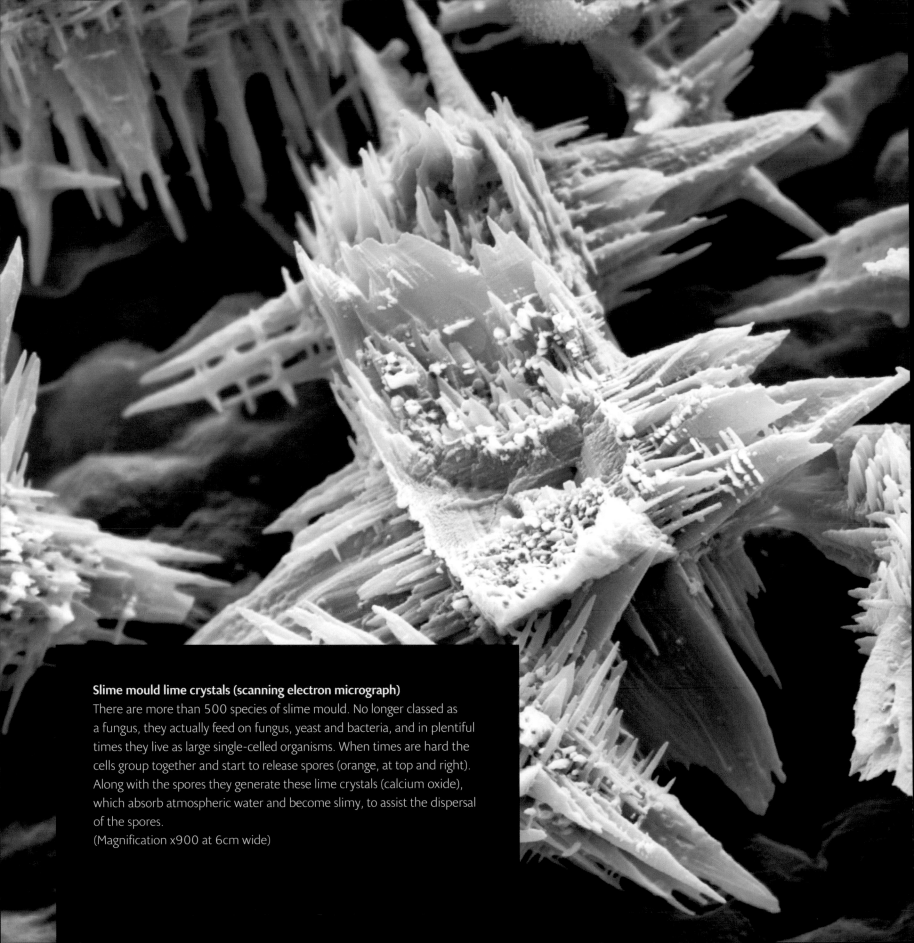

Slime mould lime crystals (scanning electron micrograph)
There are more than 500 species of slime mould. No longer classed as
a fungus, they actually feed on fungus, yeast and bacteria, and in plentiful
times they live as large single-celled organisms. When times are hard the
cells group together and start to release spores (orange, at top and right).
Along with the spores they generate these lime crystals (calcium oxide),
which absorb atmospheric water and become slimy, to assist the dispersal
of the spores.
(Magnification x900 at 6cm wide)

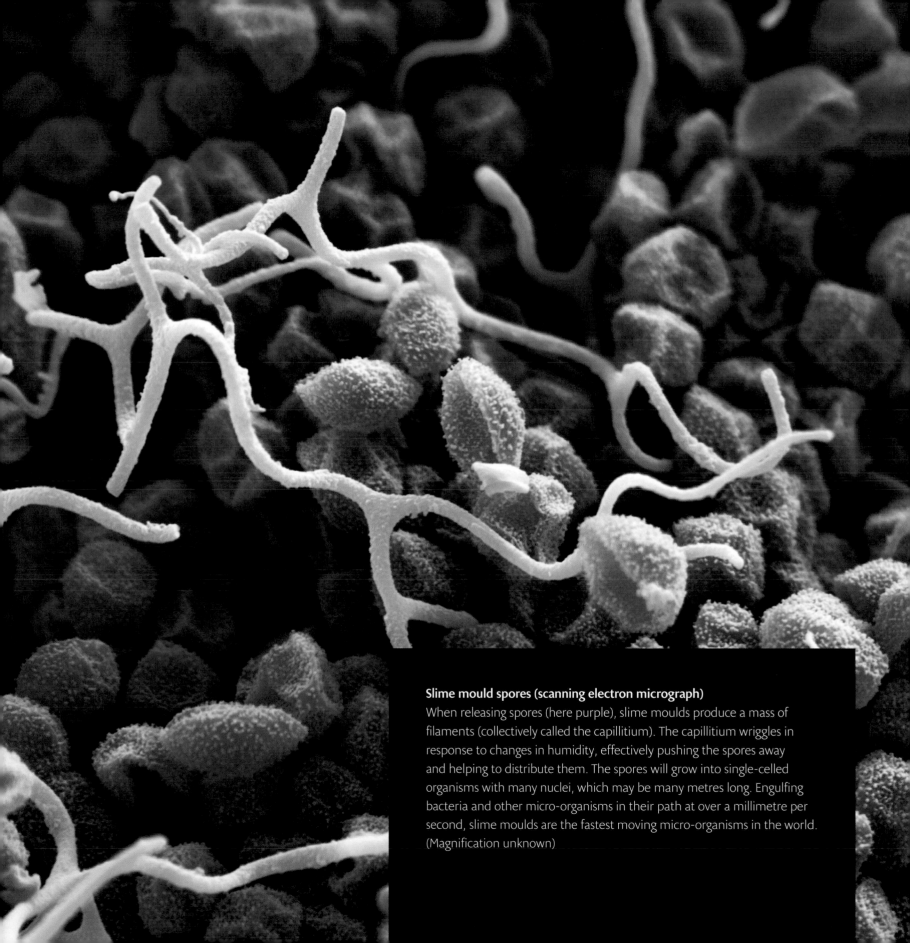

Slime mould spores (scanning electron micrograph)
When releasing spores (here purple), slime moulds produce a mass of
filaments (collectively called the capillitium). The capillitium wriggles in
response to changes in humidity, effectively pushing the spores away
and helping to distribute them. The spores will grow into single-celled
organisms with many nuclei, which may be many metres long. Engulfing
bacteria and other micro-organisms in their path at over a millimetre per
second, slime moulds are the fastest moving micro-organisms in the world.
(Magnification unknown)

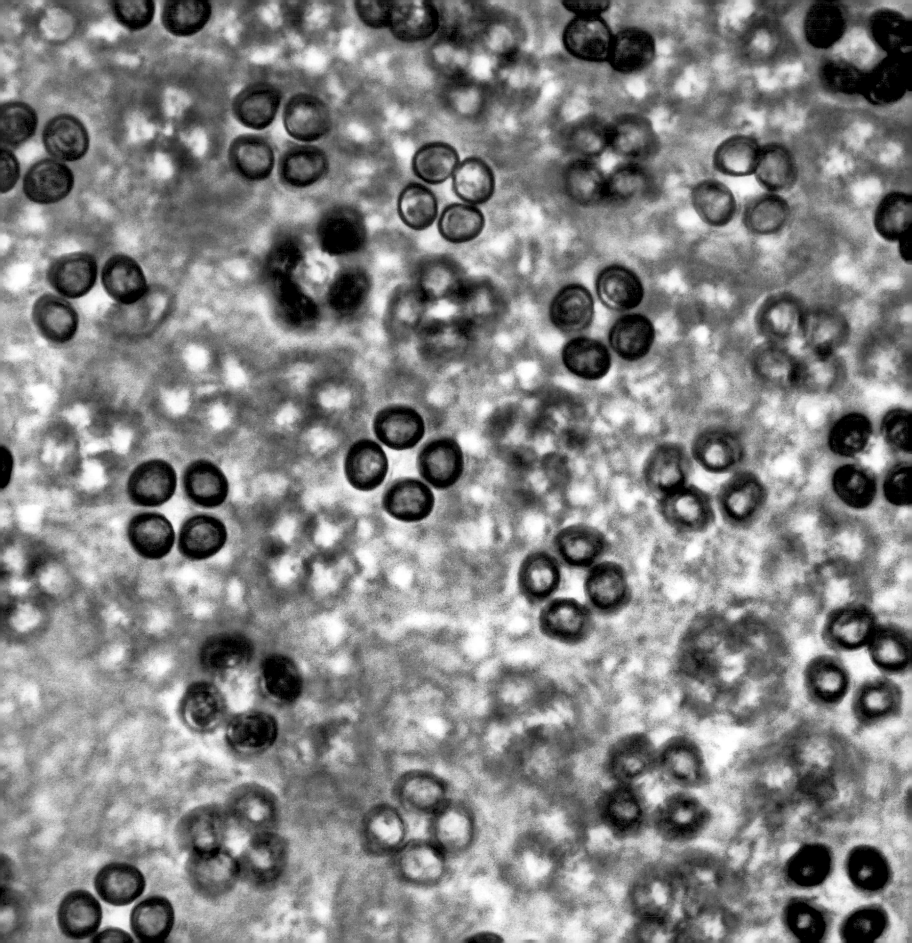

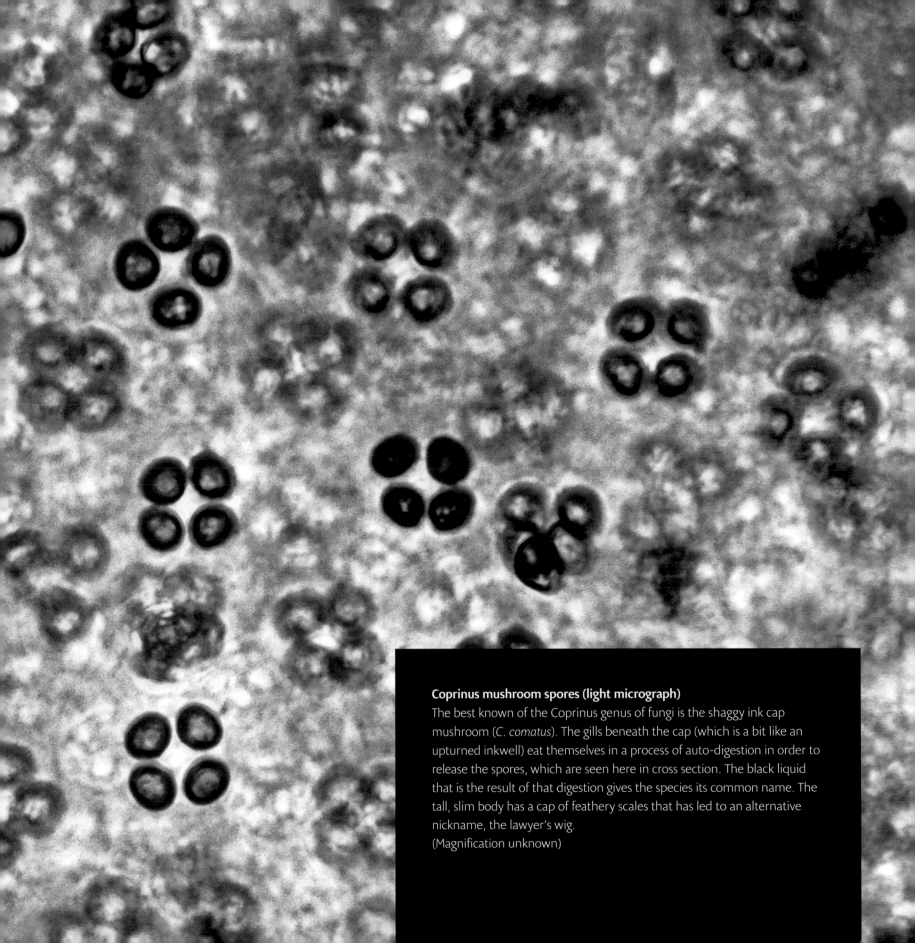

Coprinus mushroom spores (light micrograph)
The best known of the Coprinus genus of fungi is the shaggy ink cap mushroom (*C. comatus*). The gills beneath the cap (which is a bit like an upturned inkwell) eat themselves in a process of auto-digestion in order to release the spores, which are seen here in cross section. The black liquid that is the result of that digestion gives the species its common name. The tall, slim body has a cap of feathery scales that has led to an alternative nickname, the lawyer's wig.
(Magnification unknown)

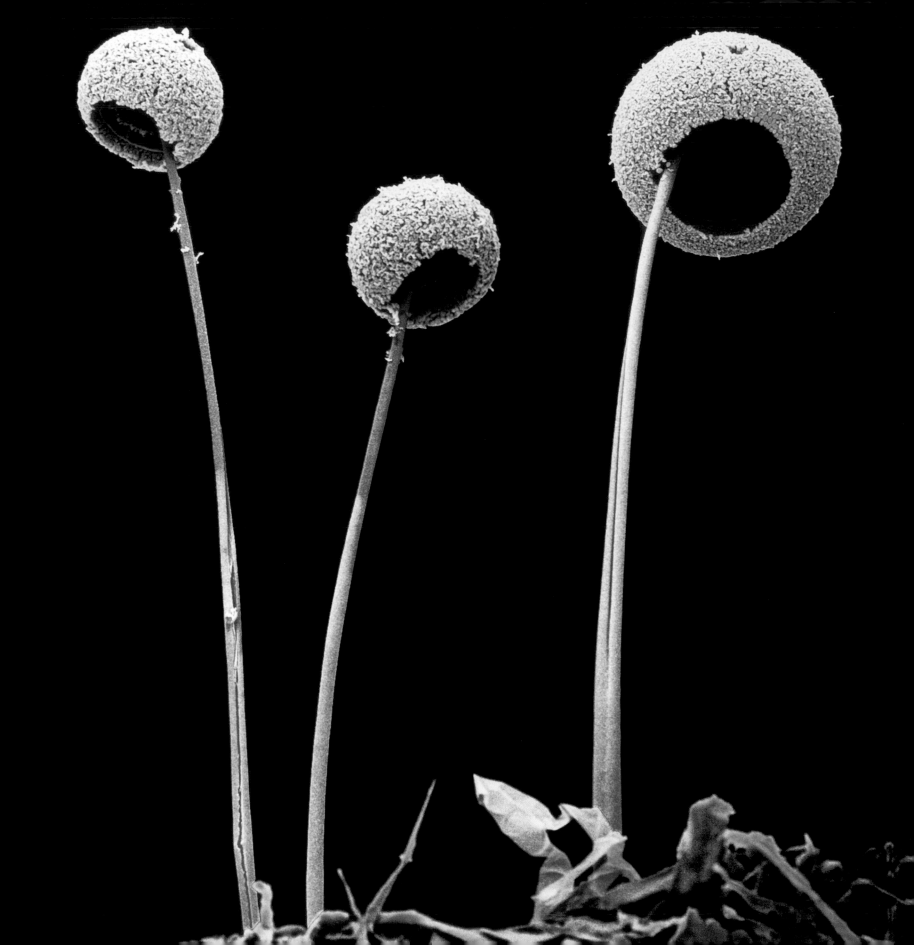

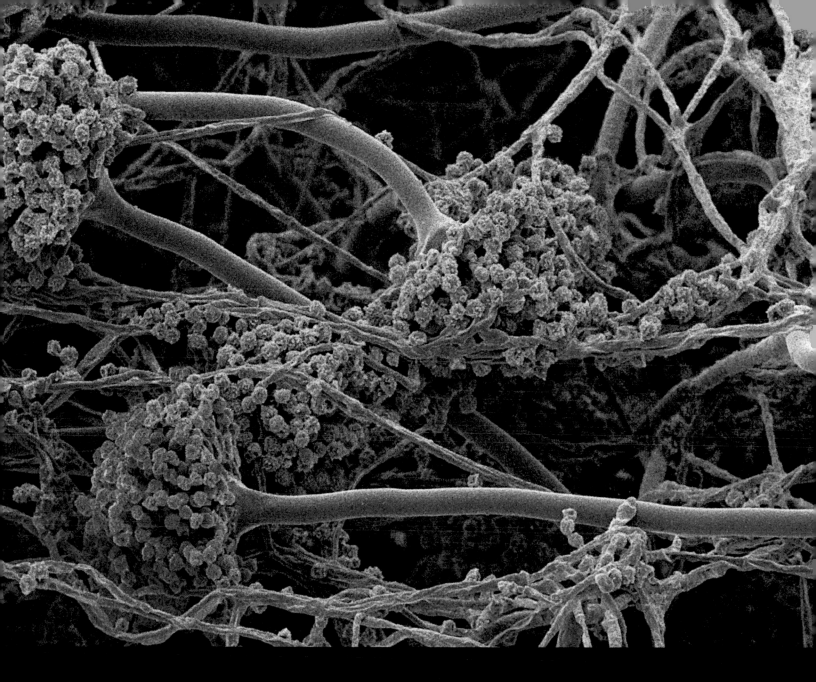

Left: *Aspergillus niger* **fungus (scanning electron micrograph)**
Above: *Aspergillus fumigatus* **fungus (scanning electron micrograph)**
There are several hundred species of *Aspergillus* fungus, all of them forms
of mould found on plants and starchy foods. They reproduce through
spores (conidia) at the end of stems (conidophores). *A. niger* (left) forms
almost completely spherical spores radiating outwards from the tip of the

stem, while *A. fumigatus* (above) only creates a hemisphere. The latter can
cause serious human diseases called aspergillosis, if inhaled by those with
weakened immune systems. The former is involved in the production of
corn syrup and anti-flatulence tablets.
(Left: Magnification unknown)
(Above: Magnification x670 at 7cm wide)

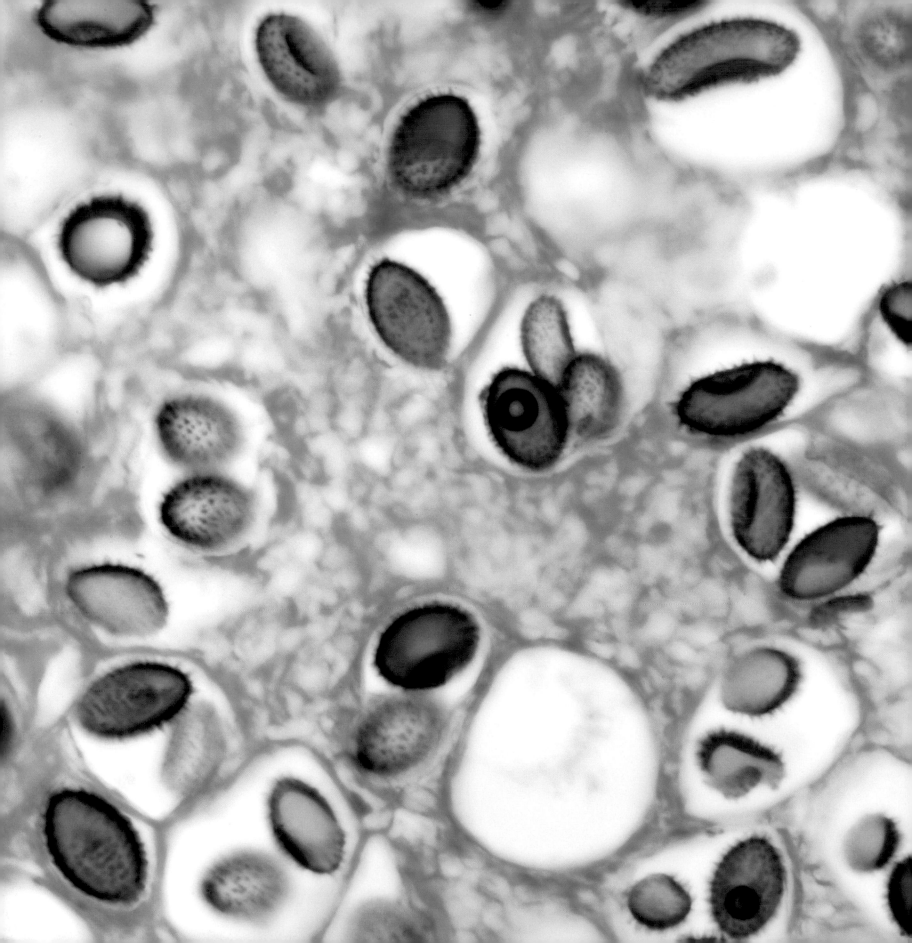

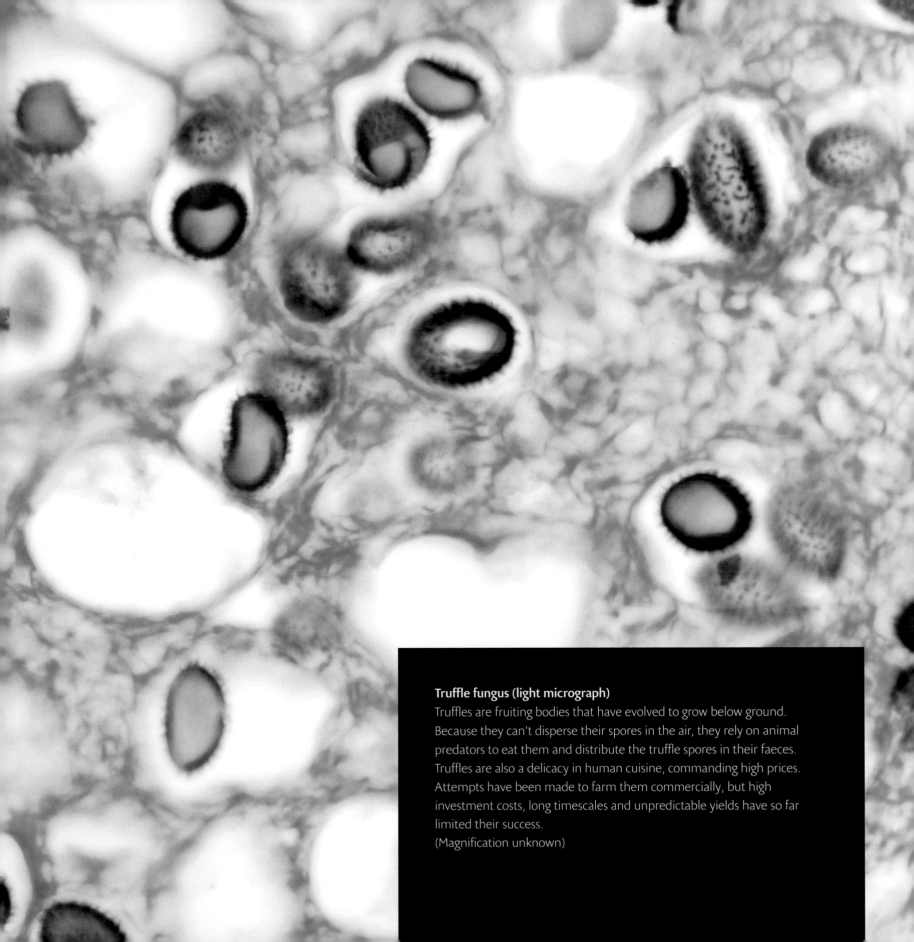

Truffle fungus (light micrograph)
Truffles are fruiting bodies that have evolved to grow below ground. Because they can't disperse their spores in the air, they rely on animal predators to eat them and distribute the truffle spores in their faeces. Truffles are also a delicacy in human cuisine, commanding high prices. Attempts have been made to farm them commercially, but high investment costs, long timescales and unpredictable yields have so far limited their success.
(Magnification unknown)

Above: Dermatophytic fungus (scanning electron micrograph)
This image shows the stems (hyphae) from which spores (here in pink) are growing in *Trichophyton rubrum*. This is the fungus most commonly the cause of athlete's foot, nail infections and other conditions, especially in men and less often in women and animals. Such fungi (dermatophytes) attack dead skin, nails and hair, all of which contain the protein keratin. The itching that we feel is caused by fungal enzymes eating the keratin; scratching only helps to spread the fungus.
(Magnification x3200 at 10cm wide)

Right: Puffball fungal spore (scanning electron micrograph)
Unlike mushrooms, puffballs have no open cap, and usually no stem. Instead, like truffles, their mass of spores (the gleba) is completely enclosed in a ball but unlike truffles, is above ground. As the spores mature, the ball dries out and cracks, allowing them to escape on the wind. A footfall or even a raindrop is enough to burst the ball and send out a puff of spores. Some are edible, some are not, and some resemble young mushrooms of the deadliest *Amanita* species. Beware!
(Magnification x3000 at 10cm wide)

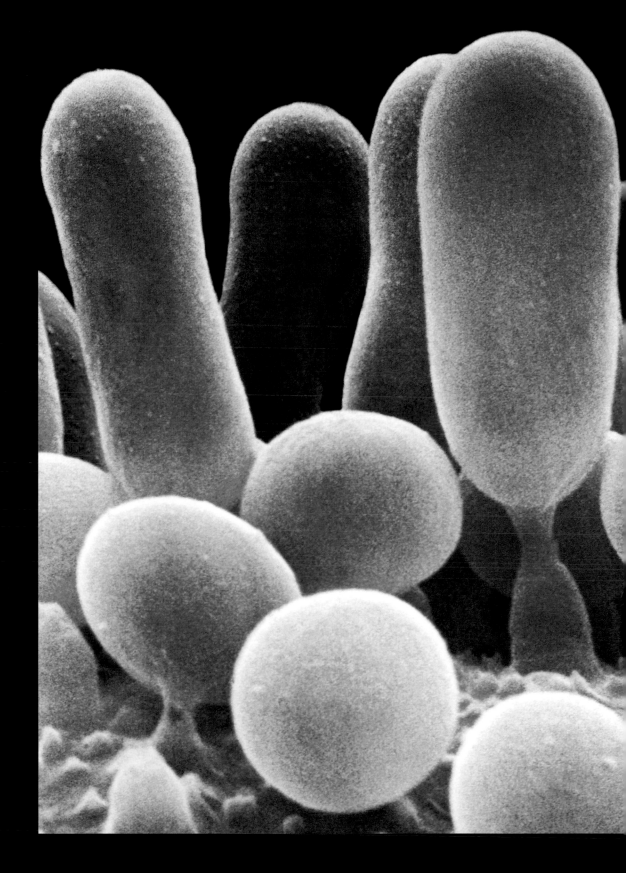

**Left: Butterfly wing scale and spore
(scanning electron micrograph)**
Butterflies generally feed on flower nectar,
not on mushrooms. They are less efficient
pollinators than, for example, hairy bees. But
when the air is thick with the spores of fungi,
the butterfly may still become an unconscious
assistant of their dispersal. Here, a tiny
butterfly's wing has trapped an even tinier
mushroom spore during flight. It will fall off
later and give the original mushroom a wider
distribution than it might have expected.
(Magnification x3350 at 10cm wide)

**Right: Powdery mildew
(scanning electron micrograph)**
Powdery mildew attacks the leaves and stems
of many plants, and is the result of infection
by several species of fungus: these spores are
from *Mycotypha africana*. These fungi thrive
in humid, temperate environments such as
greenhouses. They are spread by insects like
the woolly aphid, which feeds off infected
plants and ingests the fungus, later depositing
it in faeces on other plants. Some infected
crops can be treated chemically, or biologically
with parasitic fungi that feed on the infection,
not the leaf.
(Magnification x8600 at 6cm wide)

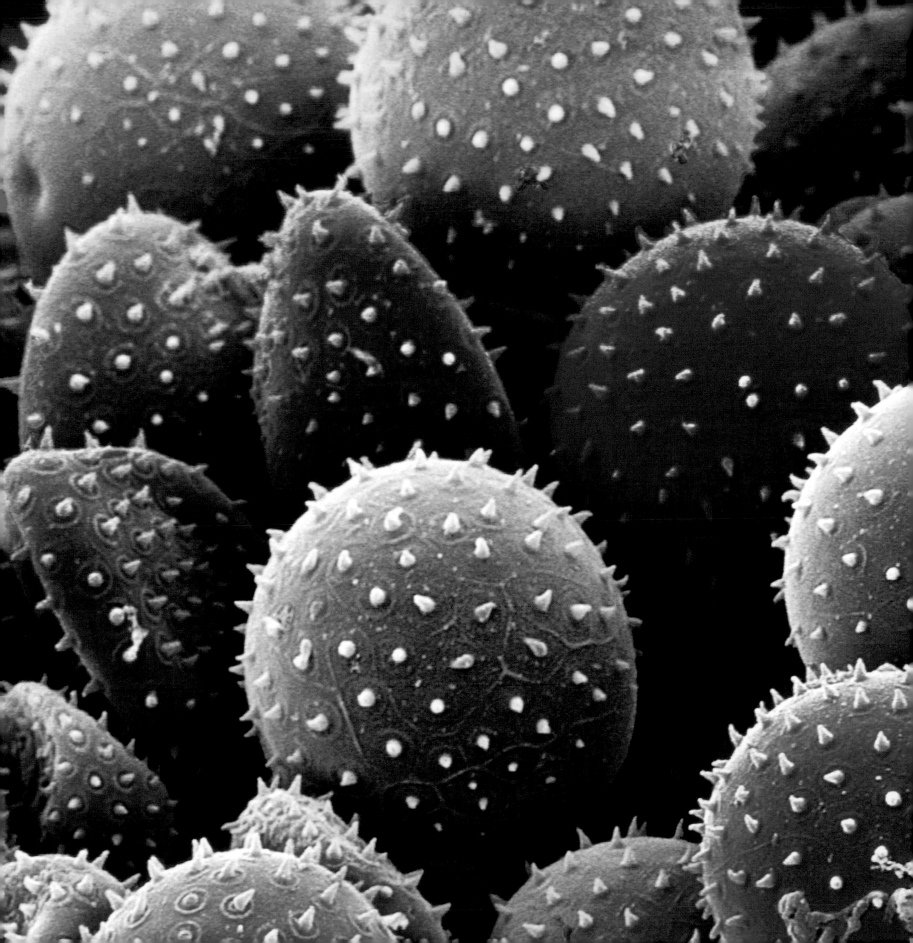

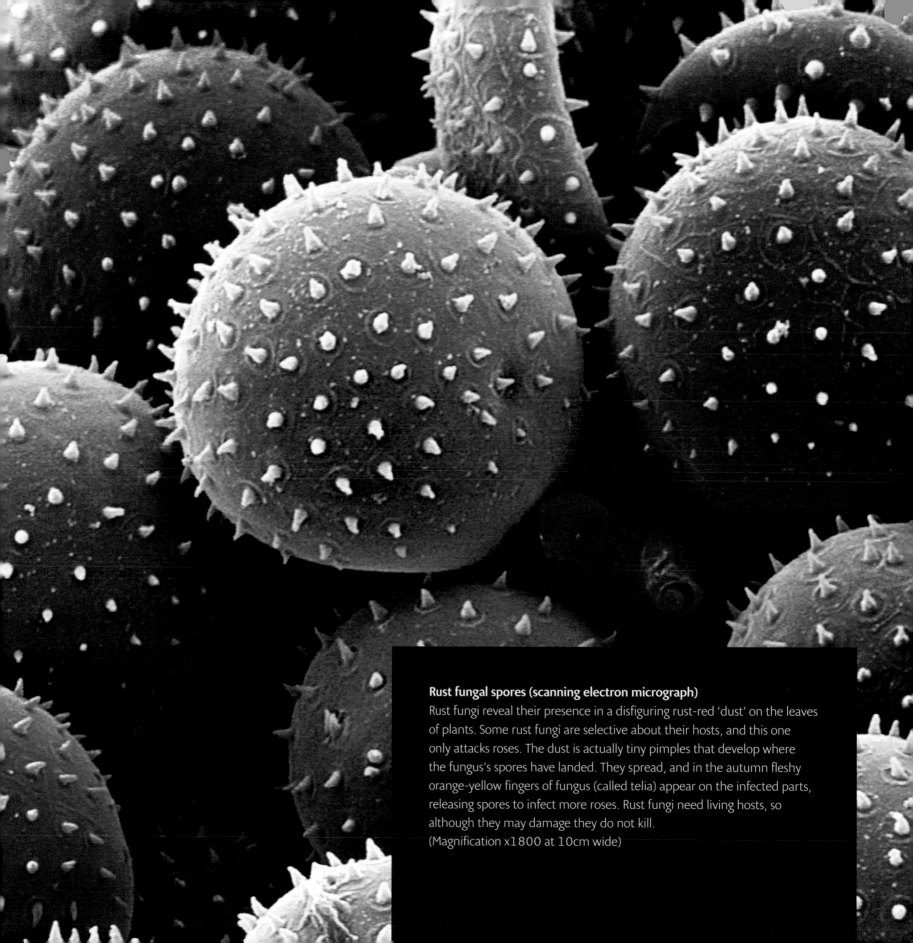

Rust fungal spores (scanning electron micrograph)
Rust fungi reveal their presence in a disfiguring rust-red 'dust' on the leaves of plants. Some rust fungi are selective about their hosts, and this one only attacks roses. The dust is actually tiny pimples that develop where the fungus's spores have landed. They spread, and in the autumn fleshy orange-yellow fingers of fungus (called telia) appear on the infected parts, releasing spores to infect more roses. Rust fungi need living hosts, so although they may damage they do not kill.
(Magnification x1800 at 10cm wide)

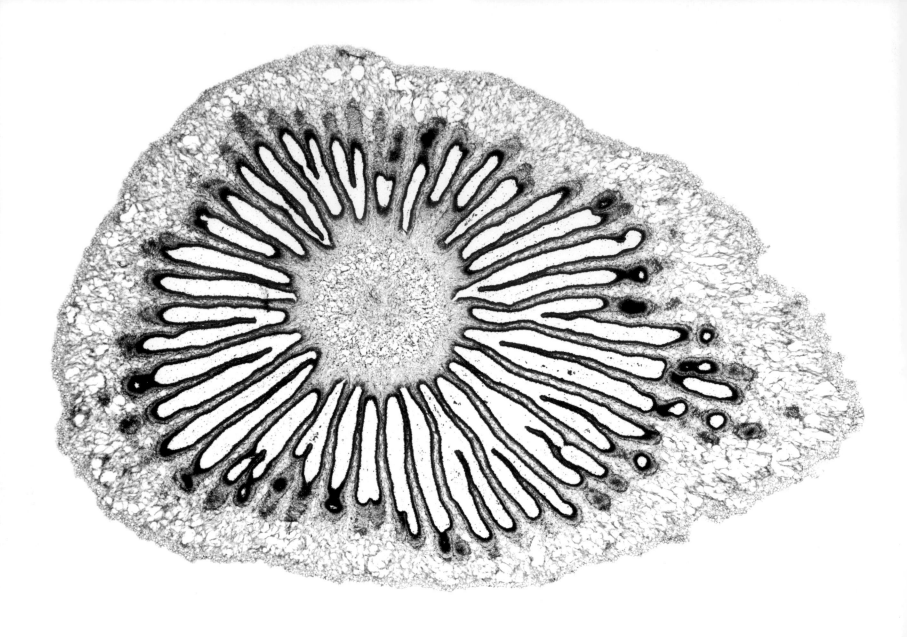

Above: Mushroom gill cap (light micrograph)

The *Agaricus* genus includes some of the most edible mushrooms and the most poisonous. They all have the classic mushroom shape, a cap on top of a stem. They all have gills, the radial, spore-producing divisions on the underside of the cap, seen here in cross section. The young mushroom protects these gills with a veil of tissue across them, which survives in maturity as a frilly skirt (called an annulus) around the stem. (Magnification x11 at 10cm wide)

Right: Bird's nest mushroom (light micrograph)

Bird's nest mushrooms are the small cup-like fungi that grow on rotting fallen logs. The 'eggs' in the nest (called peridioles) are where the mushroom's spores are produced. From above, the spores look like flat round discs, and their dispersal is remarkable: when a raindrop falls into the nest at the right angle, it bounces the peridioles up the side of the cup and out, sometimes as far as a metre from the nest. From there an animal will eat and digest the peridiole, later releasing the spores in faeces. (Magnification x5 at 3.5cm wide)

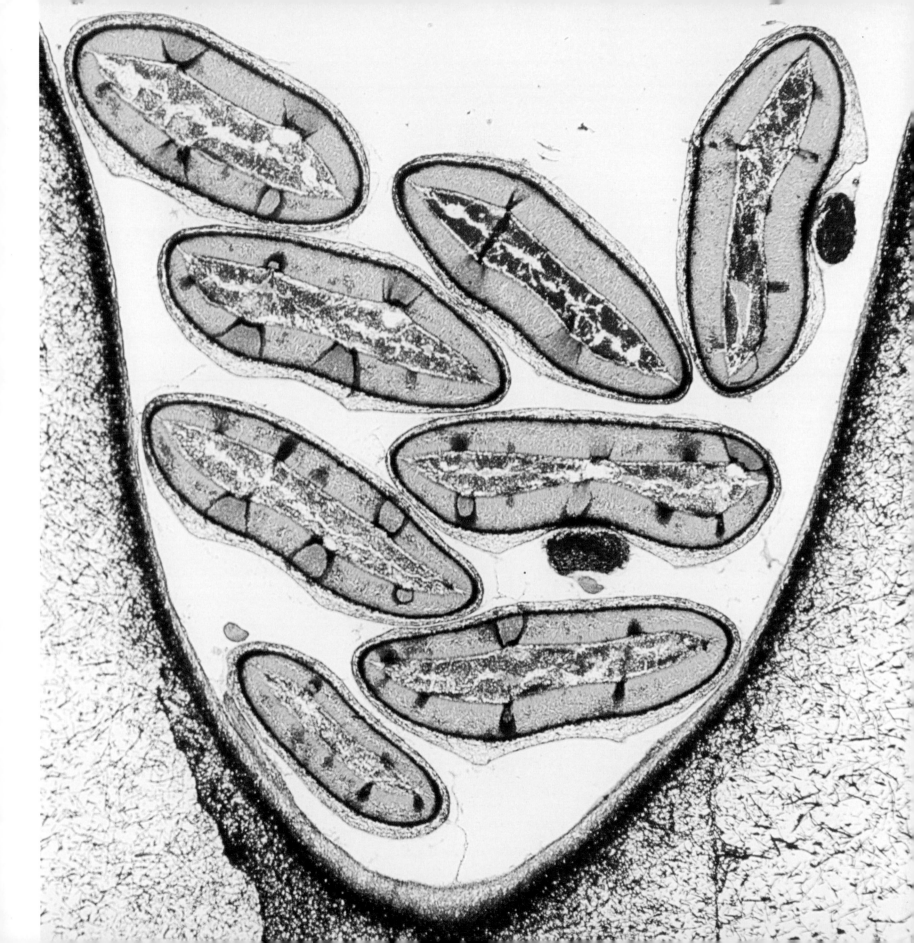

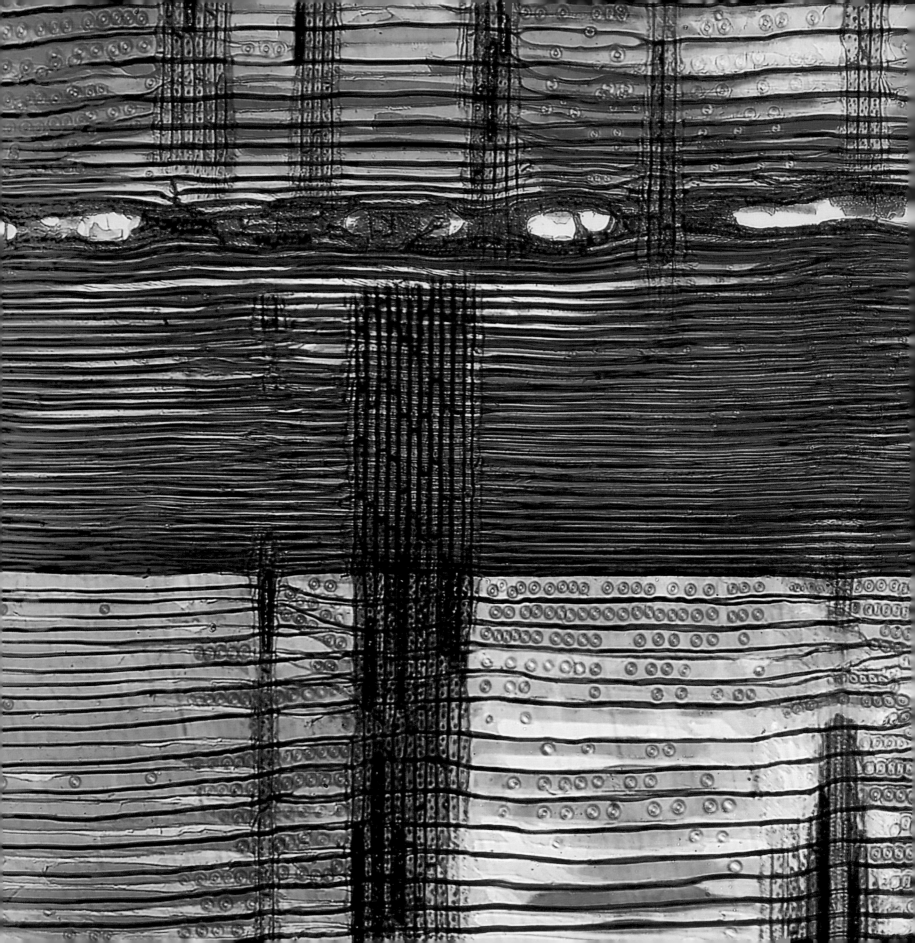

Trees and
Leaves

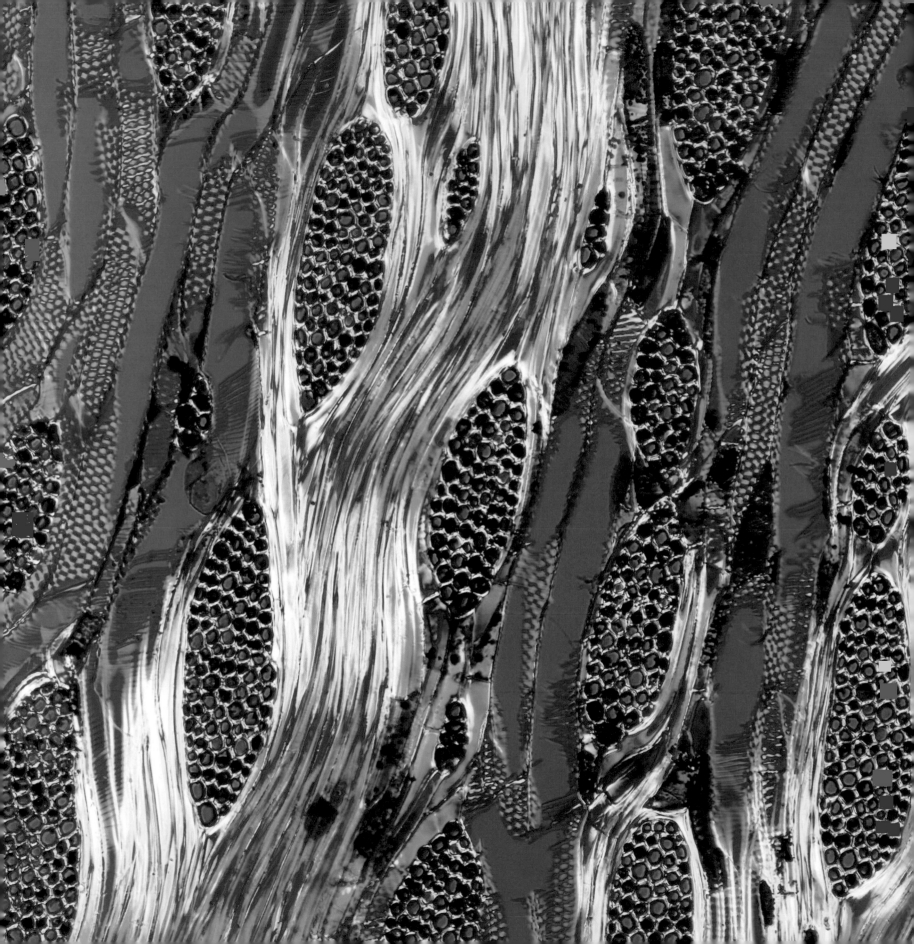

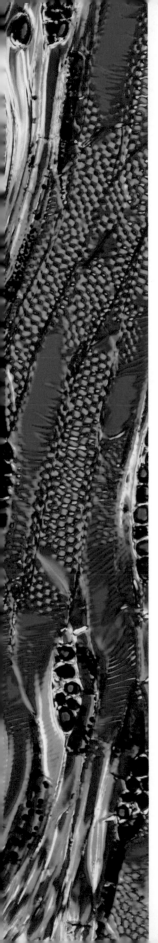

Previous page: Larch wood (polarized light micrograph)

One way of categorizing trees is by deciding whether they are deciduous (losing their leaves annually) or coniferous (producing cones that contain their pollen and ovules). Most trees are one or the other, but the larch family are both. They grow cones, male and female on the same tree, but they also drop their leaves, which take the form of needles, in the autumn. The dense water-resistant grain of larch wood, seen here, makes it a useful timber for boat-building and fence posts.
(Magnification x27 at 10cm wide)

Left: Elm stem (light micrograph)

Most of us are familiar with tree rings – the concentric circles of growth that are visible when you cut across a limb of timber. Some deciduous trees also have rays – lines radiating out from the centre to the outer rings. They carry essential nutrition from the core of the tree (the pith) to its edge. In this cross section the black areas are rays of many cells bearing water and minerals to the periphery, through the false-coloured fibres of elm wood.
(Magnification x100 at 10cm tall)

Right: Stem of a cabbage palm (light micrograph)

The swollen roots of the cabbage palm have been cultivated for food and medicine in Polynesia. The long, wide, flat leaves have found many uses – in roofing, and for ornamental or ceremonial clothing. Here in cross section you can see two rays (surrounded by yellow cells), which carry nutrition from the central pith of the palm stem to its outer layers. It's related to the dragon tree and considered botanically to be part of the asparagus family.
(Magnification unknown)

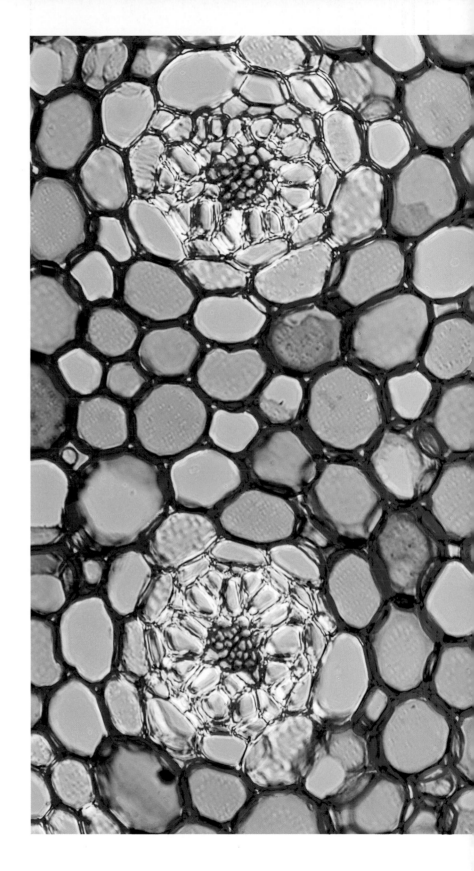

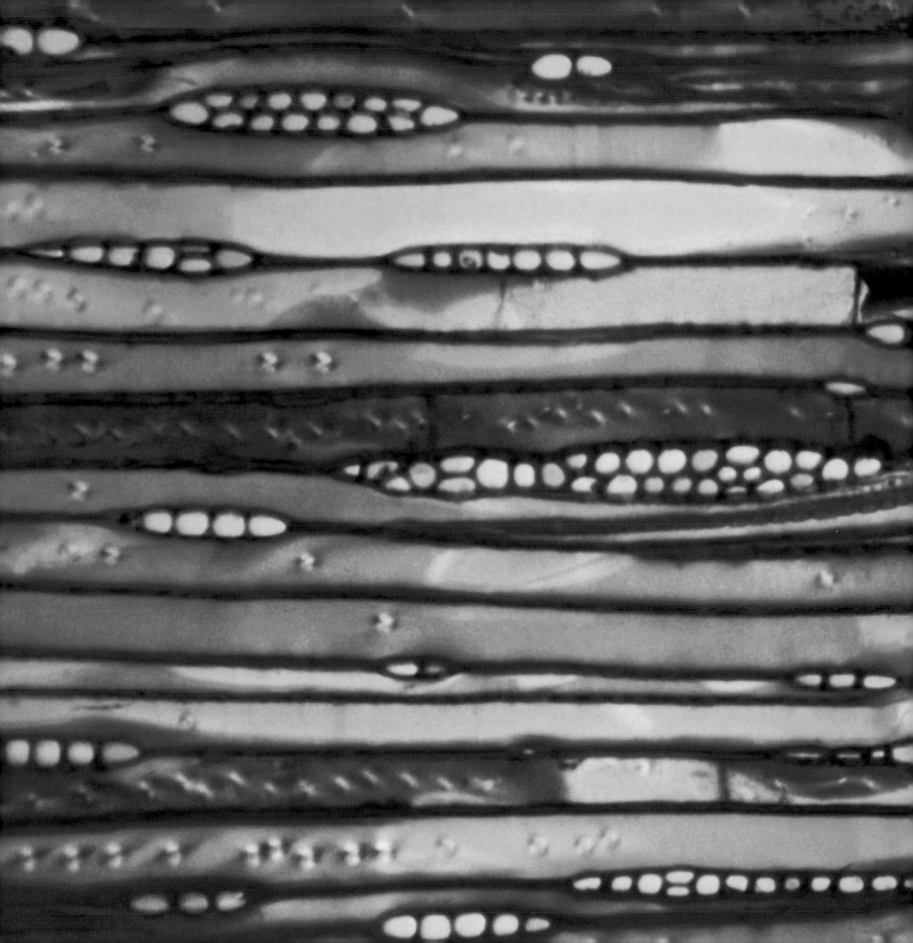

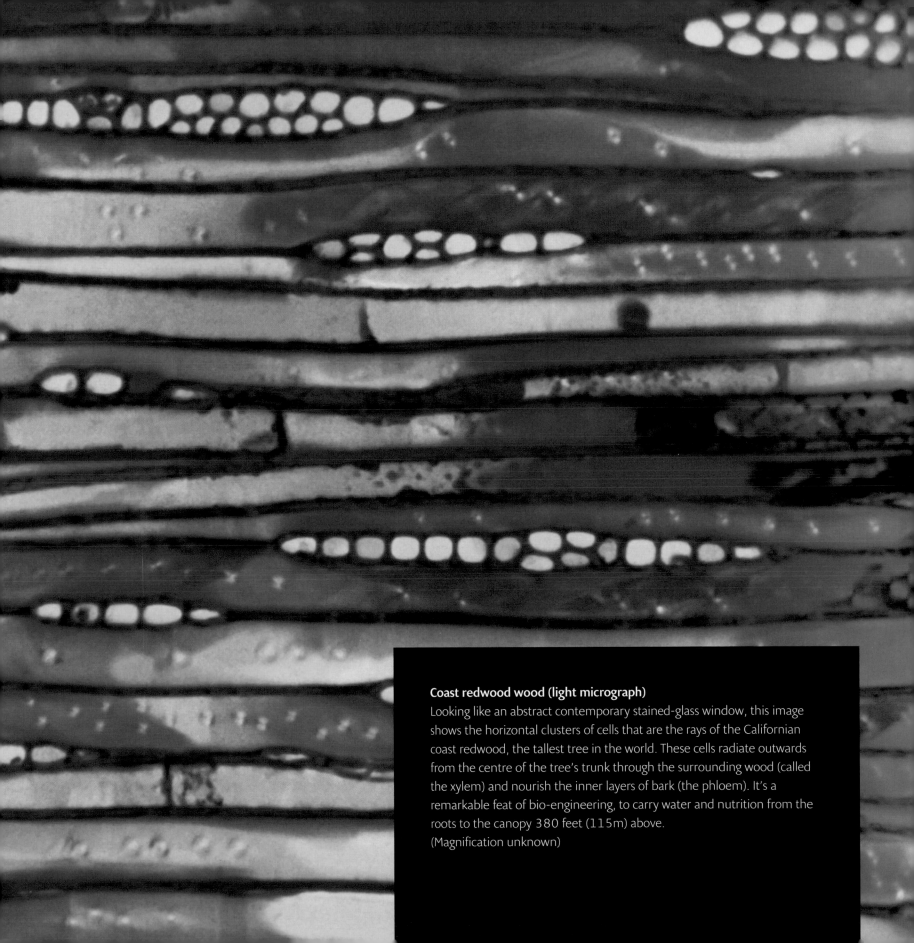

Coast redwood wood (light micrograph)
Looking like an abstract contemporary stained-glass window, this image shows the horizontal clusters of cells that are the rays of the Californian coast redwood, the tallest tree in the world. These cells radiate outwards from the centre of the tree's trunk through the surrounding wood (called the xylem) and nourish the inner layers of bark (the phloem). It's a remarkable feat of bio-engineering, to carry water and nutrition from the roots to the canopy 380 feet (115m) above.
(Magnification unknown)

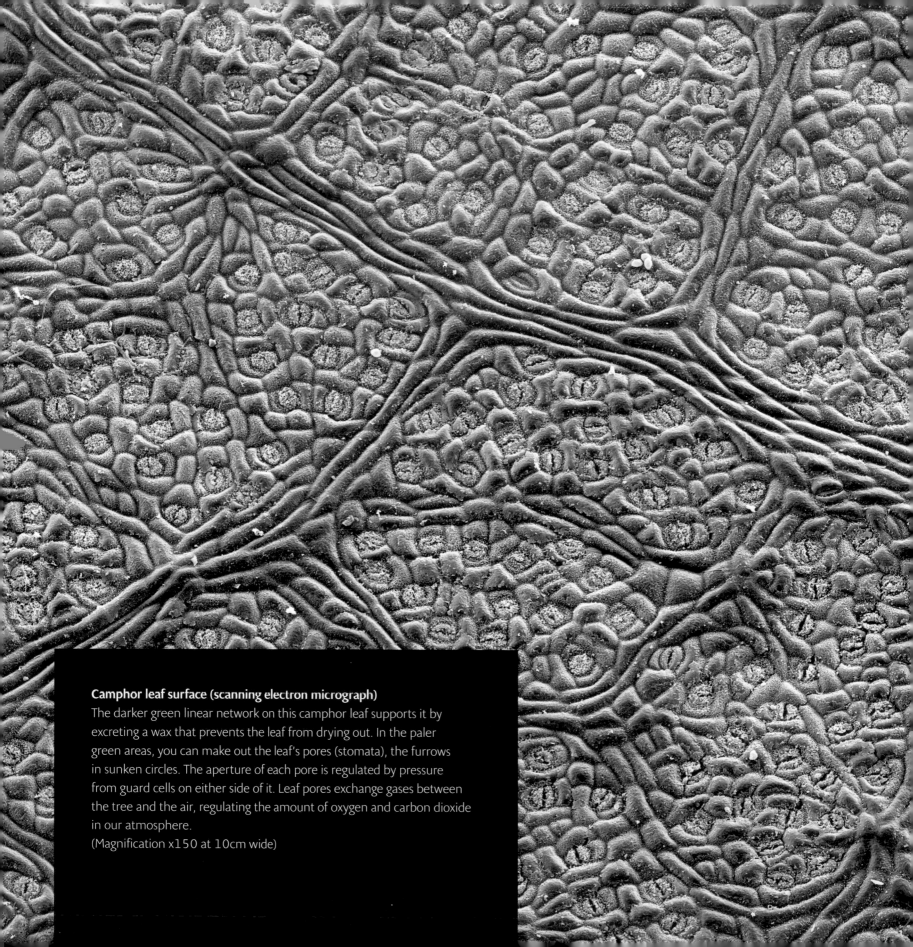

Camphor leaf surface (scanning electron micrograph)
The darker green linear network on this camphor leaf supports it by
excreting a wax that prevents the leaf from drying out. In the paler
green areas, you can make out the leaf's pores (stomata), the furrows
in sunken circles. The aperture of each pore is regulated by pressure
from guard cells on either side of it. Leaf pores exchange gases between
the tree and the air, regulating the amount of oxygen and carbon dioxide
in our atmosphere.
(Magnification x150 at 10cm wide)

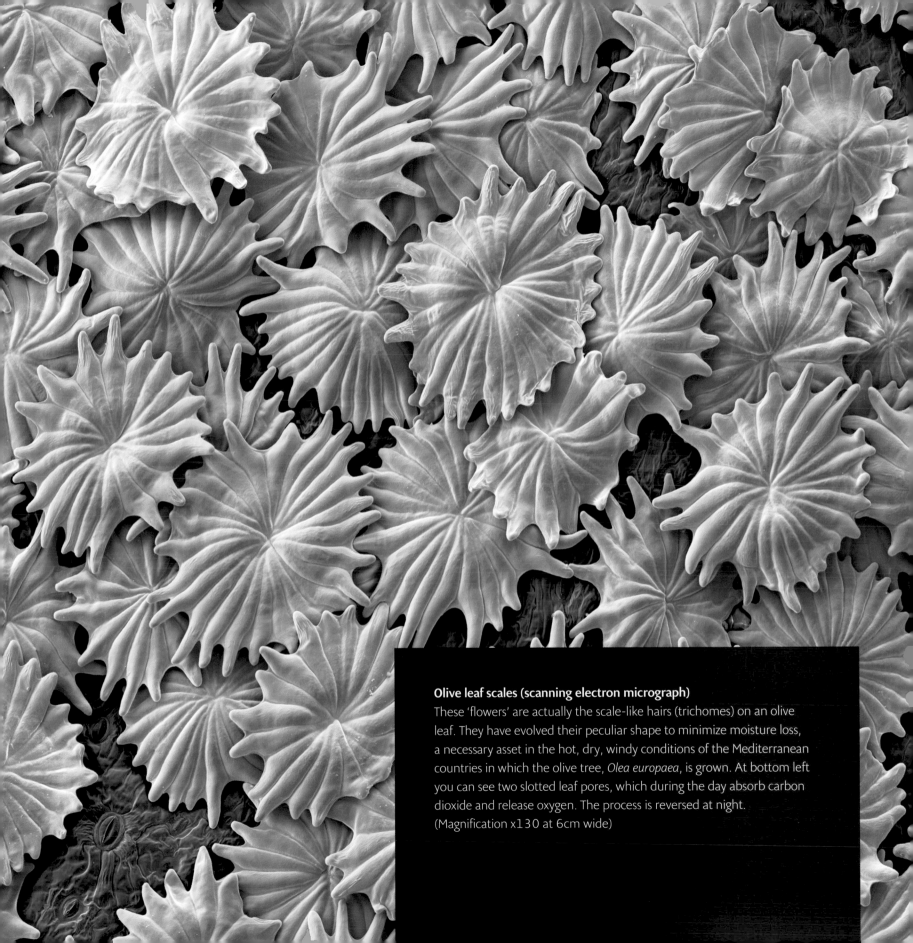

Olive leaf scales (scanning electron micrograph)
These 'flowers' are actually the scale-like hairs (trichomes) on an olive leaf. They have evolved their peculiar shape to minimize moisture loss, a necessary asset in the hot, dry, windy conditions of the Mediterranean countries in which the olive tree, *Olea europaea*, is grown. At bottom left you can see two slotted leaf pores, which during the day absorb carbon dioxide and release oxygen. The process is reversed at night.
(Magnification x130 at 6cm wide)

Above: Magnolia wood (scanning electron micrograph)

These are the loose lacy fibres of magnolia wood (the xylem cells). Running diagonally through it from top right to bottom left are the magnolia's nutrition-bearing rays. The faint line of narrower cells from top left to bottom centre is a growth ring. The variety in the image is the saucer magnolia, named for the shape of its flowers. One American cultivar of it, *Magnolia x soulangeana* 'Grace McDade', produces floral saucers 14 inches (35cm) in diameter.
(Magnification x400 at 10cm wide)

Right: *Salvinia natans* (scanning electron micrograph)

Salvinia natans is a floating fern. Its leaves have these unusual clusters of four hairs called eggbeater trichomes. Covered in tiny wax droplets, they are extremely water-repellent, so they trap a layer of air over the whole leaf, floating it and preventing it from rotting. The tip where they meet is not water-repellent, and grips the water to steady the plant, further stabilizing the air layer. This 'salvinia effect' is being studied by marine architects as a way of reducing drag on ships and thus cutting fuel consumption.
(Magnification x100 at 10cm wide)

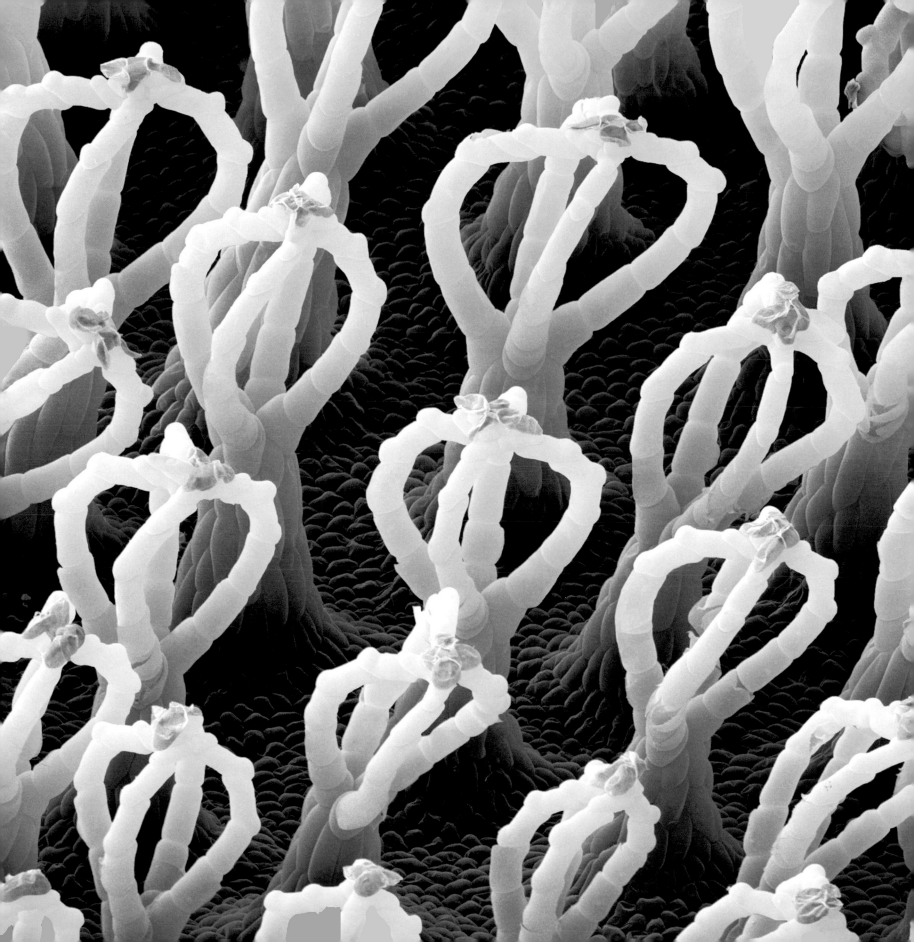

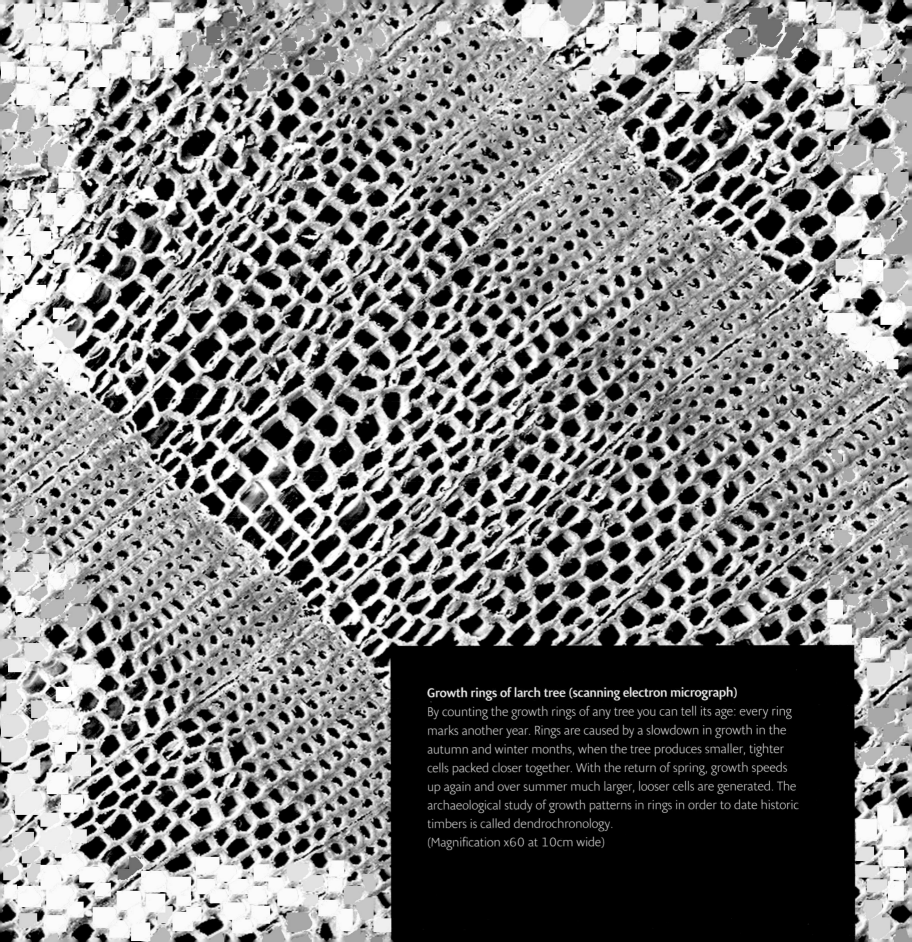

Growth rings of larch tree (scanning electron micrograph)
By counting the growth rings of any tree you can tell its age: every ring marks another year. Rings are caused by a slowdown in growth in the autumn and winter months, when the tree produces smaller, tighter cells packed closer together. With the return of spring, growth speeds up again and over summer much larger, looser cells are generated. The archaeological study of growth patterns in rings in order to date historic timbers is called dendrochronology.
(Magnification x60 at 10cm wide)

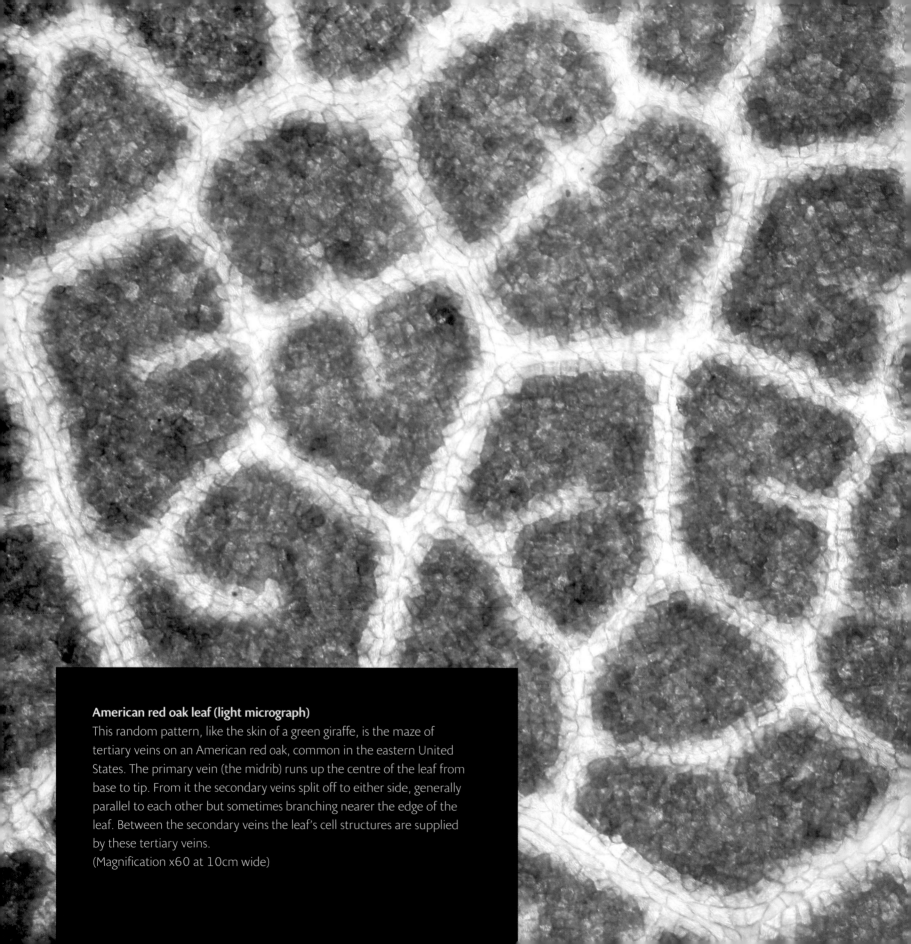

American red oak leaf (light micrograph)
This random pattern, like the skin of a green giraffe, is the maze of
tertiary veins on an American red oak, common in the eastern United
States. The primary vein (the midrib) runs up the centre of the leaf from
base to tip. From it the secondary veins split off to either side, generally
parallel to each other but sometimes branching nearer the edge of the
leaf. Between the secondary veins the leaf's cell structures are supplied
by these tertiary veins.
(Magnification x60 at 10cm wide)

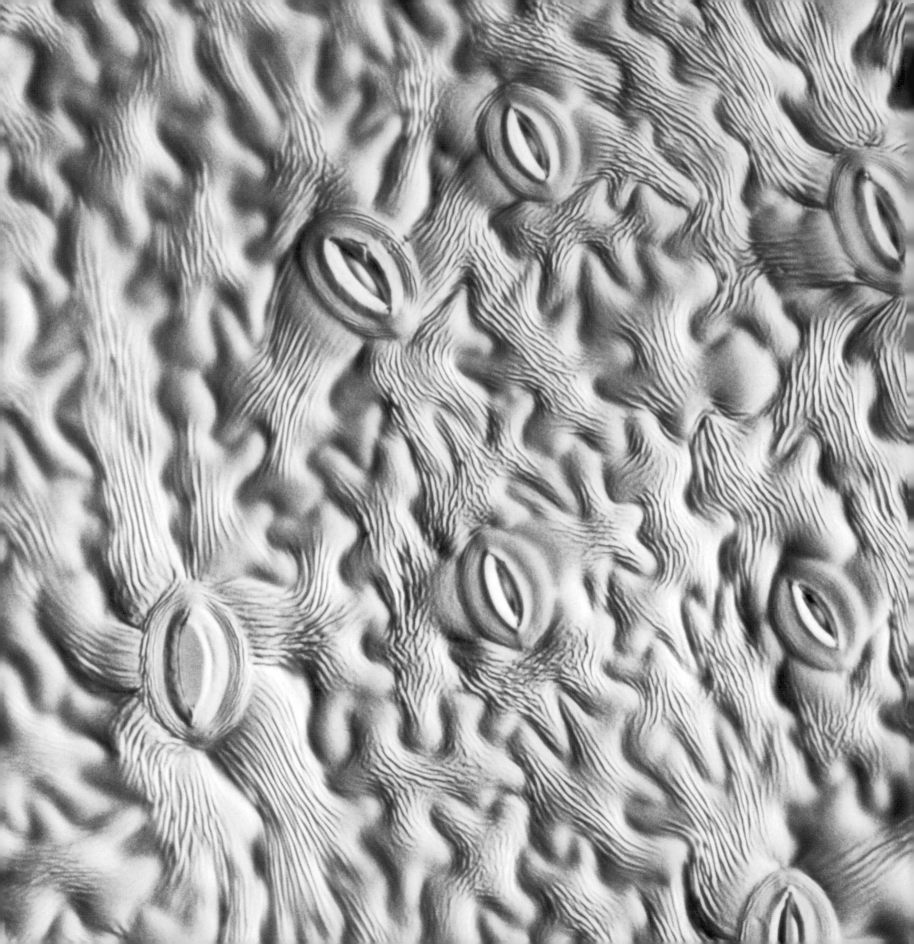

**Left: Surface of an elder leaf
(light micrograph)**
In this enhanced image the 'mouths' are
the pores on the underside of an elder leaf.
The 'lips' are the guard cells that expand and
contract on either side, closing or opening the
pores between them to permit the exchange
of gases. During the day, plants give out oxygen
as a byproduct of photosynthesis, and they
breathe in carbon dioxide, their only source of
carbon from which to grow new cells. At night
they exhale carbon dioxide and inhale oxygen.
Trees are truly the lungs of the planet.
(Magnification x200 at 3.5cm tall)

Right: Brazilian liana (light micrograph)
Lianas, the vines of the tropical forest,
form important pathways for its creatures,
but can destabilize the trees on and between
which they grow. They compete for light
and nutrition and a falling tree connected to
another by a liana may pull the second tree
over. In this cross section the circular structures
are bundles of the vine's central fibres, its
wood. Growing in parallel, they give the vine
its flexibility. The red areas surrounding them
are the rays that carry nutrients to the vine's
outer walls.
(Magnification unknown)

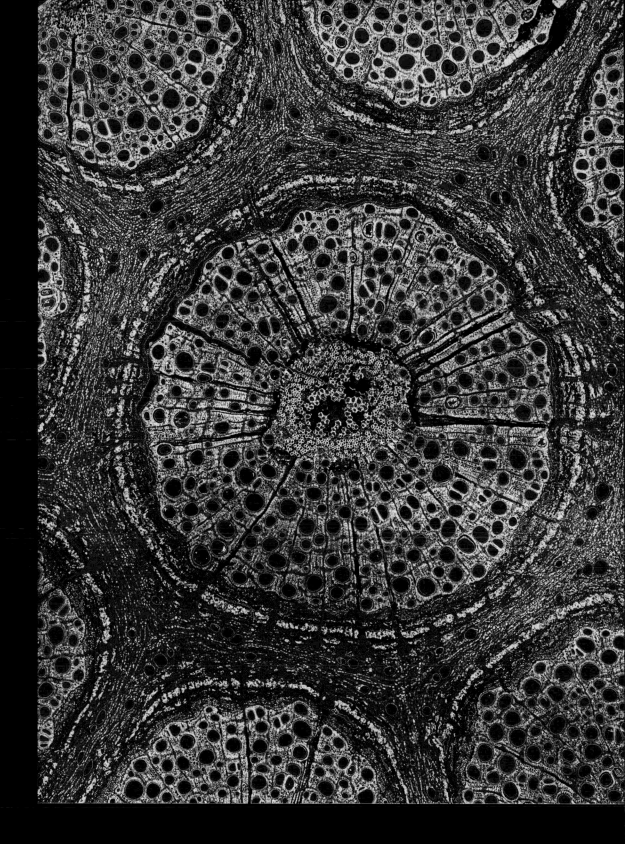

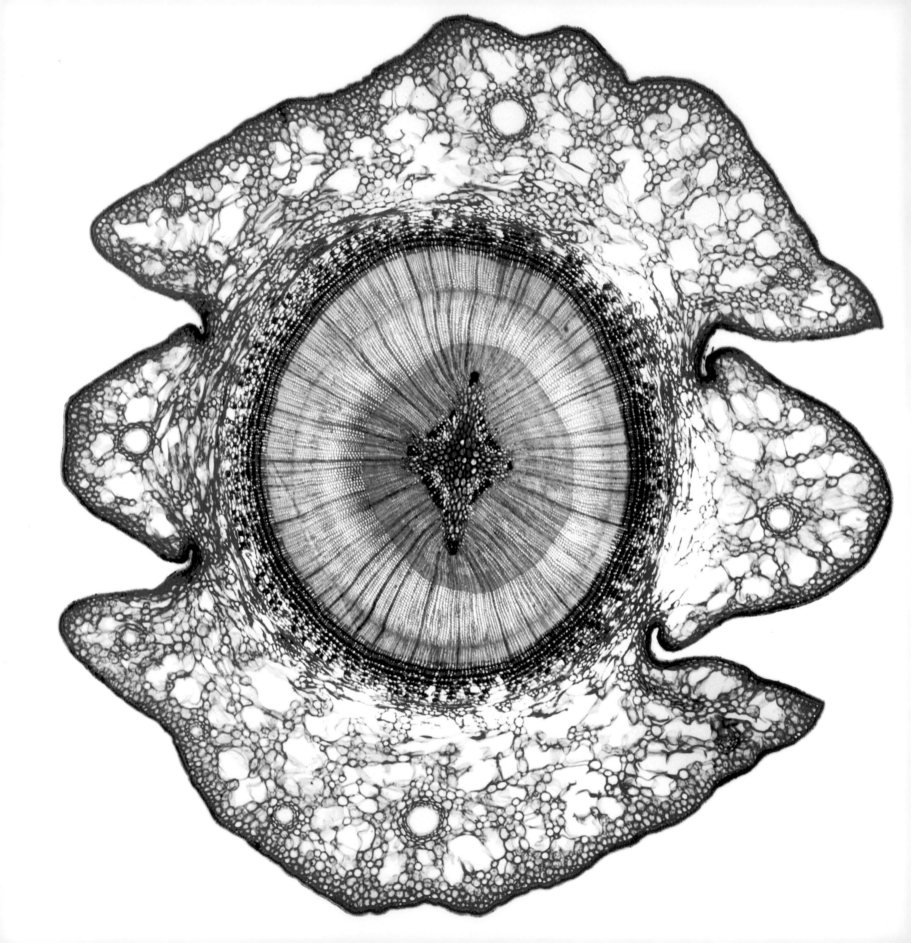

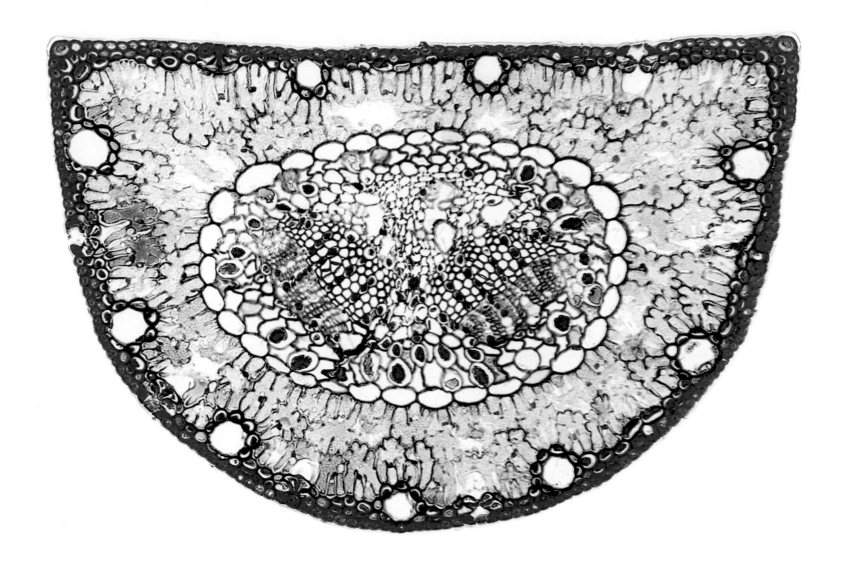

Left: Japanese cypress tree stem (light micrograph)

In this cross section of a Japanese cypress shoot, the orange matter with radiating rays is the wood (xylem cells). Beyond it, the black and pink rings are phloem cells of the inner bark. Between the xylem and the phloem, the continuous red ring is the cambium, a band of growth cells that grow inwards as xylem cells and outwards as phloem cells. The four lobes around the stem are a rare form of leaf with only one vein (the circle in each lobe), which have fused with the surface of the shoot.

(Magnification x14 at 10cm wide)

Right: Pine needle (light micrograph)

Pine needles are leaves that have evolved to minimize moisture evaporation in dry climates. Pine trees still rely on their needles for photosynthesis, which is carried out by the green cells (mesophyll) seen here just inside the thick-celled orange skin (epidermis) of the needle. The white circles just inside the epidermis are resin channels. The ring of large white cells (endodermis) conveys water and nutrients between the tree and the needle. It surrounds a woody core of blue phloem and red xylem cells.

(Magnification x46 at 10cm wide)

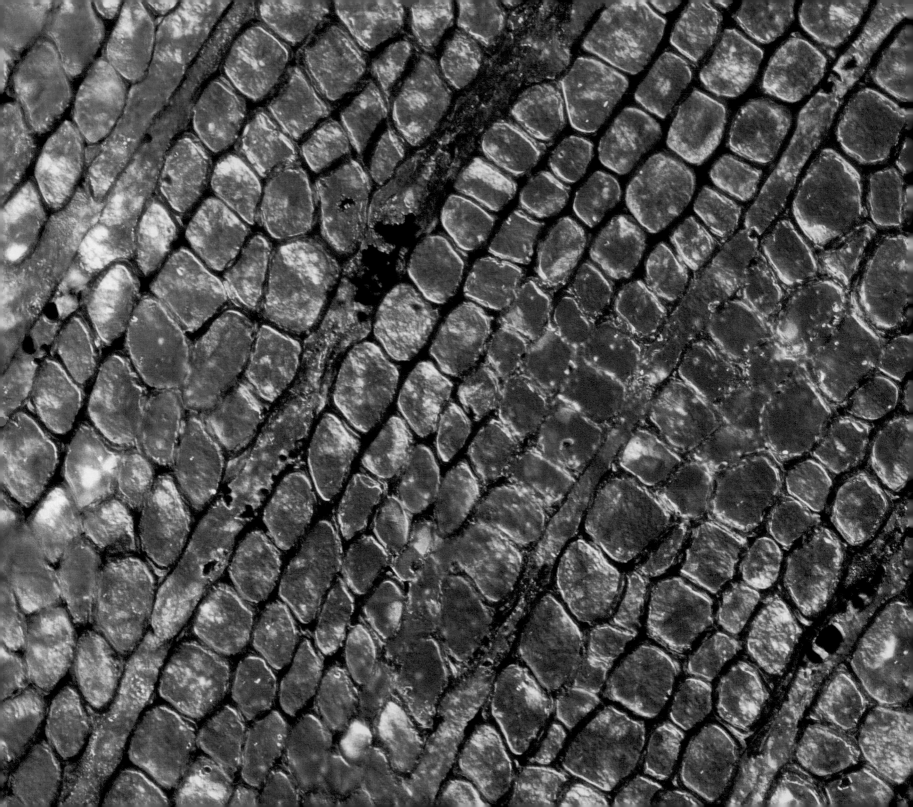

Left: Fossil wood (light micrograph)

This is a fossilized piece of 375-million-year-old timber, *Callixylon newberryi*. The species was one of the first to grow in large forests. The climate at the time (the Late Devonian age) was generally warmer than now and drier, and *Callixylon newberryi* is the ancestor of today's conifers. The expansion of forestation during the Devonian age caused a fall in atmospheric carbon dioxide. Plants locked up carbon, and in the following age, the Carboniferous, many of the world's coal deposits were formed. (Magnification x80 at 7cm wide)

Right: Sycamore maple stem (light micrograph)

The red outer layer of the stem in this image contains cork, which sycamores (and other trees) grow in the autumn to protect them from the worst of winter. The following spring new buds appear (right, above and below the stem), from which first the leaves and then the dangling bunches of pale green flowers will burst. In the autumn the winged seeds (samaras) twirl as they fall, giving the wind time to carry them further afield. (Magnification unknown)

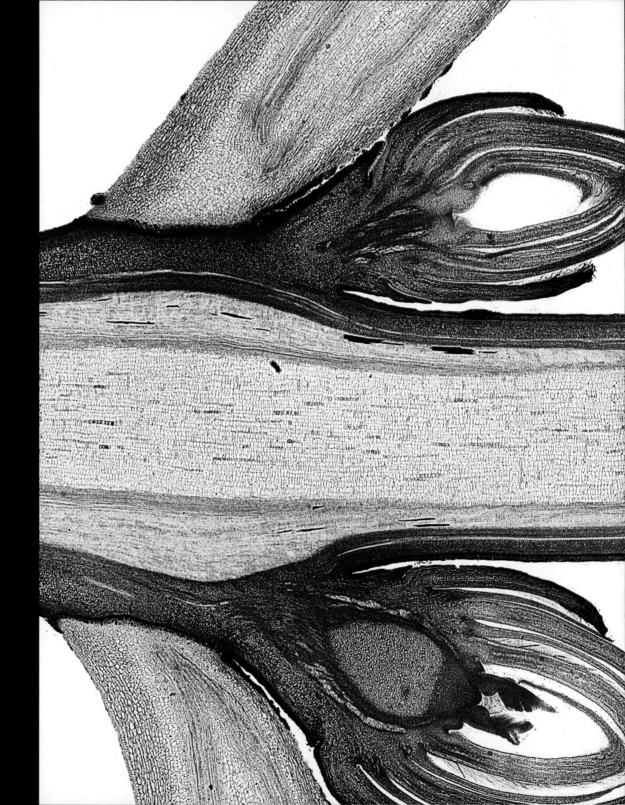

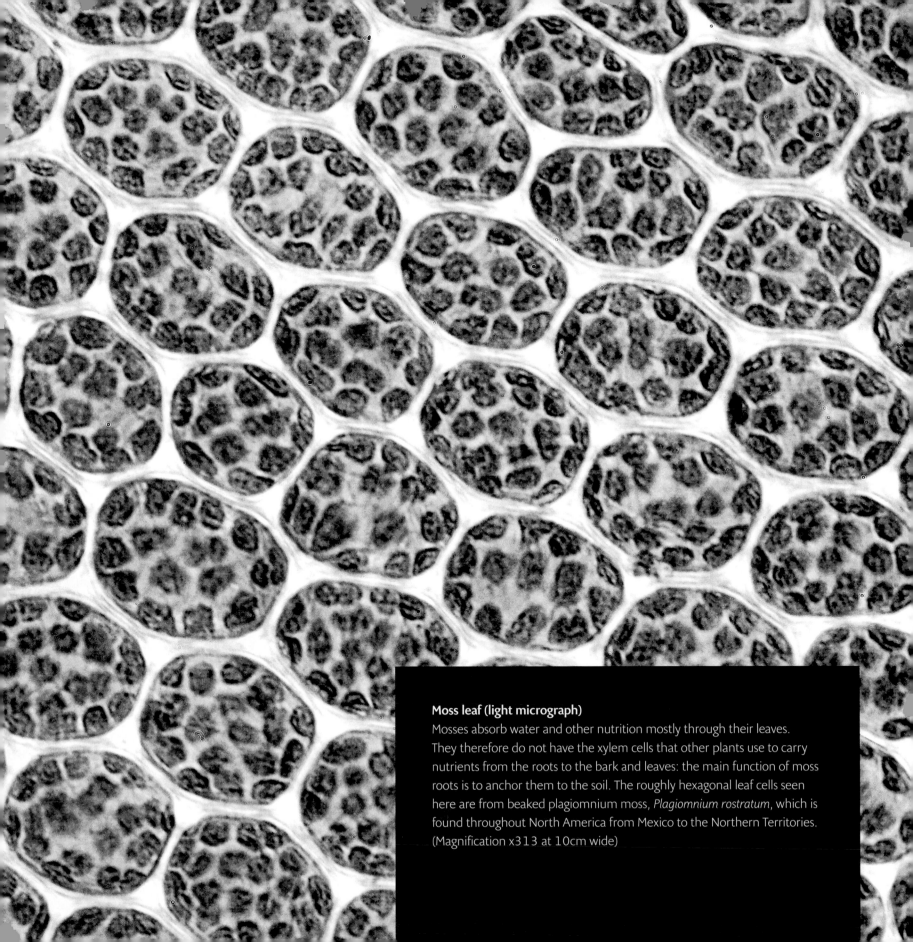

Moss leaf (light micrograph)

Mosses absorb water and other nutrition mostly through their leaves. They therefore do not have the xylem cells that other plants use to carry nutrients from the roots to the bark and leaves: the main function of moss roots is to anchor them to the soil. The roughly hexagonal leaf cells seen here are from beaked plagiomnium moss, *Plagiomnium rostratum*, which is found throughout North America from Mexico to the Northern Territories. (Magnification x313 at 10cm wide)

Left: Sphagnum moss (light micrograph)
These are leaves clustered around the stem of one of 380 species of sphagnum moss. Like other mosses, sphagnum can hold around twenty times its weight in water. It does this by having two kinds of leaf cell: smaller, green, living cells concentrate on photosynthesis while larger, clear, dead cells catch the water. Sphagnum, also known as peat moss, is important in the formation of bogs, a habitat for other specialized plants. Former bogs are a major source of peat.
(Magnification x100 at 10cm wide)

Right: *Ammophila arenaria* leaf (light micrograph)
Ammophila arenaria, or marram grass (here in cross section) is a stabilizing native of north European coastal dunes. Without it the dunes would drift over areas of human occupation such as fields and buildings. In drying winds, on quick-draining sand, the long leaf conserves moisture by rolling in on itself to form a spiky protective tube lined with hairs (bottom left) that slow the passage of the wind through it. The outer surface (top right) is waxed and thick-walled. A column of xylem cells (here red) supplies nutrition throughout the leaf.
(Magnification x138 at 10cm wide)

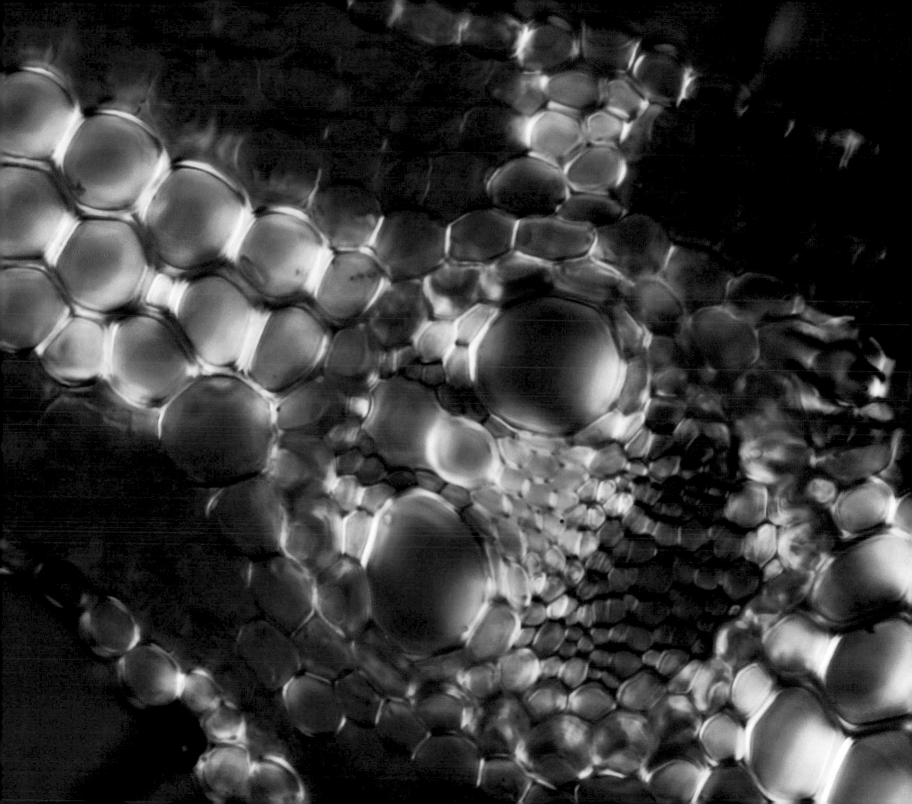

Trichomes (scanning electron micrograph)

These are the soft hairs (trichomes) from which a native of Mexico and the southwestern United States, gets its name – the flannelbush. Plants have developed trichomes for many functions: for example protection from harsh conditions, or the secretion of essential oils. Some deter predating animals, by taste, texture or sting (like the nettle). Trichomes can be crucial in differentiating similar species, and a rich botanical vocabulary exists to describe them – for example hispid (bristly); puberulent (fine and downy); or strigose (all pointing in the same direction).

(Magnification x100 at 10cm wide)

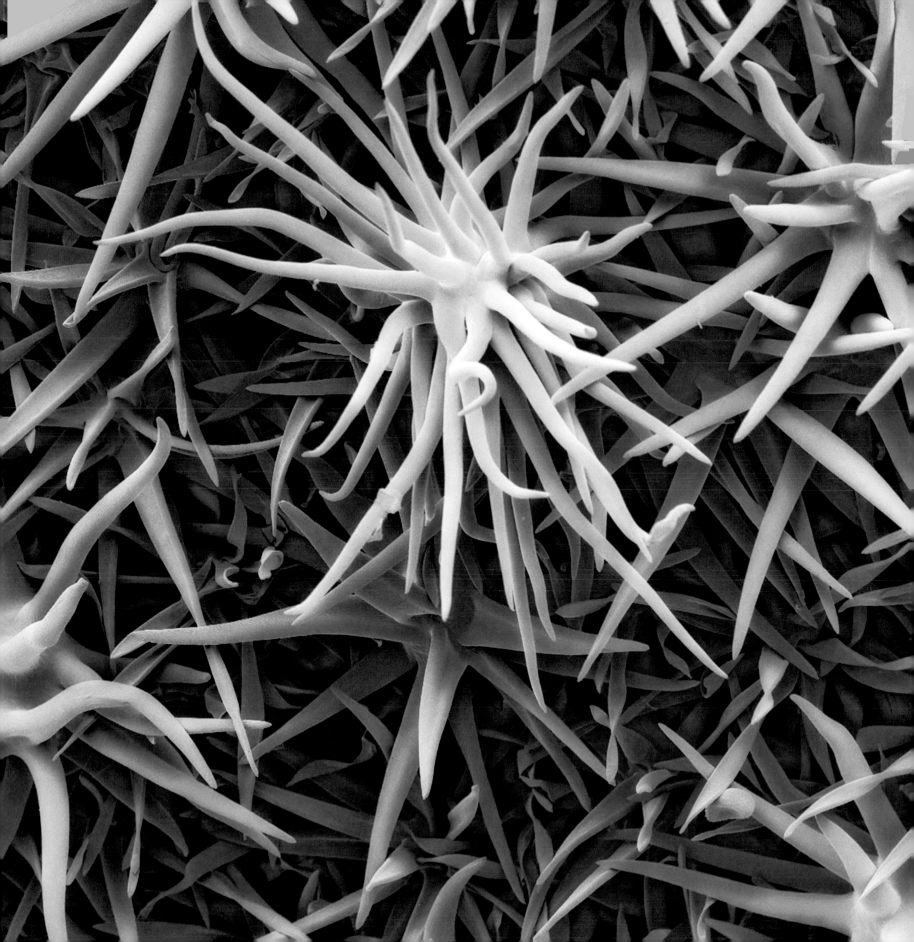

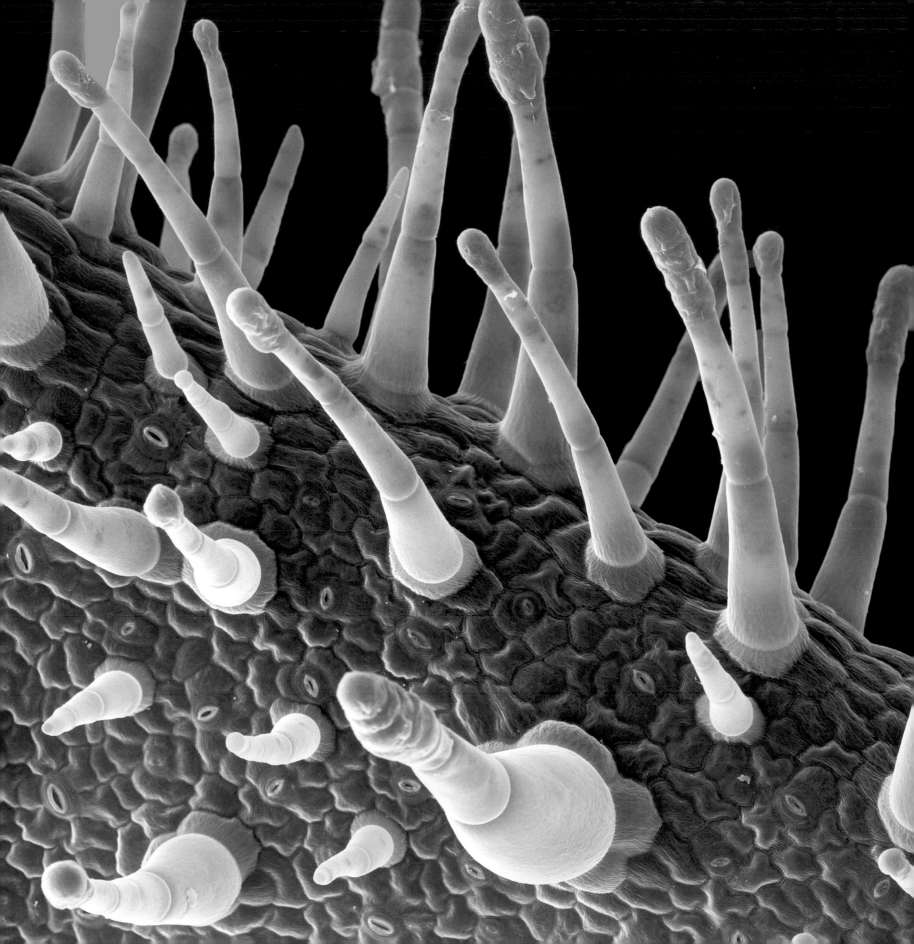

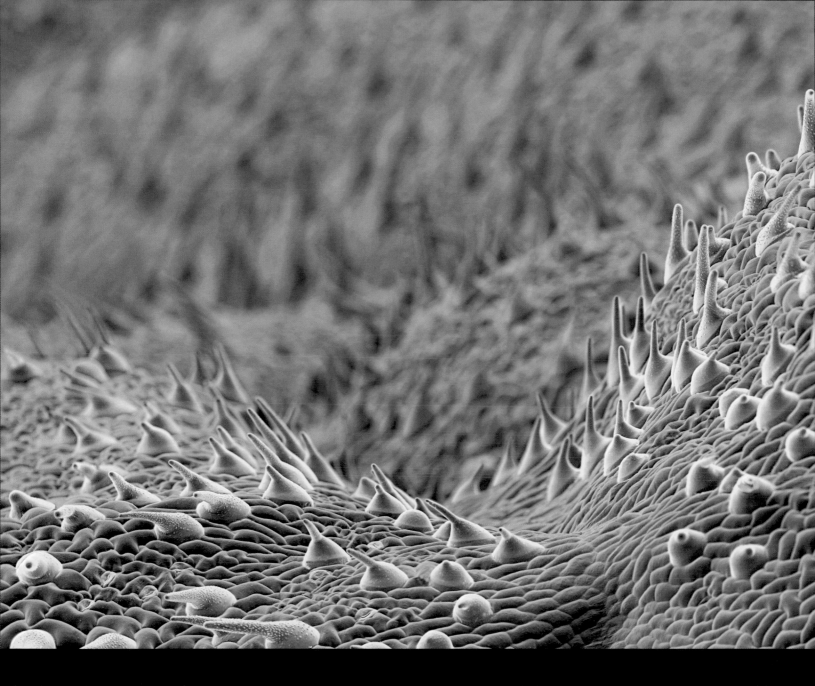

Left: Tobacco (*Nicotiana alata*) leaf (scanning electron micrograph)
The hairs (trichomes) on the upper side of a tobacco leaf are glands that
secrete a foul-tasting chemical intended to deter pests. Chemicals released
by such glands are called terpenoids and the pleasant ones are widely used
in aromatherapy. Besides scent, terpenoids may also contribute to flavour
and colour. They are found in all living things. Tobacco-family trichomes
release large quantities of diterpenoids, complex compounds of interest to
bio-engineers in the food and vitamin industries.
(Magnification unknown)

Above: Cannabis leaf trichomes (scanning electron micrograph)
Cannabis resin (tetrahydrocannabinol) is produced by the glandular hairs
(trichomes, here yellow) on the leaves of the plant Cannabis sativa, the
green cells in this image. Those using the plant recreationally will know
that hash comes from this resin, while marihuana is made from the leaves
and flowers. The earliest known use of hemp (a variety of *Cannabis sativa*)
was some 10,000 years ago and it reached Arabia in around AD 900 –
the word 'hashish' is the Arabic word for grass.
(Magnification x40 at 10cm wide)

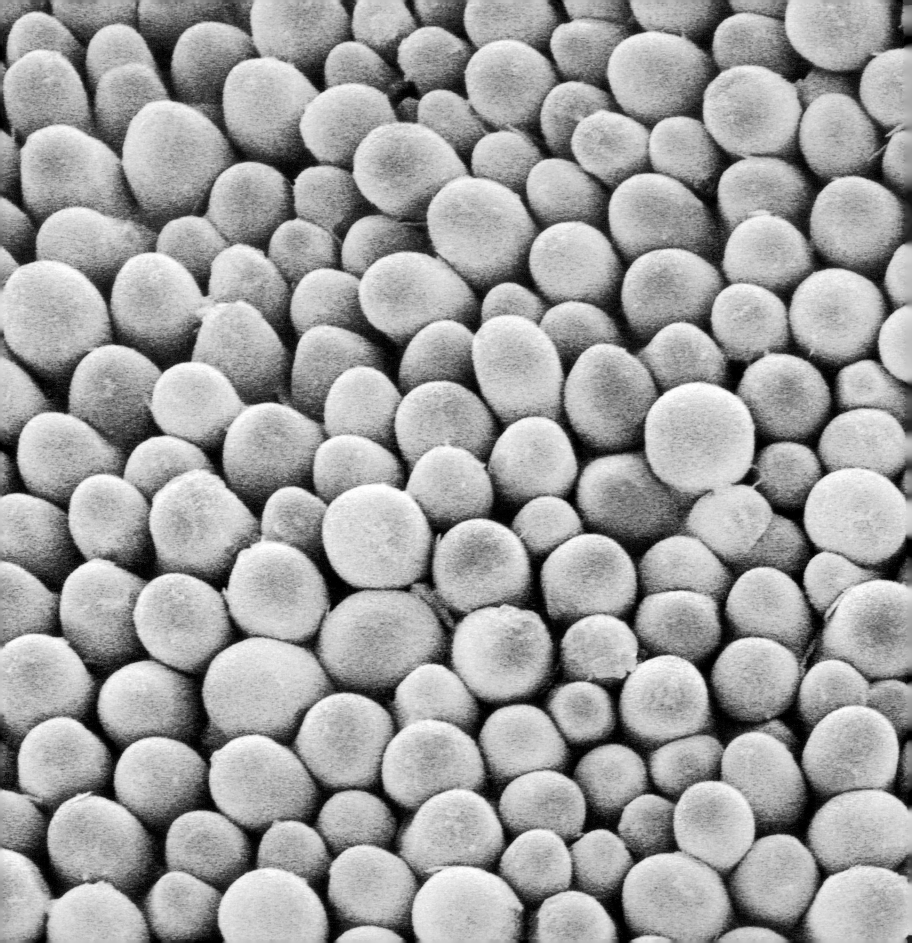

Flowers

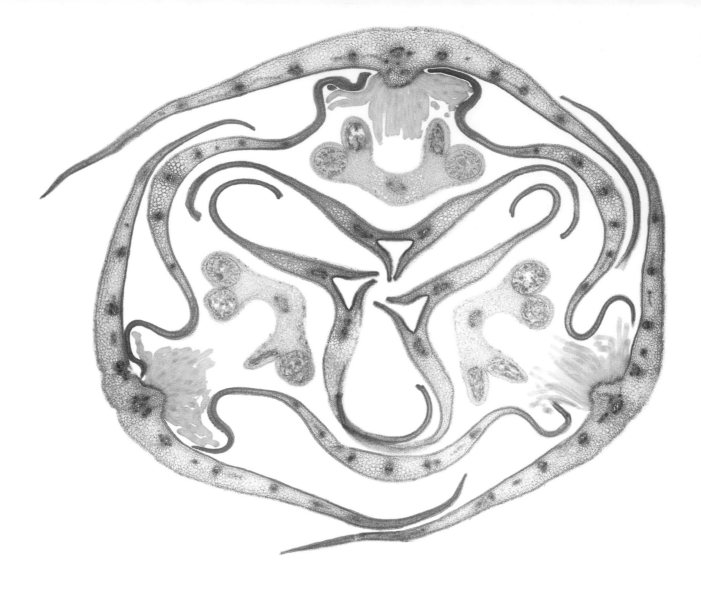

Previous page: Rape flower petal (scanning electron micrograph)

Plants draw nourishment from their roots and leaves, but it is vital for the future of the species that they successfully seed the next generation. To do this they must pollinate. The infinite variety of flowers is nature's way of competing for the attention of pollinator bees, birds or animals. This image is a detail of the petal of rape (from *rapum*, the Latin for turnip). Fields of rape, grown commercially for the oil in its seeds, form vast yellow blankets found dotted around the countryside.
(Magnification unknown)

Above: Iris bud (light micrograph)

Sepals are the leaves at the base of a flower, but some sepals have evolved to resemble and amplify the petals above them. In this cross section of an iris bud, the inner propeller-like shape is made by the three central petals. The outer ring of three sepals will act as landing platforms for pollinating insects attracted by their 'beards' (here yellow). Arriving insects brush against the pollen-producing anthers (brown) and carry the pollen to the next iris that they visit.
(Magnification x22 at 10cm wide)

Right: Passion flower bud (light micrograph)

Spanish Christian missionaries used the passion flower to illustrate the suffering of Jesus, hence its name. In this cross section of a bud, for example, the double ring of small discs within the five petals will become the characteristic radiating filaments of the flower, said to represent the crown of thorns. The five anthers (the large four-lobed structures) are the five wounds that Jesus received, while at the centre the three sets of stigmas are the three nails that held him to the cross.
(Magnification x8 at 10cm wide)

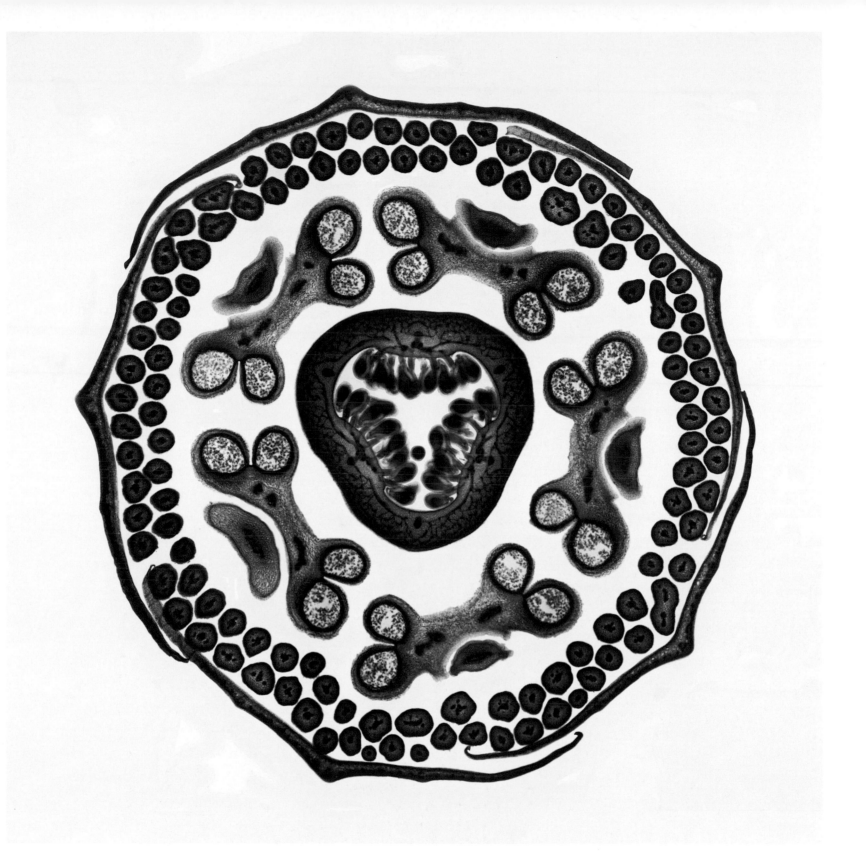

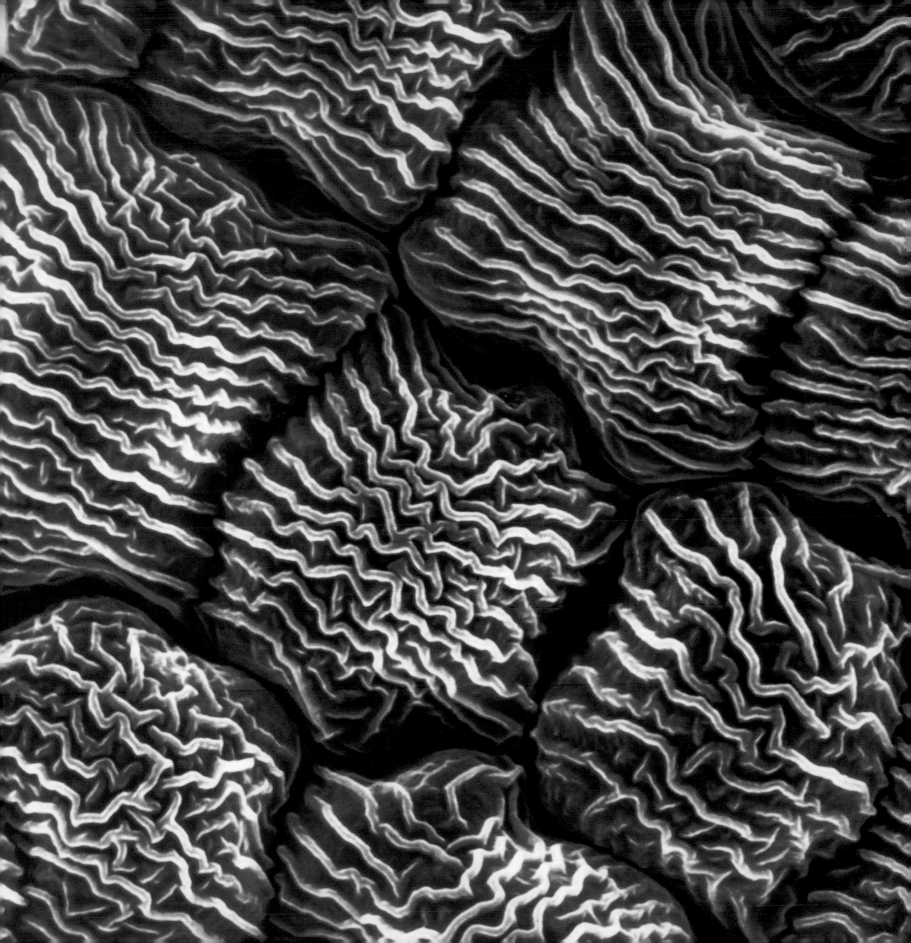

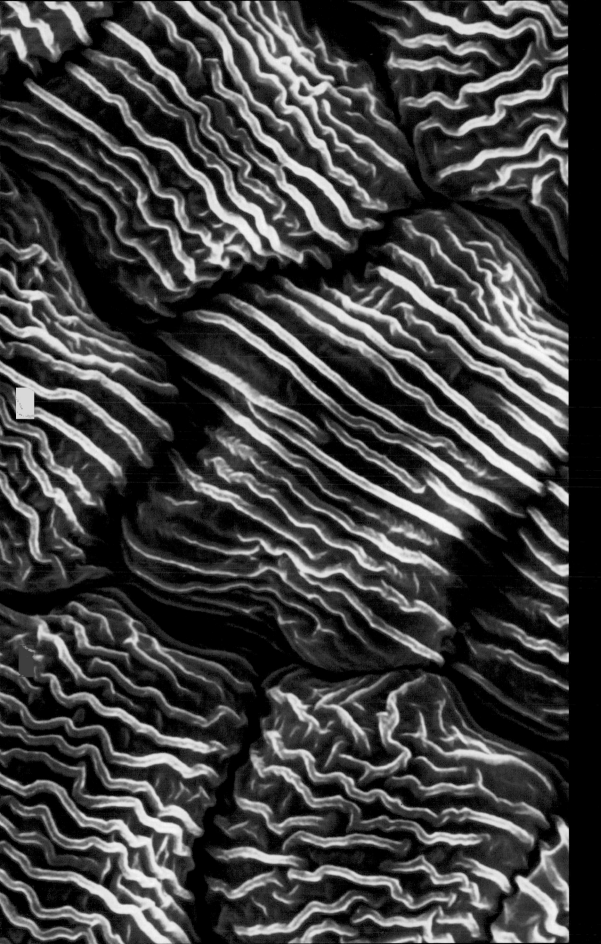

**Left: Wild mustard petal
(scanning electron micrograph)**
This colour-enhanced image shows the
complex structure of the surface of a wild
mustard petal. The sections are called pap
and they limit moisture loss, which would
wither the delicate petal. The flower uses
this display to attract the bees and flies on
which it relies for pollination. After pollina
it produces long thin seed pods that are
poisonous to animals but not birds, which
therefore the plant's primary distributors.
(Magnification x470 and 2.5cm tall)

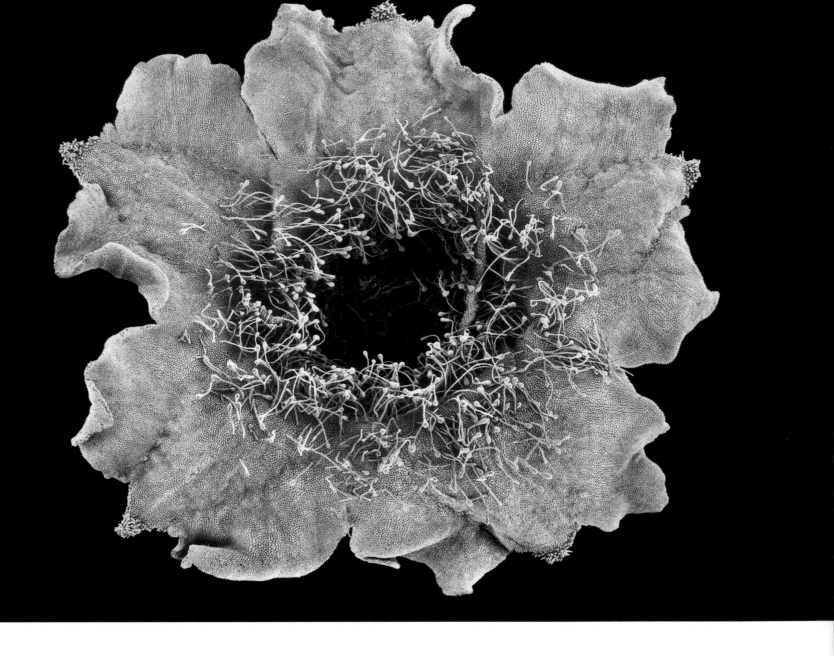

Above: Chinese fever vine flower (scanning electron micrograph)

Flowers use both appearance and scent to attract pollinators. This beautiful blossom adopts a dual approach, which attracts flies but perhaps not humans: its Latin name is *Paederia foetida* and the *Paederia* family are nicknamed sewer vines. Its stems and leaves emit a noxious sulphurous smell when crushed. Despite this it is used as a spice in northeastern India, and – as its common name suggests – in Chinese folk medicine. It's also called skunk vine.

(Magnification unknown)

Right: Suckling clover (scanning electron micrograph)

A perianth consists of petals (the corolla) and sepals (the calyx). Both petals and sepals are modified leaves. In this image of a *Trifolium dubium* clover flower head, you can see that it is actually composed of many small flowers, called florets. Each corolla of sharp creamy petals is sheathed in its own green calyx. *Trifolium* means three-leaved, and this species is the model for the three-lobed Irish shamrock. Mutant *Trifolium*s occasionally produce four-part leaves, the lucky four-leaved clover of folklore.

(Magnification unknown)

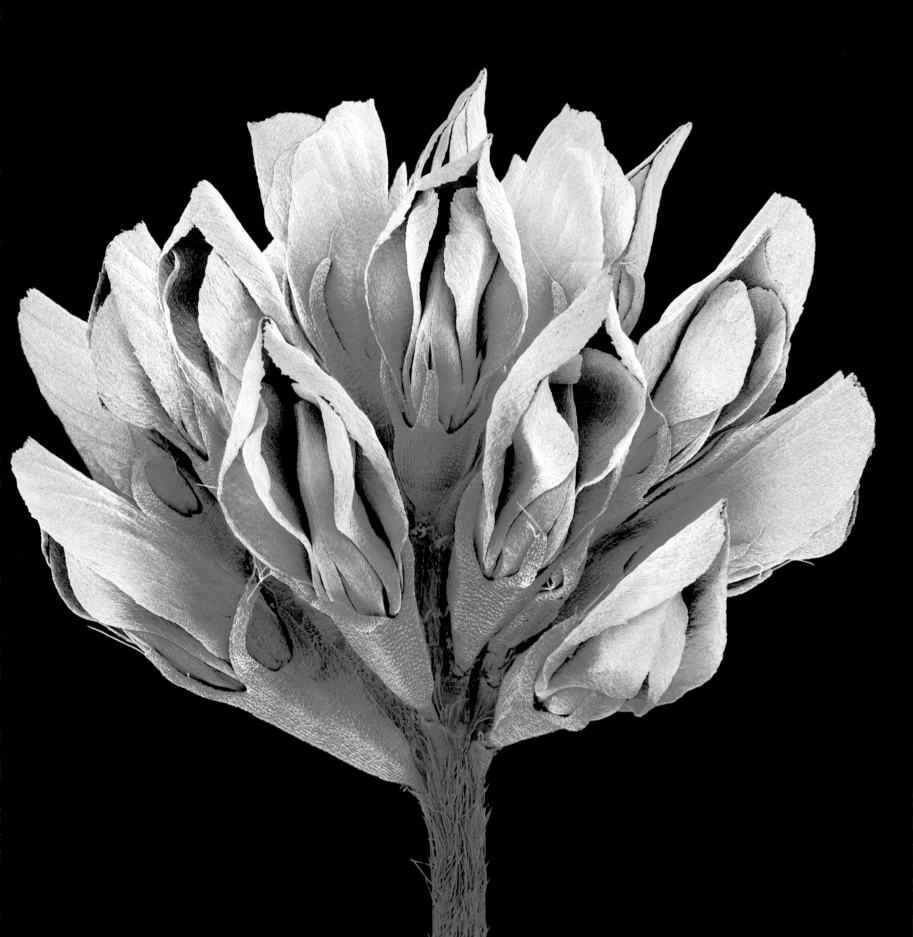

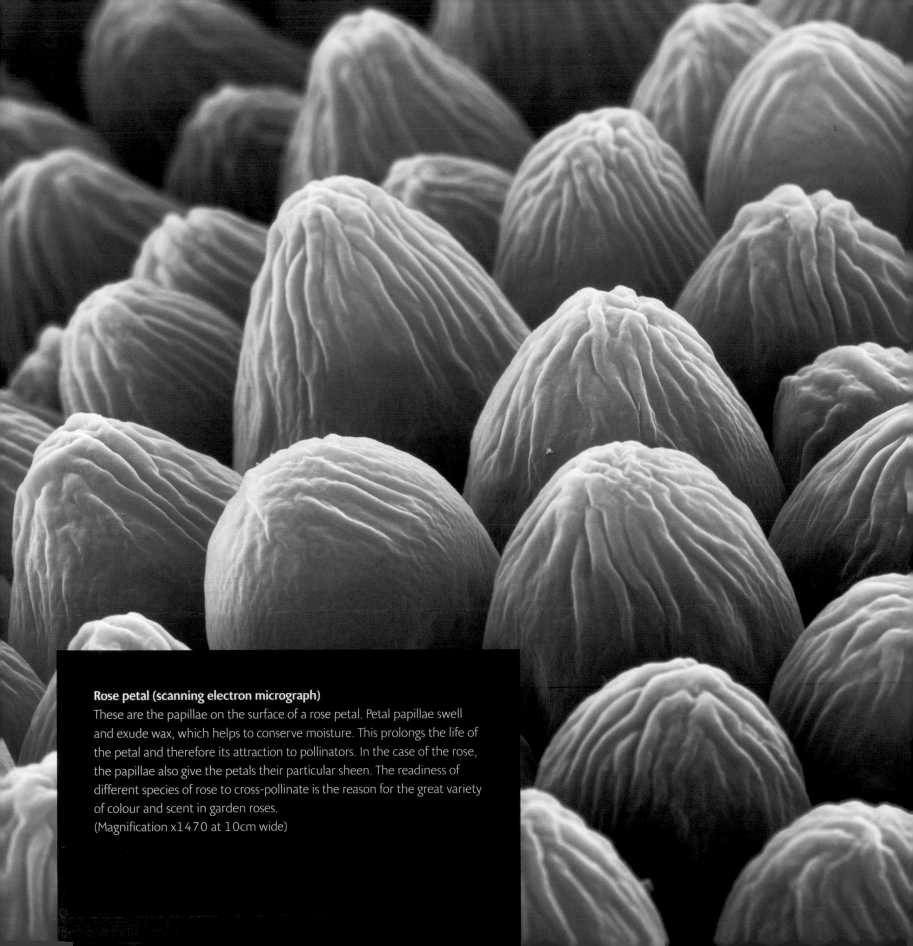

Rose petal (scanning electron micrograph)
These are the papillae on the surface of a rose petal. Petal papillae swell
and exude wax, which helps to conserve moisture. This prolongs the life of
the petal and therefore its attraction to pollinators. In the case of the rose,
the papillae also give the petals their particular sheen. The readiness of
different species of rose to cross-pollinate is the reason for the great variety
of colour and scent in garden roses.
(Magnification x1470 at 10cm wide)

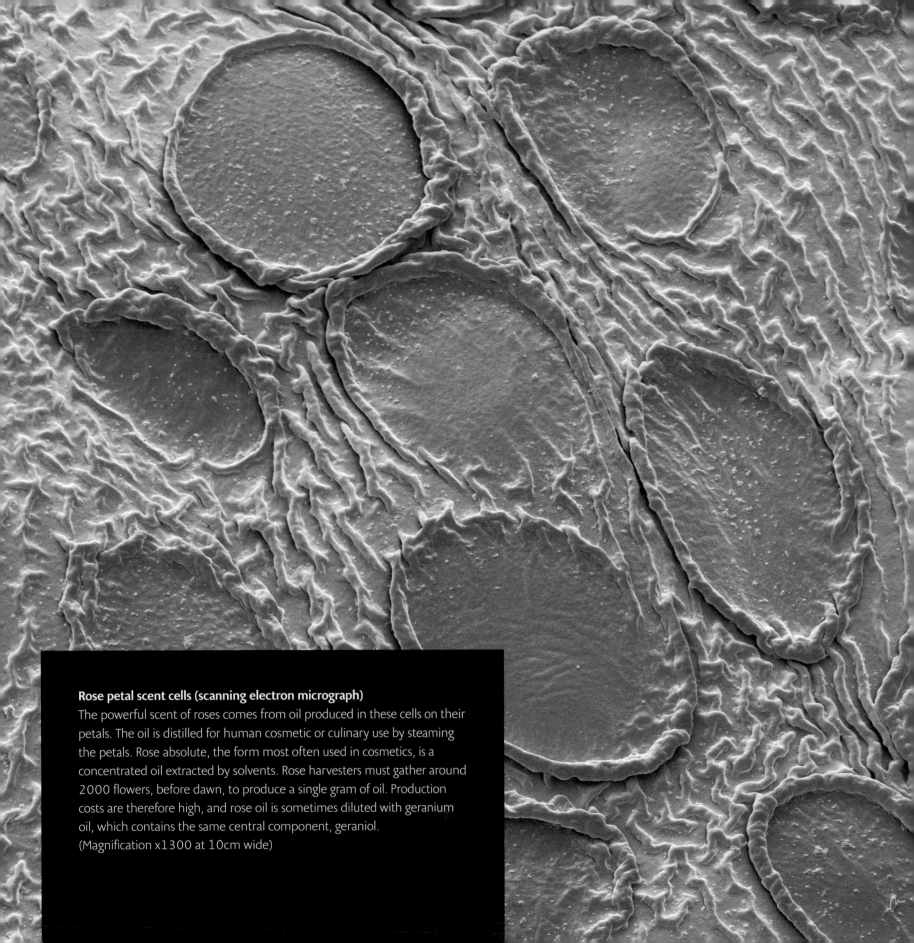

Rose petal scent cells (scanning electron micrograph)
The powerful scent of roses comes from oil produced in these cells on their petals. The oil is distilled for human cosmetic or culinary use by steaming the petals. Rose absolute, the form most often used in cosmetics, is a concentrated oil extracted by solvents. Rose harvesters must gather around 2000 flowers, before dawn, to produce a single gram of oil. Production costs are therefore high, and rose oil is sometimes diluted with geranium oil, which contains the same central component, geraniol.
(Magnification x1300 at 10cm wide)

Orchid petal (scanning electron micrograph)

The flower of the *Phalaenopsis* family of orchids is supposed to resemble a moth in flight, hence its common name the moth orchid, and its Latin name, which means 'moth-like'. This detail of a petal shows a pore (stomata) on the left, an aperture that controls water and gas levels within the flower. It serves the same purpose as similar structures on leaves, evidence that petals are modified leaves that have evolved to support reproduction instead of photosynthesis.
(Magnification x425 at 7cm wide)

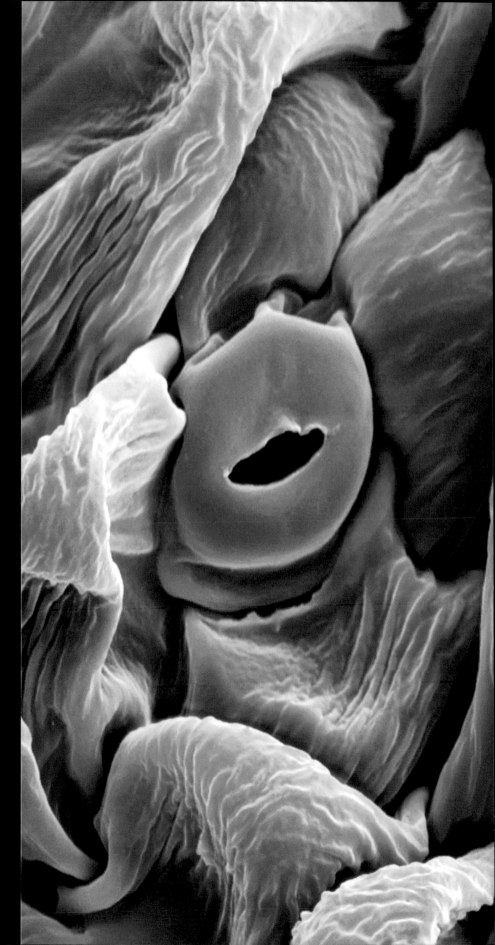

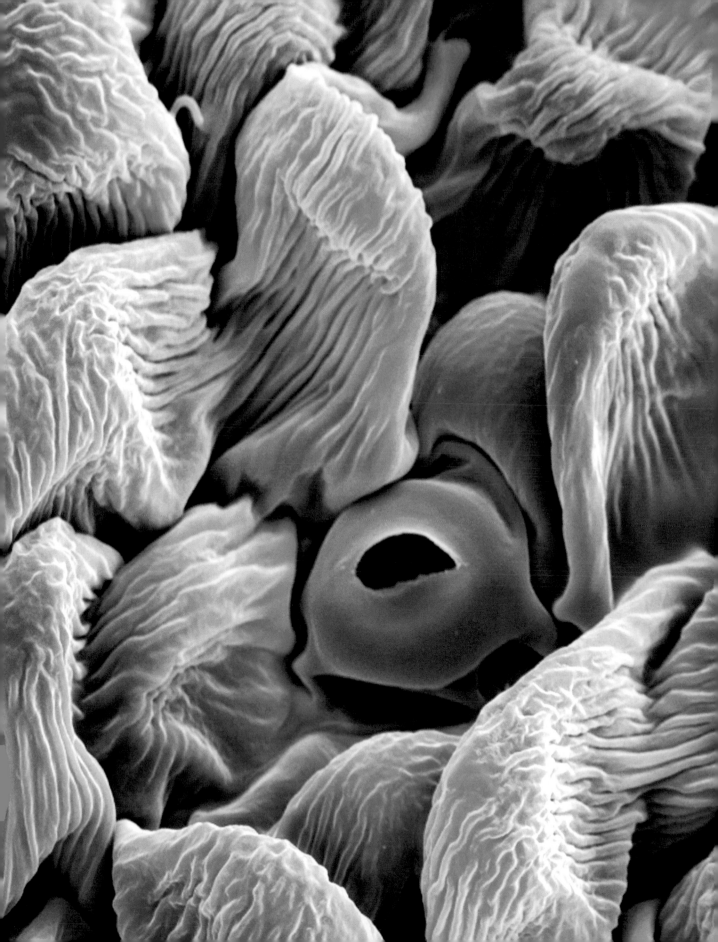

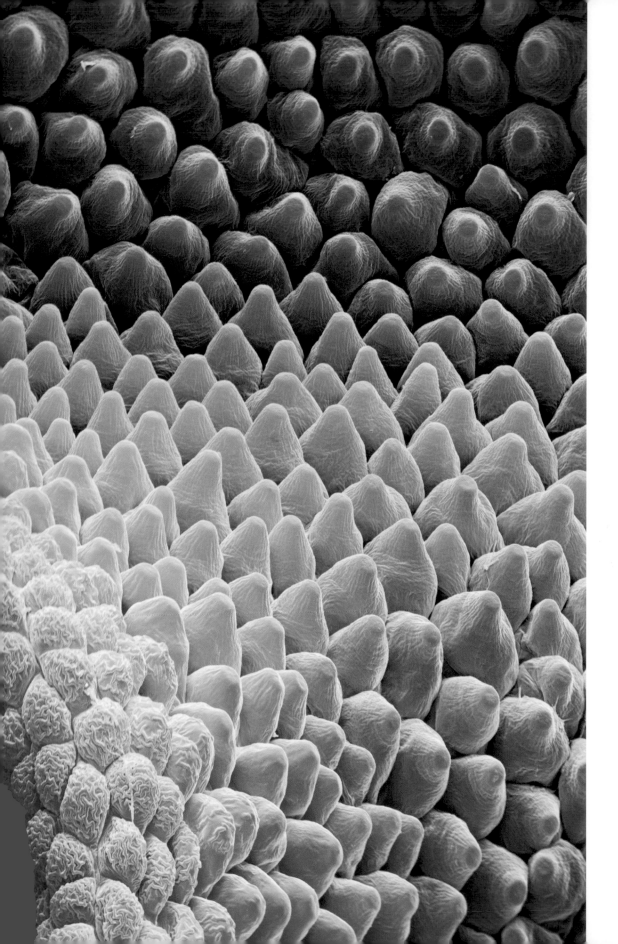

Left: Water mint flower cells
(scanning electron micrograph)
This is the surface of a water mint petal, one of many that make up the hemispherical flower head, packed with tiny florets. While many plants have adapted to attract specific specialized pollinators, the water mint is pollinated by many insects. This can be an advantage in local ecologies where individual insect species are subject to significant fluctuations in population; a plant that relies on only one species is at risk in years when its pollinator is in decline.
(Magnification x680 at 10cm tall)

Right: Valerian petal
(scanning electron micrograph)
These irregular hexagonal cells are the pimples (papillae) on the surface of a valerian petal. Valerian grows wild with pink or white flowers; the red garden variety is a distant relative. It is often a component of herbal sleep remedies, having been used for its calming, sedative properties for at least 2500 years. The remedy is prepared from the roots. The flowers have such a sweet fragrance that they have been used in the past as a perfume.
(Magnification x300 at 10cm wide)

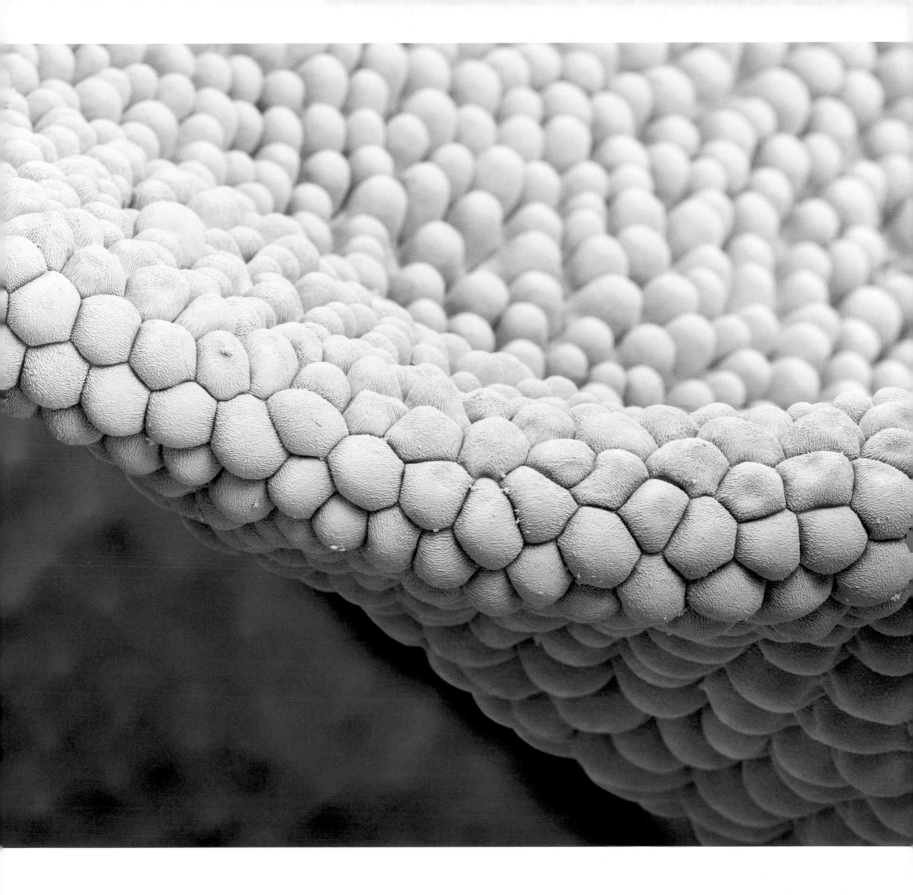

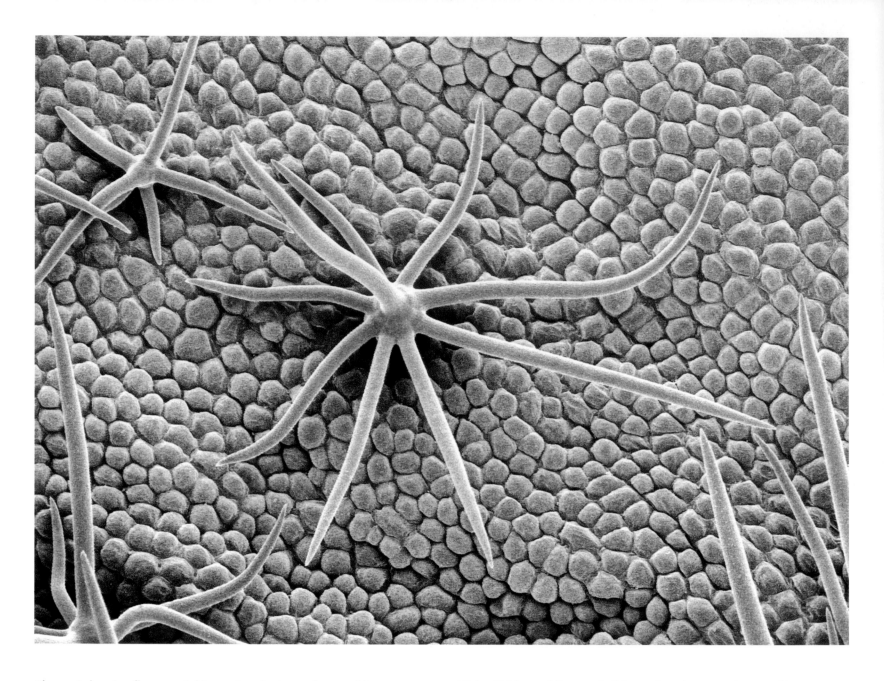

Above: Aubergine flower petal (scanning electron micrograph)
These hair-like clusters (trichomes) on the surface of aubergine (eggplant)
petals give shade, helping to reduce moisture loss in warm weather, and
to form a barrier against frost to which the aubergine plant is susceptible.
The flowers, leaves and roots contain a natural pesticide, solanine, which
defends the plant against predators but which is also toxic to humans.
The fruit of the aubergine is technically a berry and contains its seeds. The
seeds taste of tobacco, to which the plant is related.
(Magnification unknown)

Right: Chickweed flower pistil (scanning electron micrograph)
This, computer-enhanced, is the stigma surrounding the column (style) of
the female reproductive organ (pistil) in the chickweed flower. The stigma
traps chickweed pollen ,which then enters the style and makes its way to
the egg chamber (ovary). The ovary is lined with eggs (ovules) and once
they have been fertilized, they mature into seeds that are cast as soon as
the flowers set. The seeds germinate in late autumn or winter. Chickweed
leaves are edible and used in salad.
(Magnification unknown)

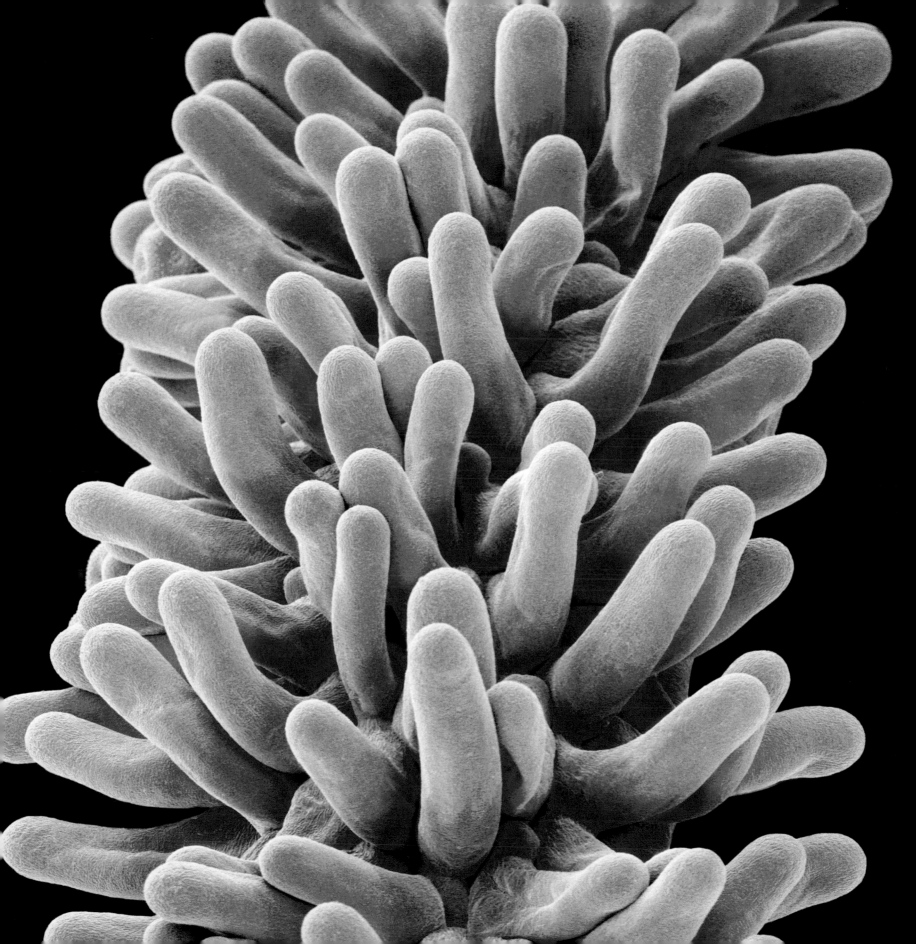

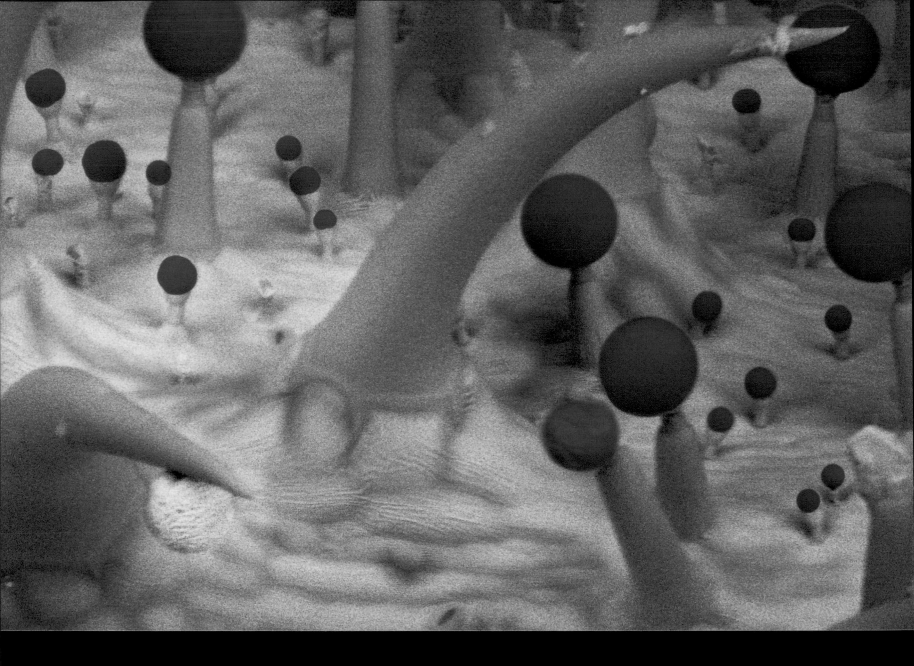

Above: Scented geranium leaf (scanning electron micrograph)
Cross-pollination between different species has given us the wide range
of scented geraniums available today. Scented geraniums are, you may
be surprised to learn, not geraniums but pelargoniums – the two families
were redefined in the eighteenth century, having originally all been classed
as geraniums. This is a close-up of the leaf of a lemon-scented geranium.
The red spheres on some hairs (trichomes) are glands that secrete a
scented oil. The scent discourages grazing livestock and attracts pollinators.
The yellow sphere is a grain of pollen.
(Magnification x136 at 10cm wide)

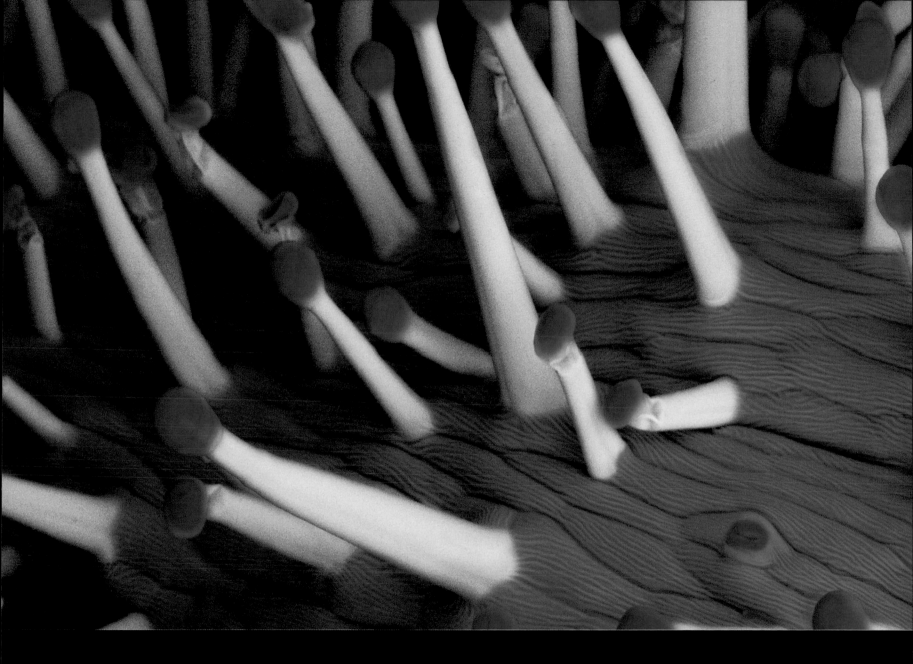

Above: *Diascia vigilis* **(scanning electron micrograph)**

The *Diascia* family are a common sight in gardens. The low-growing plant forms a cushion of pink flowers in a variety of shades. They may appear two-coloured because of the presence of these oil-producing spherical glands on the petals. More oil is stored in two unusual spurs behind the flower (whose common name is twinspur). The *Rediviva* family of bees has evolved to gather this oil by developing unusually long front legs. The spurs vary in length between *Diascia* species and so do the legs of the individual *Rediviva* species adapted to harvest from them.

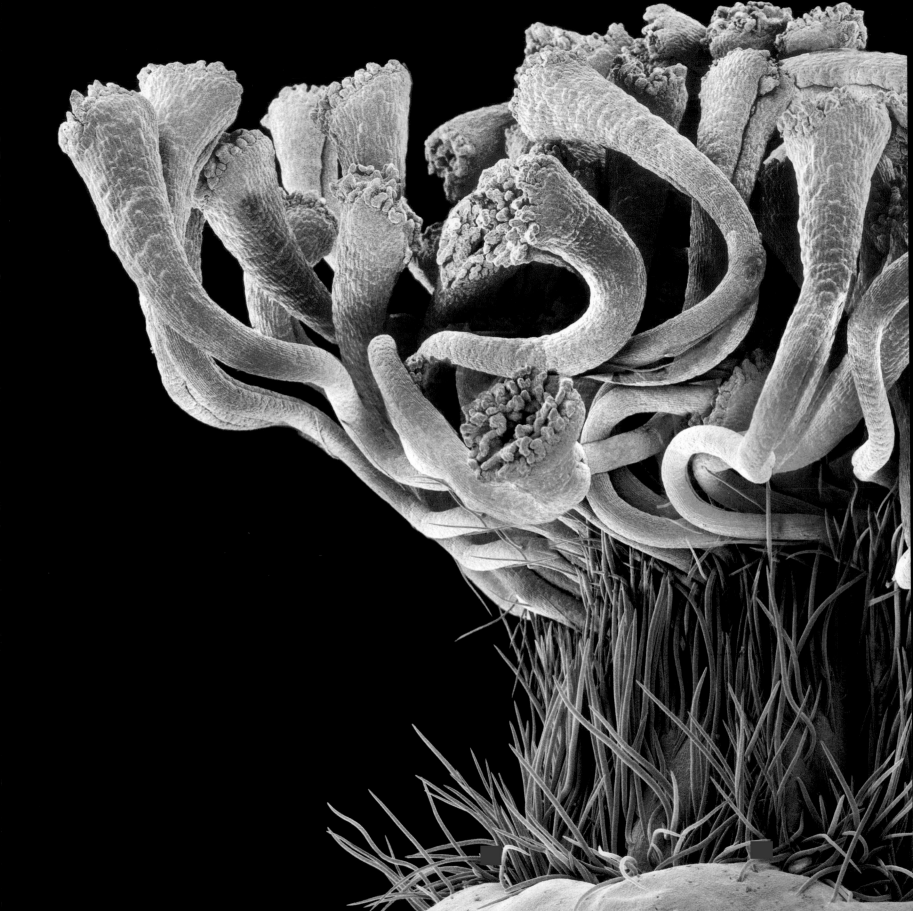

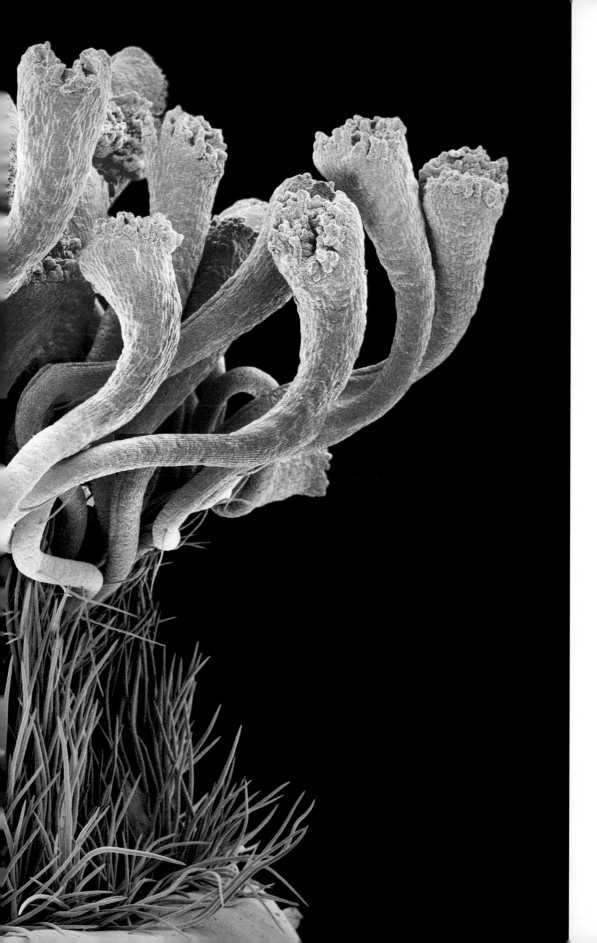

Rose pistil (scanning electron micrograph)
Stripped of the petals and an enclosing ring of male reproductive structures (stamens), this is a striking view of the female reproductive system (pistil) of a rose. Below this crown of the stigma waiting to receive sperm-generating pollen, the rose has many ovaries. After fertilization they swell to become rosehips, food for birds, which later disperse the seeds from the hips in their faeces. Most garden roses no longer produce hips because they have been bred to have so many petals that there isn't room for pollinating insects.
(Magnification unknown)

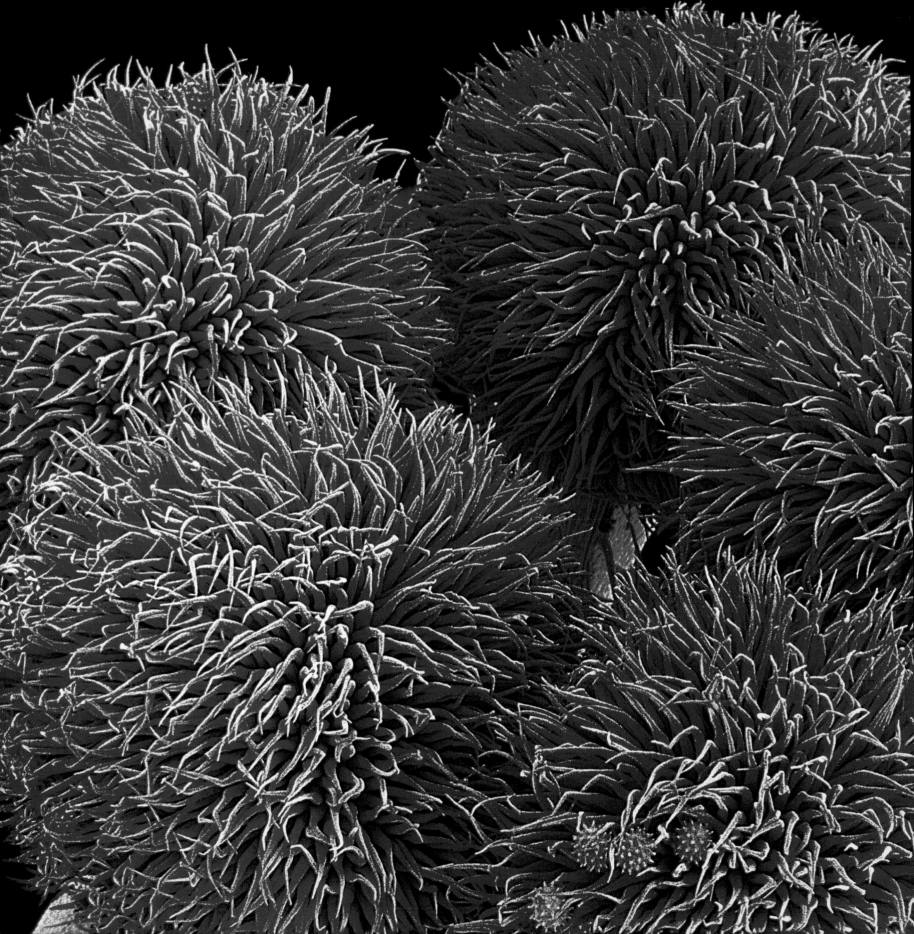

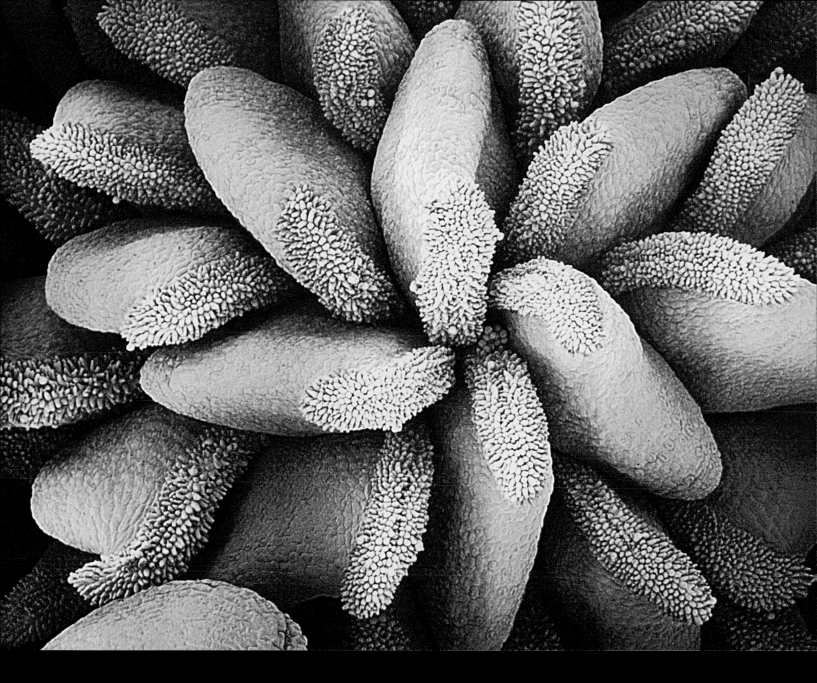

Left: Hibiscus flower pollination (scanning electron micrograph)
These spectacular pompoms are the five sets of stigma in a hibiscus flower. One, at bottom right, has successfully captured some pollen, which will fertilize the egg chamber below. The chamber will develop into a woody five-sided seed pod, which dries out and splits open to release the seed. Hibiscus flowers make a pungent tea infusion, and in many cuisines the plant is used as a souring ingredient. Children in the Philippines crush the flowers and leaves, making a liquid in which to blow bubbles with a straw. (Magnification unknown)

Above: Buttercup flower pistils (scanning electron micrograph)
At the centre of a buttercup flower, each of these tightly packed little yellow 'loaves' is an egg chamber (ovary). The hairs forming a strip on each one are the stigma, ready to catch any passing pollen. Fossilized seeds of a member of the buttercup family have been dated to around 4000 million years ago. The Latin name, *Ranunculus*, means 'little frog'. The plant is toxic to livestock, causing blisters in the mouth and throat. (Magnification x21 at 7cm wide)

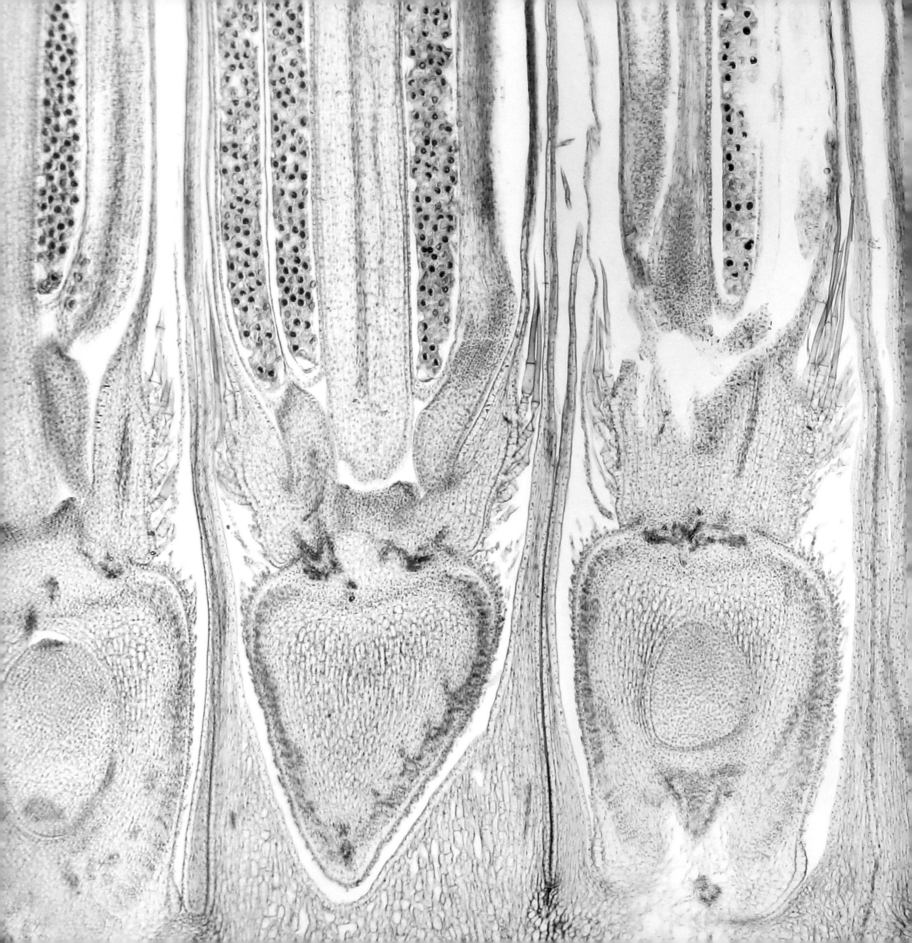

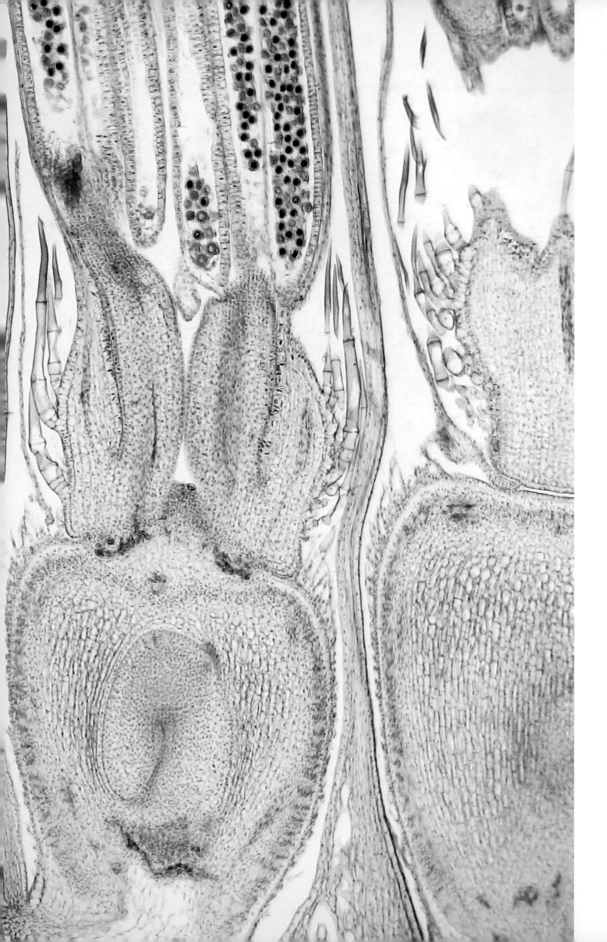

Sunflower ovules (light micrograph)
The roughly triangular chambers at the bottom of this image are individual sunflower eggs (ovules), and in most of them you can see a sunflower seed developing. Centrally above each ovule is the stem (style), which supports the pollen-gathering stigma, and bunched around each style are the flower's elongated pollen producers (anthers), in which the pollen is clearly visible. It is sadly not true that sunflower heads twist to follow the sun throughout the course of a day.
(Magnification x60 at 10cm wide)

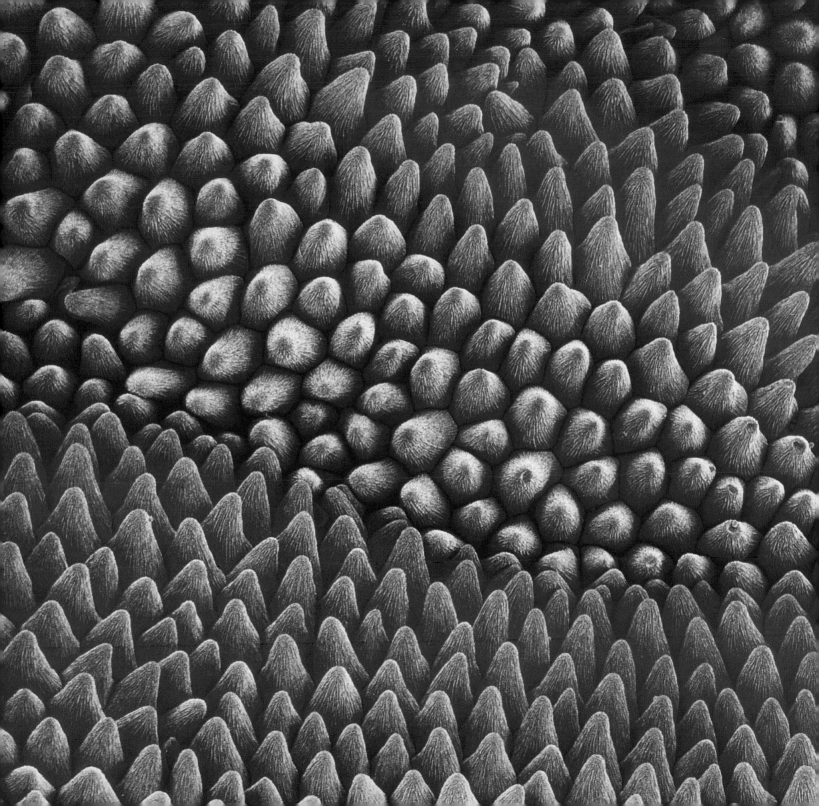

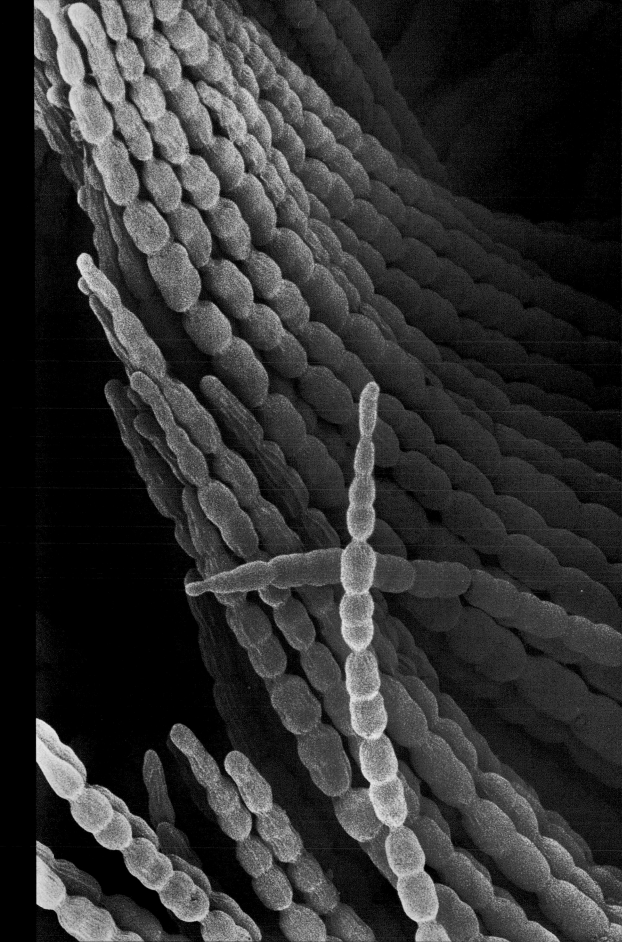

**Left: Pansy petal
(scanning electron micrograph)**

These are the hairs (trichomes) on the surface of a pansy petal. Traditionally pansies were said to represent remembrance, and the flower's English name comes from the French word 'pensée', meaning 'thought'. The Italian name means 'little flame' and in Hungary they call it the Little Orphan. Pansies produce a very distinctive seed head, consisting of three linear pods meeting at the centre like a three-pointed star. Each pod bursts open when the round seeds within have matured.
(Magnification x360 at 7cm wide)

**Right: Periwinkle petal surface
(scanning electron micrograph)**

This dense growth of fine hairs (trichomes) on the petal of a periwinkle is in marked contrast to the plant's leaves, which are smooth and glossy. Two species of periwinkle are popular with gardeners. *Vinca major* and *Vinca minor* form dense mats of low evergreen foliage, punctuated in season with cheerful five-petalled purple flowers. They make useful ground cover, but can invasively stifle other plants – wherever their stems make contact with the soil they will take root.
(Magnification x80 at 6cm wide)

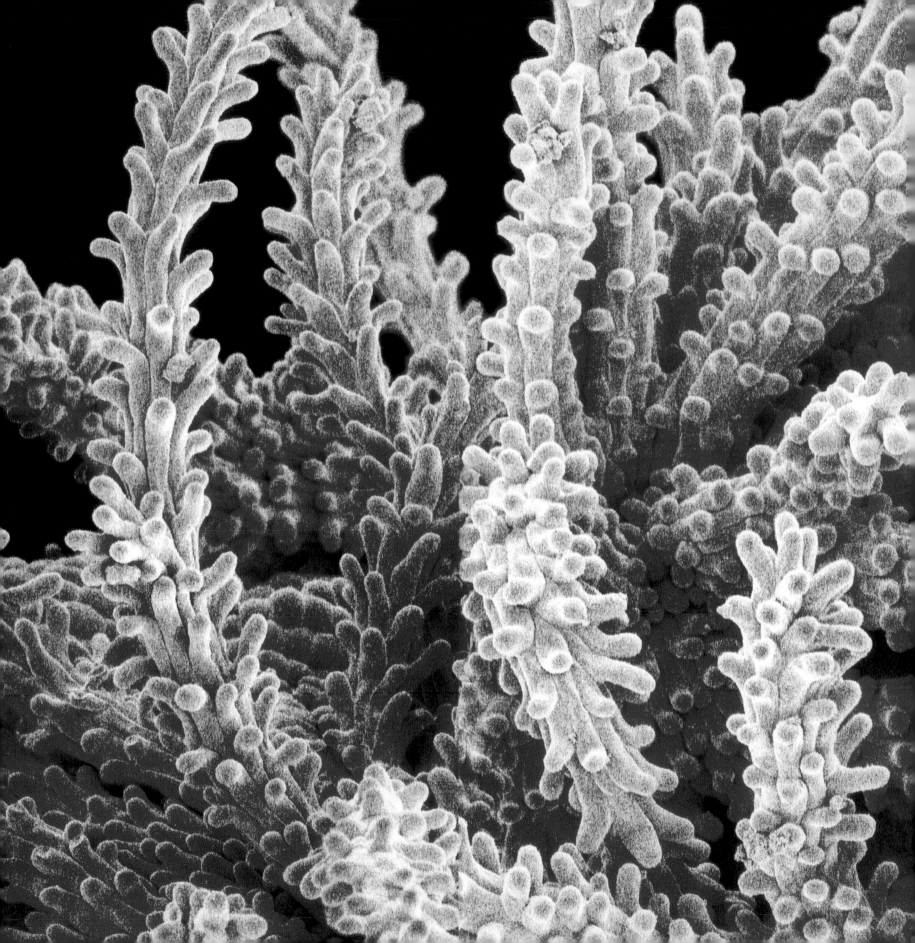

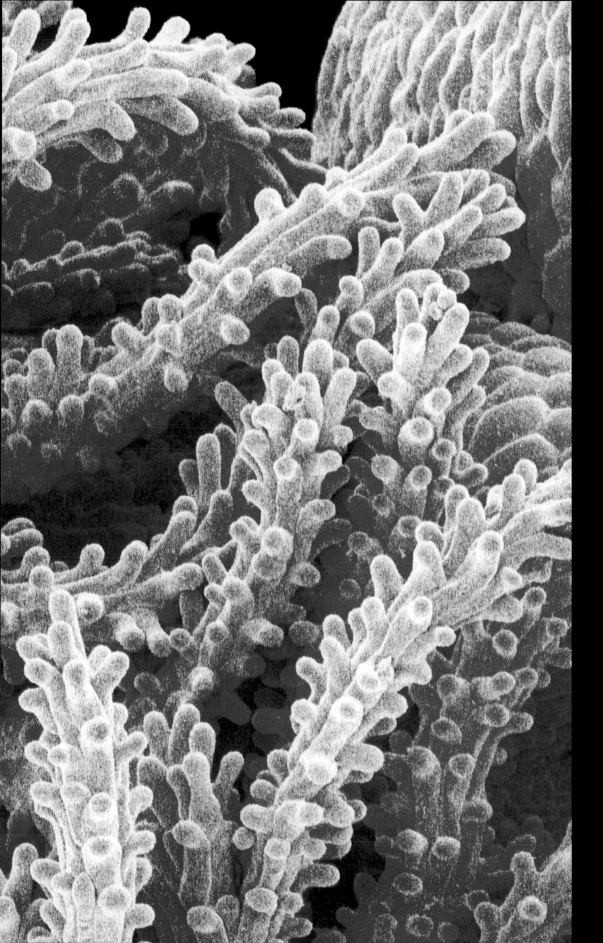

Flower carpels
(scanning electron micrograph)

The female reproductive unit of a flower is called the pistil. A simple pistil consists of one carpel: the stigmas, usually at the top, which catch the male pollen; the style, the column connecting the stigmas to the ovary; and the ovary itself, in which ovules are fertilized by the pollen and become seeds. Sometimes a number of carpels may become fused together at their base, with several styles and their stigmas leading to a single ovary. The result is called a compound pistil.
(Magnification unknown)

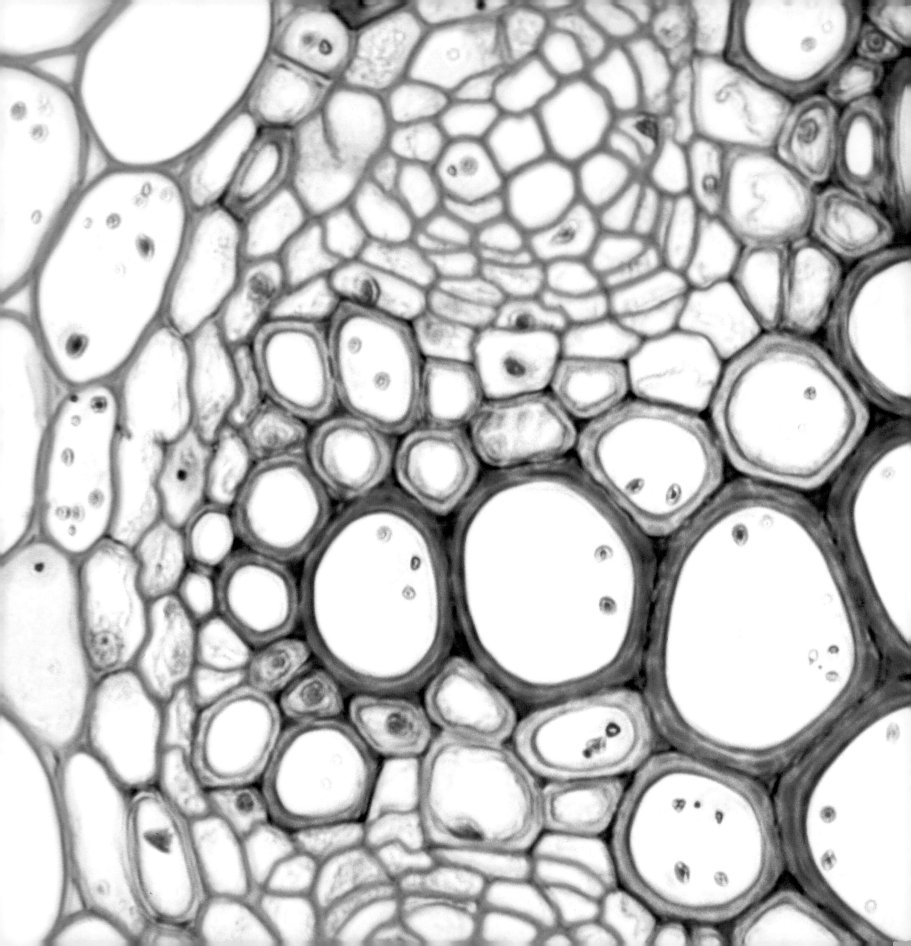

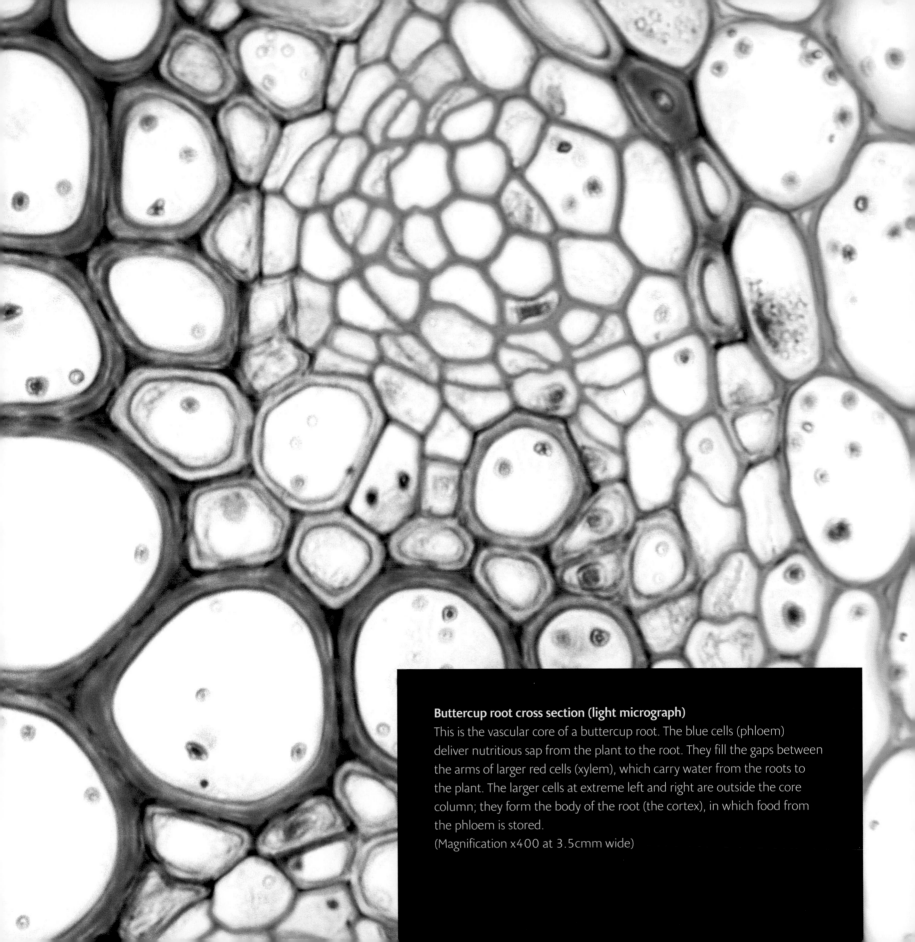

Buttercup root cross section (light micrograph)
This is the vascular core of a buttercup root. The blue cells (phloem) deliver nutritious sap from the plant to the root. They fill the gaps between the arms of larger red cells (xylem), which carry water from the roots to the plant. The larger cells at extreme left and right are outside the core column; they form the body of the root (the cortex), in which food from the phloem is stored.
(Magnification x400 at 3.5cmm wide)

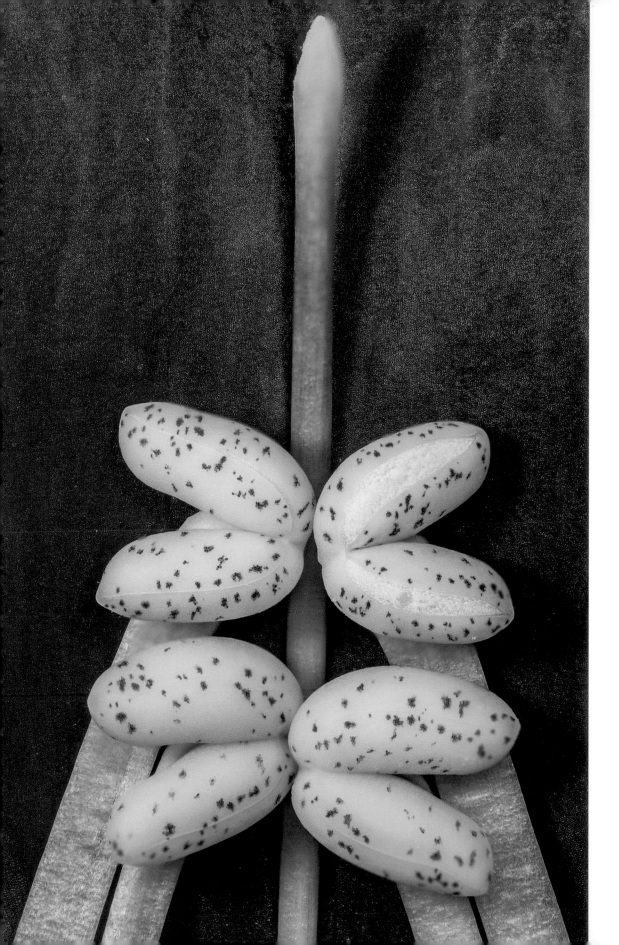

Left: Foxglove reproductive organs (light micrograph)

Most foxgloves are biennial plants, and their purple flowers only appear in the second year of growth. Inside the flowers are these, the plant's reproductive organs. The central stem is the female style, with a stigma at its tip and (out of sight below) the ovary, in which the seeds develop. On either side of the style are two pairs of male anthers on their own stems (called filaments). The anthers contain spores that mature into pollen.
(Magnification x44 at 10cm wide)

Right: Wallflower bud (light micrograph)

This cross section of a young wallflower bud shows the presence of the plant's reproductive organs even at this early stage. The large pink disc at the centre is the pistil, the female organ composed of stigma, style and an ovary. It is surrounded by six four-lobed shapes, the male anthers. The lobes are four sacs within the anther called microsporangia, in which spores divide and become grains of pollen. The tightly packed layers surrounding all these organs are the petals and sepals of the wallflower, wrapped up into a bud.
(Magnification x2.5 at 10cm tall)

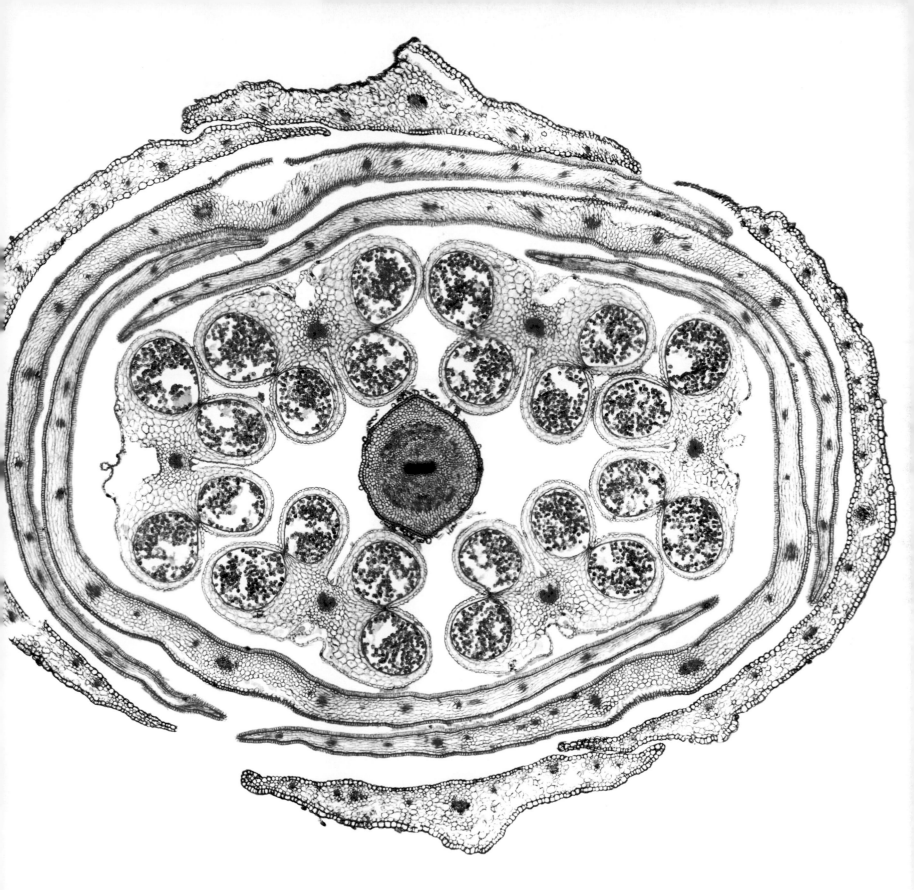

Vegetables

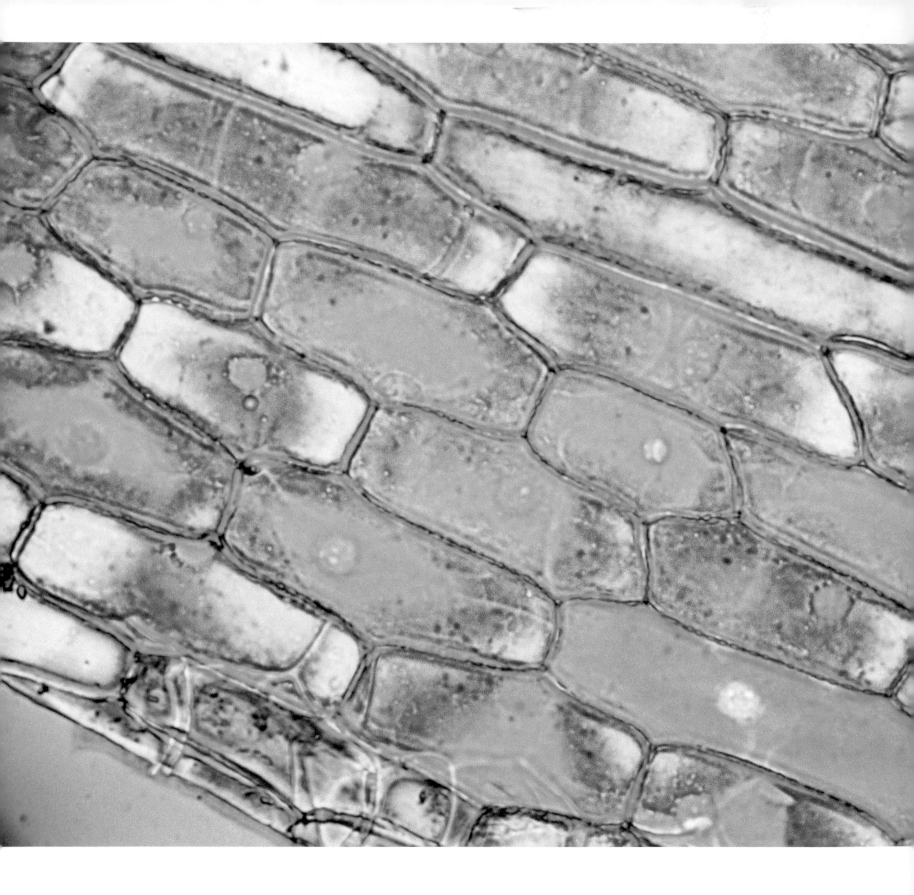

Previous page: Potato starch grains (light micrograph)

Potatoes are native to Peru and Bolivia, where they may have been cultivated for 10,000 years. They only reached Europe in the late sixteenth century following Spanish conquests in South America. Since then potatoes have become a staple of many European cuisines, so central to some diets that a crop failure spelled disaster. These grains of potato starch have found uses not only in the processed food industry but also as wallpaper paste and an element in early colour photography.
(Magnification x120 at 10cm wide)

Left: Epidermal cells of onion bulb (light micrograph)

Onions are part of the large *Allium* family, which also includes leeks, garlic and chives. The layers of an onion, known as scales, are modified leaves. In each of the scale cells shown here the small dot at its centre is its nucleus. The onion's wild origins are unknown, but it has been cultivated for at least 7000 years, probably first in central Asia. Cutting into an onion releases the gas syn-Propanethial-S-oxide, which irritates our eyes, causing them to weep.
(Magnification unknown)

Right: Bell pepper leaf (scanning electron micrograph)

Christopher Columbus is said to have introduced peppers to Europe on his return from the Americas in 1493. They were called peppers because Europeans had been introduced to peppercorns and called all hot spices peppers. Bell peppers come in many colours depending on which variety they are; but red ones are usually just green ones that have been allowed to mature. In this detail of a leaf you can see three leaf pores, the eye-like apertures that regulate the exchange of gases between plant and atmosphere.
(Magnification x757 at 10cm wide)

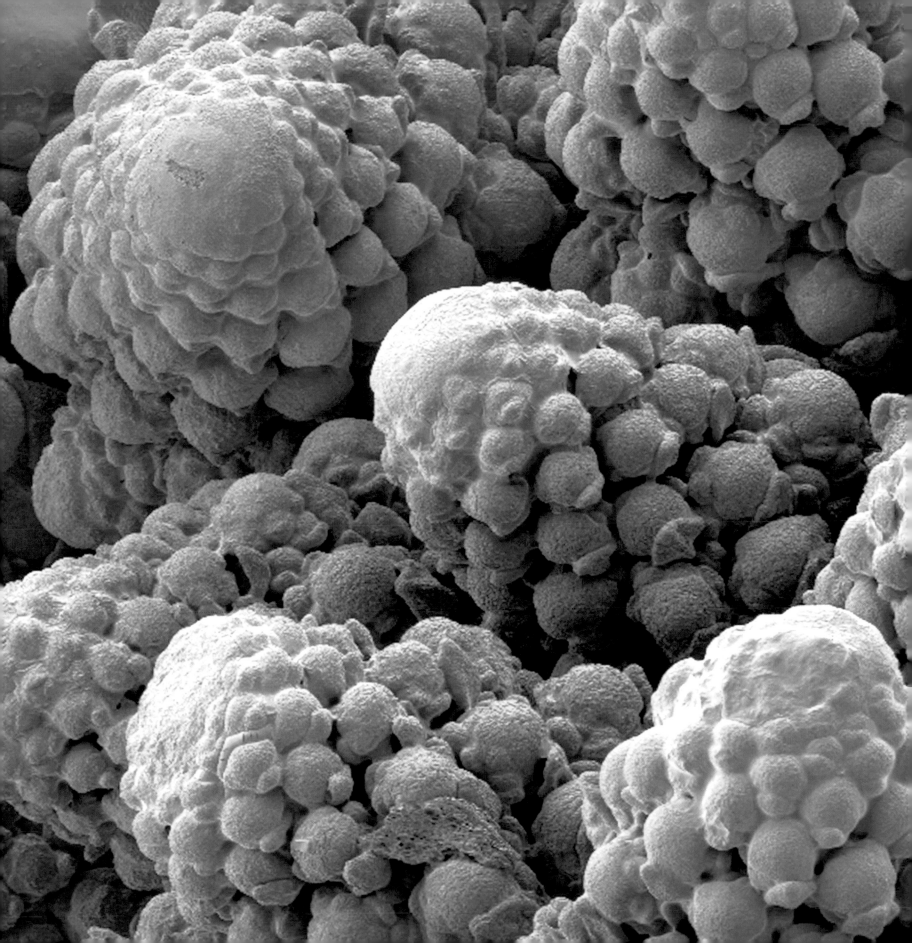

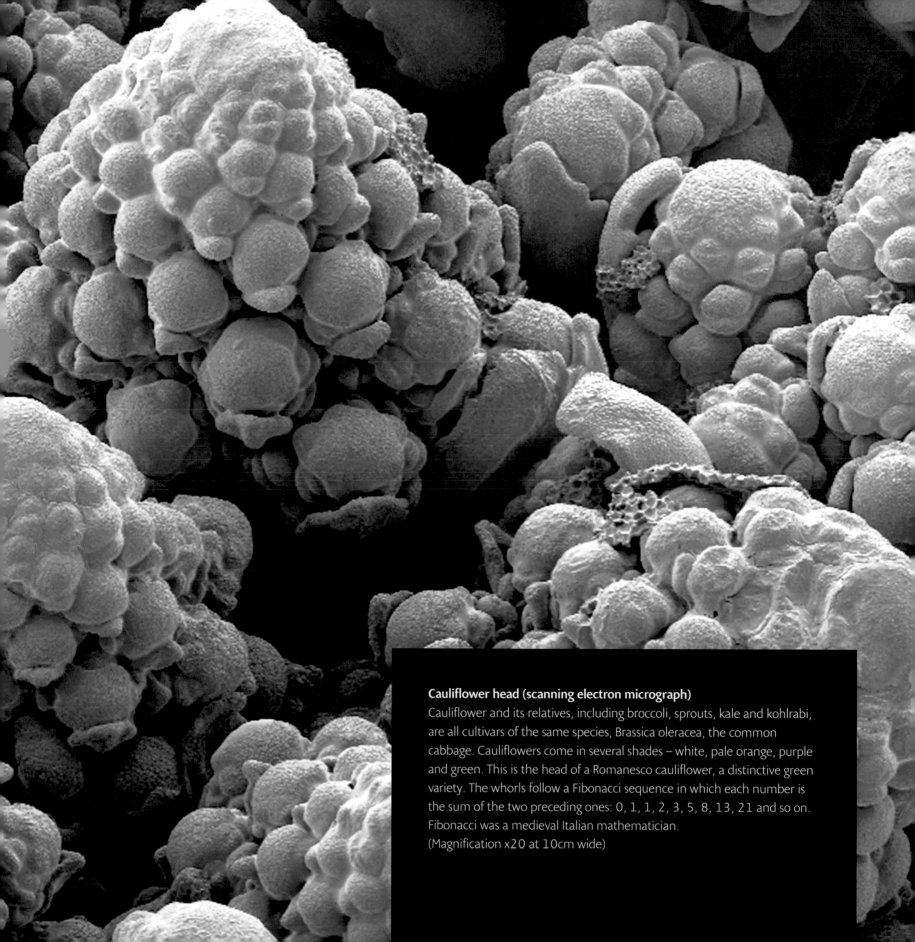

Cauliflower head (scanning electron micrograph)
Cauliflower and its relatives, including broccoli, sprouts, kale and kohlrabi, are all cultivars of the same species, Brassica oleracea, the common cabbage. Cauliflowers come in several shades – white, pale orange, purple and green. This is the head of a Romanesco cauliflower, a distinctive green variety. The whorls follow a Fibonacci sequence in which each number is the sum of the two preceding ones: 0, 1, 1, 2, 3, 5, 8, 13, 21 and so on. Fibonacci was a medieval Italian mathematician.
(Magnification x20 at 10cm wide)

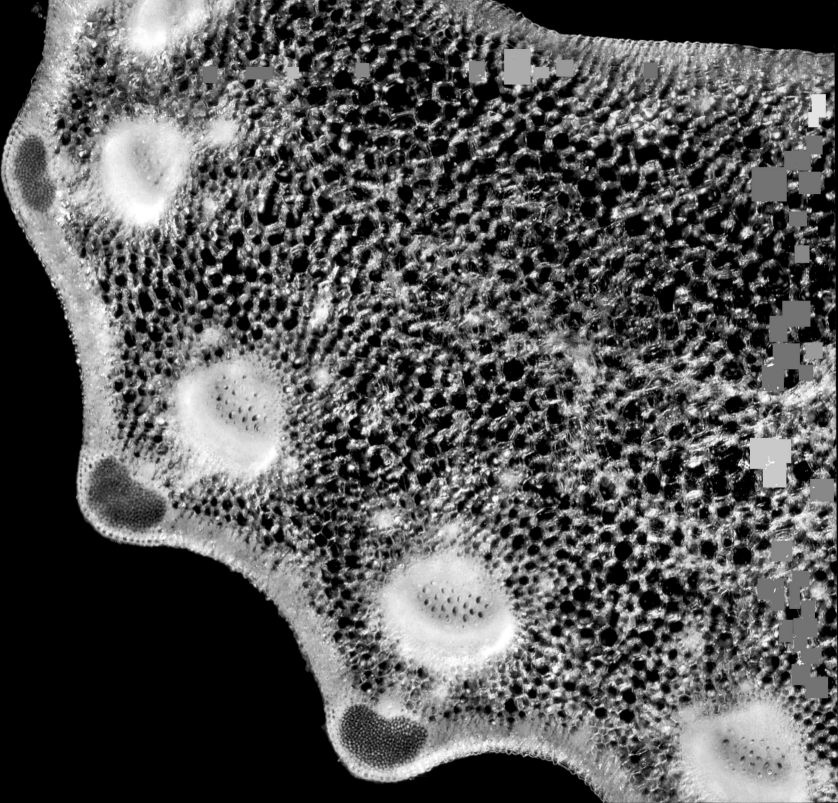

Left: Celery stem (light micrograph)

In this cross section of a celery stem the solid white circles are bundles of phloem cells that convey sugars between the roots and the leaves. Within the phloem are xylem cells (the dark holes in green tissue), which carry water and minerals. It's the phloem, xylem and green outer surface (the epidermis) that give celery its stringy texture when eaten. Celery contains allergens that are not destroyed by cooking it, and which can cause anaphylactic shock in those allergic to it.
(Magnification x22 at 6cm wide)

Right: Wild carrot seeds
(scanning electron micrograph)

The cultivated carrot that we use in cooking is a subspecies of its wild ancestor, whose seed is seen here. Its sharp hooks are designed to catch the fur of any passing animal, and at the same time to discourage the animal from eating it. It will later fall far from the original plant, improving the species' distribution. Although the wild root is edible when young, it soon becomes too tough and woody. Furthermore, the growth above ground closely resembles the extremely poisonous hemlock plant.
(Magnification x45 at 10cm wide)

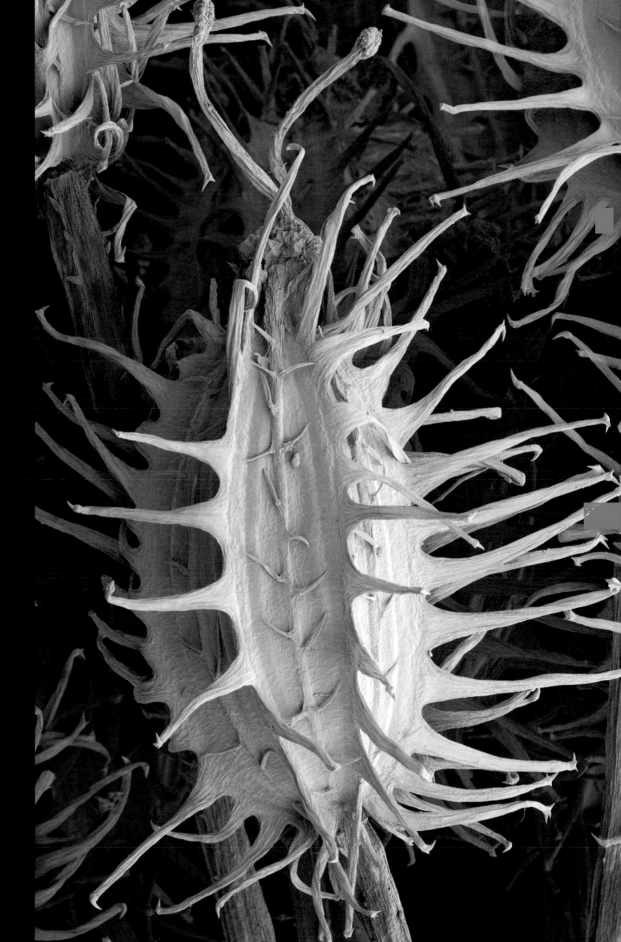

Sweet potato root (light micrograph)
Christopher Columbus was one of the first Europeans to taste the sweet potato, although it has been cultivated in central and southern America for at least 5000 years. It is only a distant relative of the potato, and belongs to the same immediate family as the garden climber morning glory. In this cross section of a root, the red cells are xylem, carrying water to the plant, while the surrounding blue cells are growth cells (cambium), which generate xylem cells where they touch xylem and phloem where they touch phloem.
(Magnification x45 at 10cm wide)

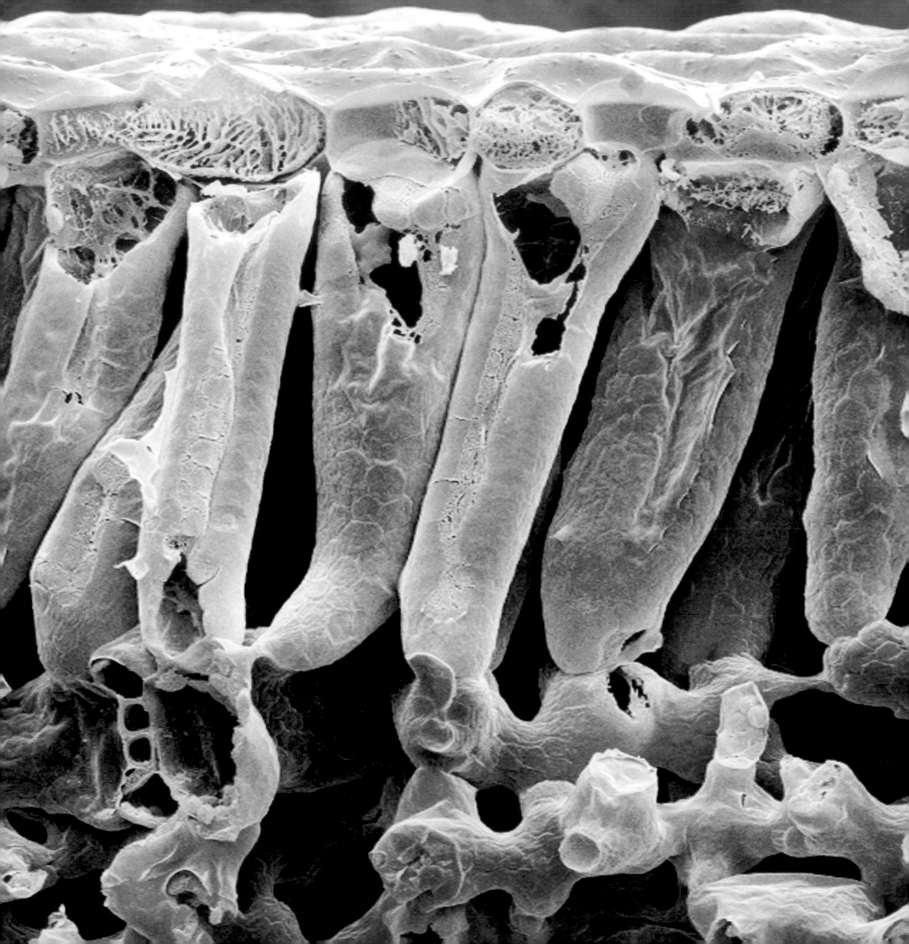

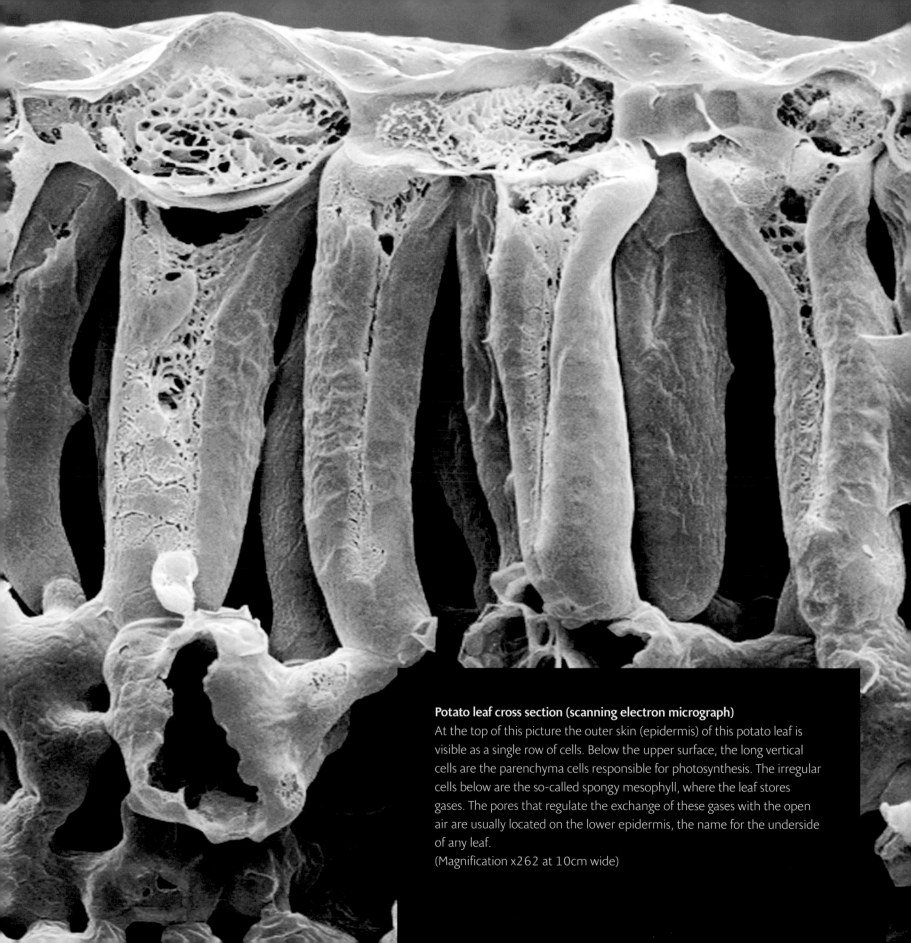

Potato leaf cross section (scanning electron micrograph)
At the top of this picture the outer skin (epidermis) of this potato leaf is visible as a single row of cells. Below the upper surface, the long vertical cells are the parenchyma cells responsible for photosynthesis. The irregular cells below are the so-called spongy mesophyll, where the leaf stores gases. The pores that regulate the exchange of these gases with the open air are usually located on the lower epidermis, the name for the underside of any leaf.
(Magnification x262 at 10cm wide)

Left: Plant cell mitosis (light micrograph)

Onion root cells prepared on a microscope slide with water and hydrochloric acid can be observed dividing and forming new cells, a process called mitosis. Cells with solid single dots (nuclei) are not dividing. Those in which the nucleus is a round cluster of lines are preparing to divide. Those in which the lines are breaking up the circle are undergoing division. Finally, those with two solid dots are a pair of nuclei not long after mitosis, soon to be separated by a cell wall.
(Magnification x450 at 10cm wide)

Above: Young broad bean root (light micrograph)

Broad beans have been cultivated for at least 8000 years. At the heart of this broad bean root a ring of xylem cells (here green) encloses a column of small phloem cells. Intruding into the phloem are four partial partitions (black) of xylem cells, which strengthen the structure of the root. Outside the xylem, the large cells (blue) are the parenchyma, the storage cells of the root, which have relatively thin cell walls for their size.
(Magnification unknown)

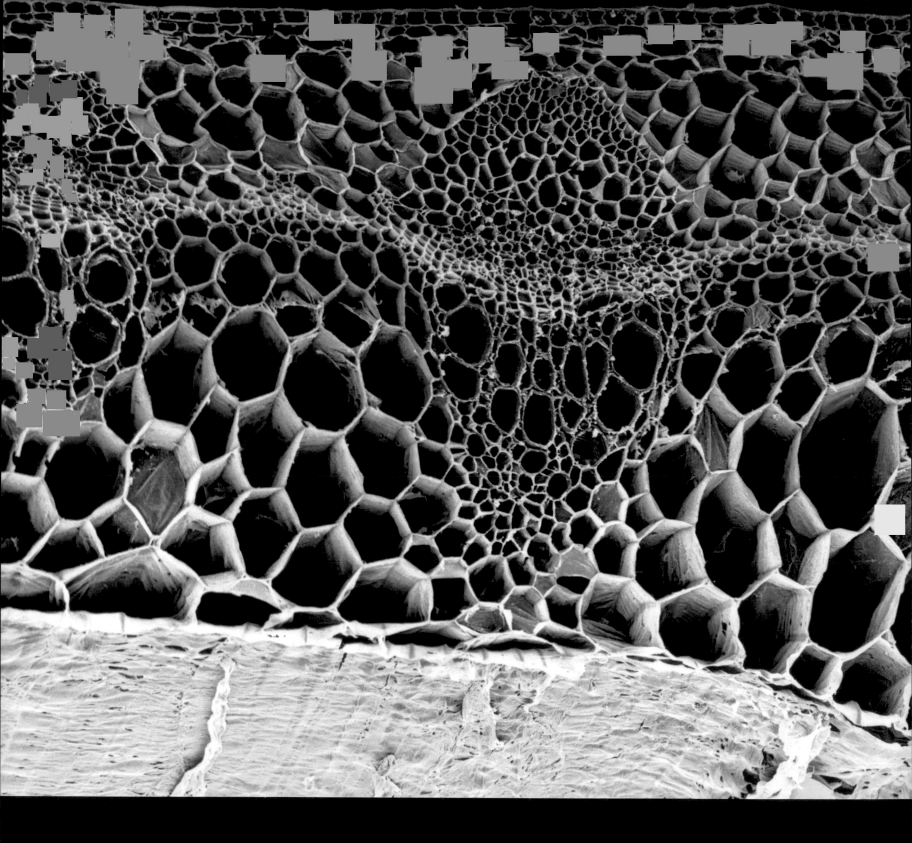

Left: Pea stem (scanning electron micrograph)

An outer skin two cells deep (the epidermis, at top of this image) surrounds the pea stem. The solid layer of tissue (at bottom) is the core of the stem. Between these two, the wavy line of smaller cells divides the stem's storage cells (the parenchyma, above it) and its structural cells (lignified cells, below the line). The line also divides the egg-shaped supply cells (vascular bundles, orange), with the phloem nearer the epidermis and the xylem nearer the centre of the stem.
(Magnification x90 at 10cm wide)

Right: Chloroplast in cell of pea plant (transmission electron micrograph)

Photosynthesis is the conversion, powered by light, of carbon dioxide into carbohydrates that nourish a plant. A chloroplast (here green) is a special unit within some leaf cells where this photosynthesis takes place. The linear features visible within it are flattened, light-reactive membranes called grana; they contain the chlorophyll that makes green plants green. Chloroplasts, highly mobile, contain their own DNA and divide to reproduce. They are descended from photosynthetic bacteria. Plant cells can only inherit chloroplasts during mitosis; they cannot manufacture them.
(Magnification x1680 at 4.5cm wide)

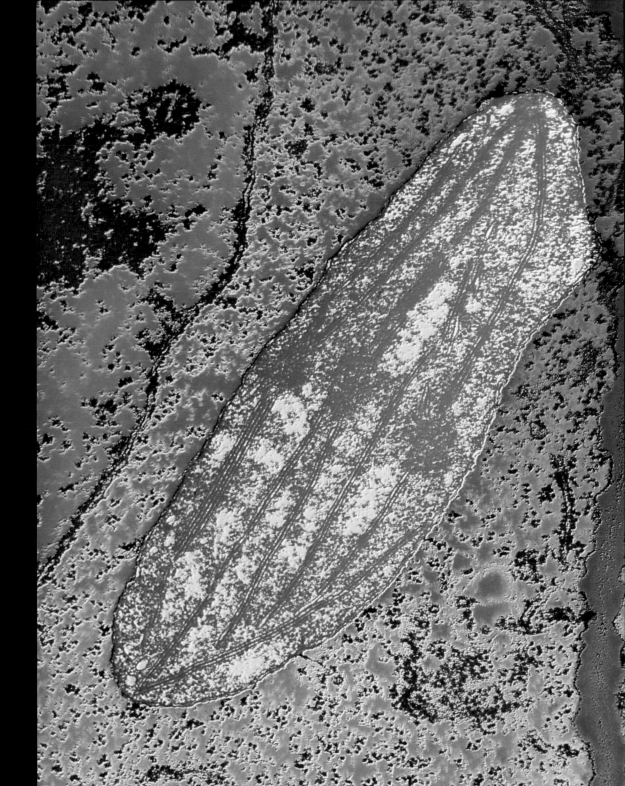

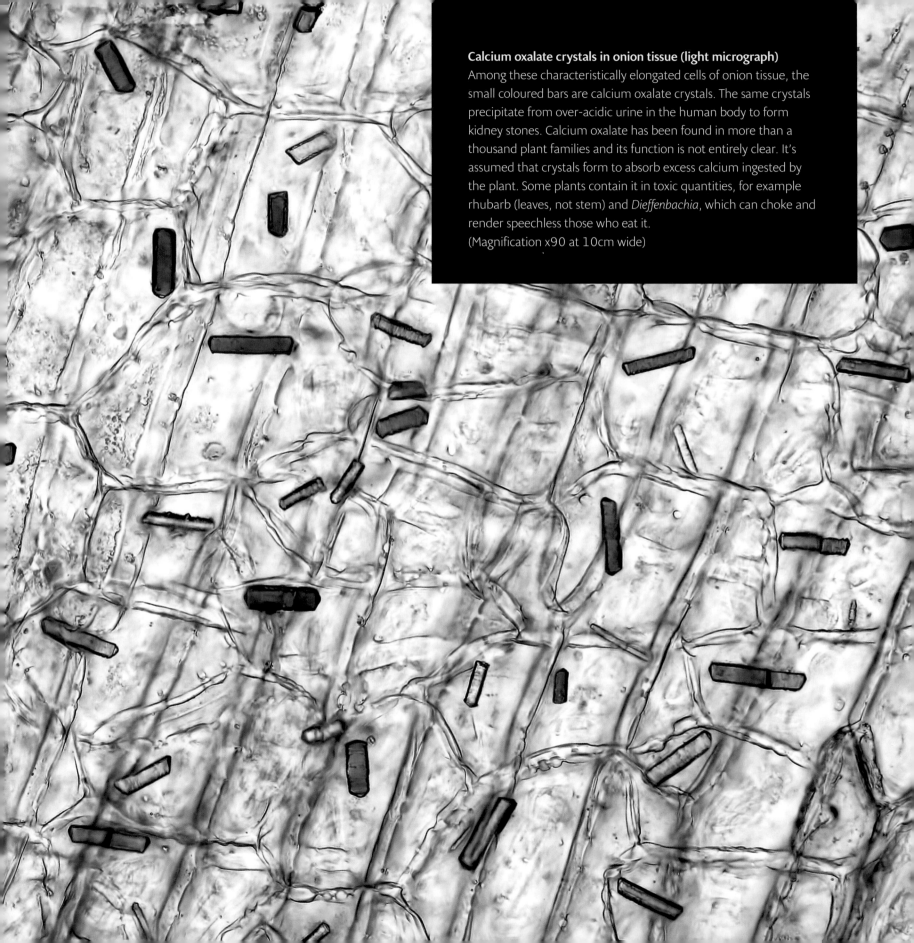

Calcium oxalate crystals in onion tissue (light micrograph)
Among these characteristically elongated cells of onion tissue, the small coloured bars are calcium oxalate crystals. The same crystals precipitate from over-acidic urine in the human body to form kidney stones. Calcium oxalate has been found in more than a thousand plant families and its function is not entirely clear. It's assumed that crystals form to absorb excess calcium ingested by the plant. Some plants contain it in toxic quantities, for example rhubarb (leaves, not stem) and *Dieffenbachia*, which can choke and render speechless those who eat it.
(Magnification x90 at 10cm wide)

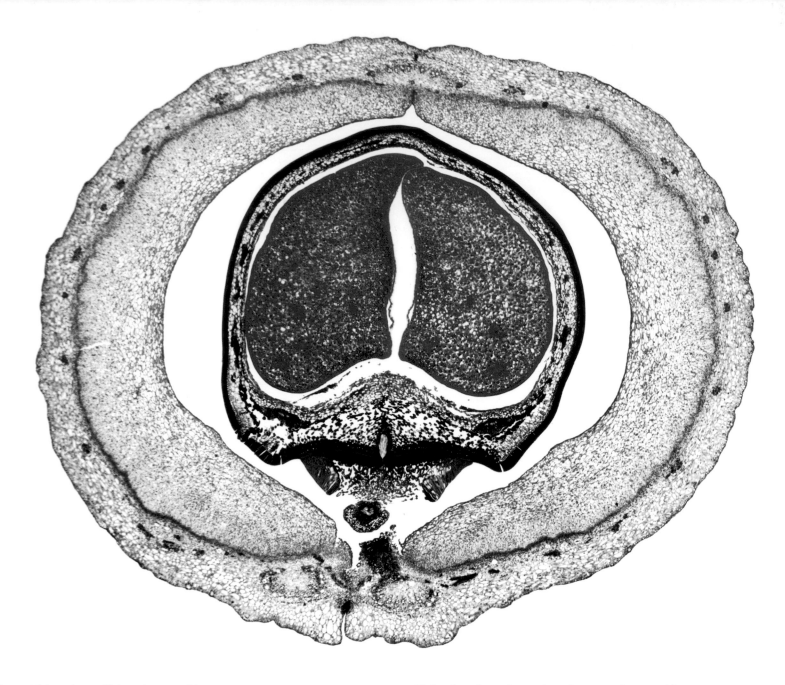

Above: Kidney bean (light micrograph)
A kidney bean is technically a fruit in which the seed sits, attached to the wall of the fruit by a stalk (funicle, at bottom). Its coat (testa, here black) surrounds the two simple leaves (cotyledons, red) that will be first to appear above the ground when the seed germinates. The protective wall of the fruit is called the pericarp. Its three layers are the outer face (exocarp), the inner face (endocarp, purple) and between them the structural tissue (mesocarp, pink).
(Magnification x11 at 10cm wide)

Right: Soya bean (scanning electron micrograph)
Soya beans have been grown agriculturally for at least 9000 years, China having the earliest evidence of their cultivation. Soya beans are around 25 per cent starch, which is stored in the smooth round globules seen here (yellow). Starch fuels the seed's germination. The beans are exceptionally high in protein and minerals and make a good substitute for meat in the human diet. They are also used as feed for livestock.
(Magnification x470 at 10cm wide)

**Cabbage root infection
(scanning electron micrograph)**
This infection of a cabbage root will cause club root, a condition in which the roots develop tumorous growth and the cabbage heads are starved of nutrition. The infecting organism is called *Plasmodiophora brassicae*, the yellow spheres seen here clogging xylem cells. It shares many characteristics with slime moulds. The roots develop abnormal galls because the parasitic organism encourages cell division. Once the host plant is dying the spores return to the soil, where they swim in search of new plants to infect.
(Magnification x510 at 10cm wide)

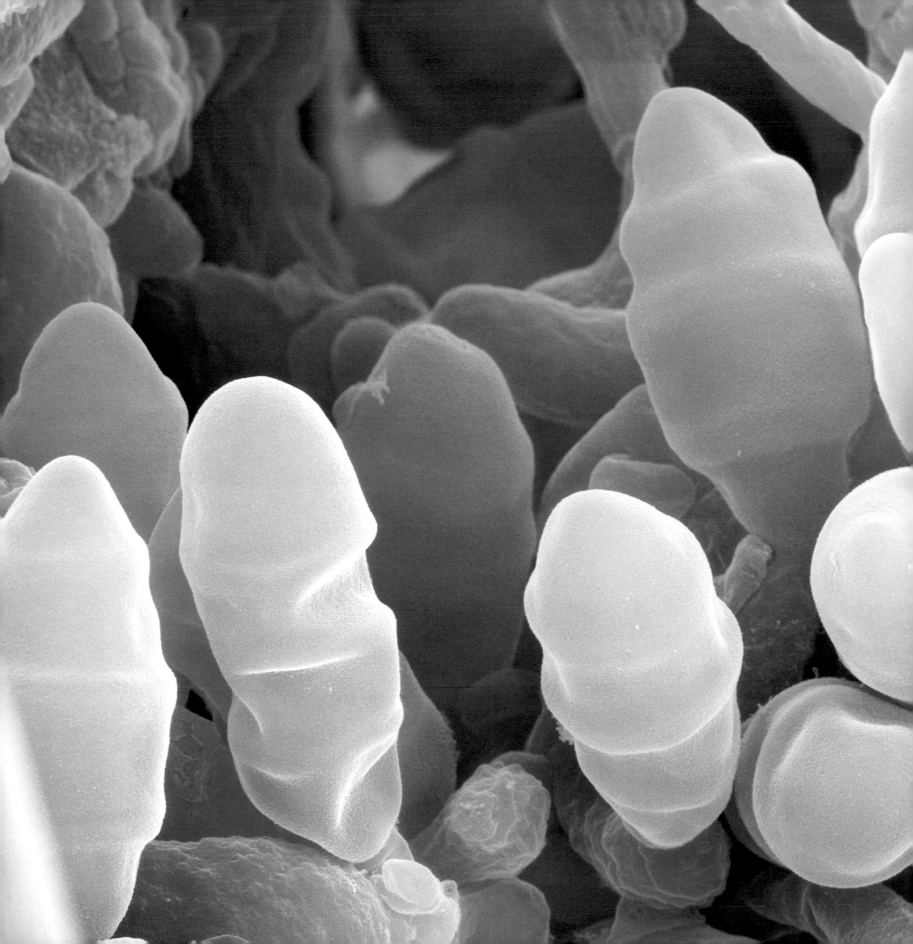

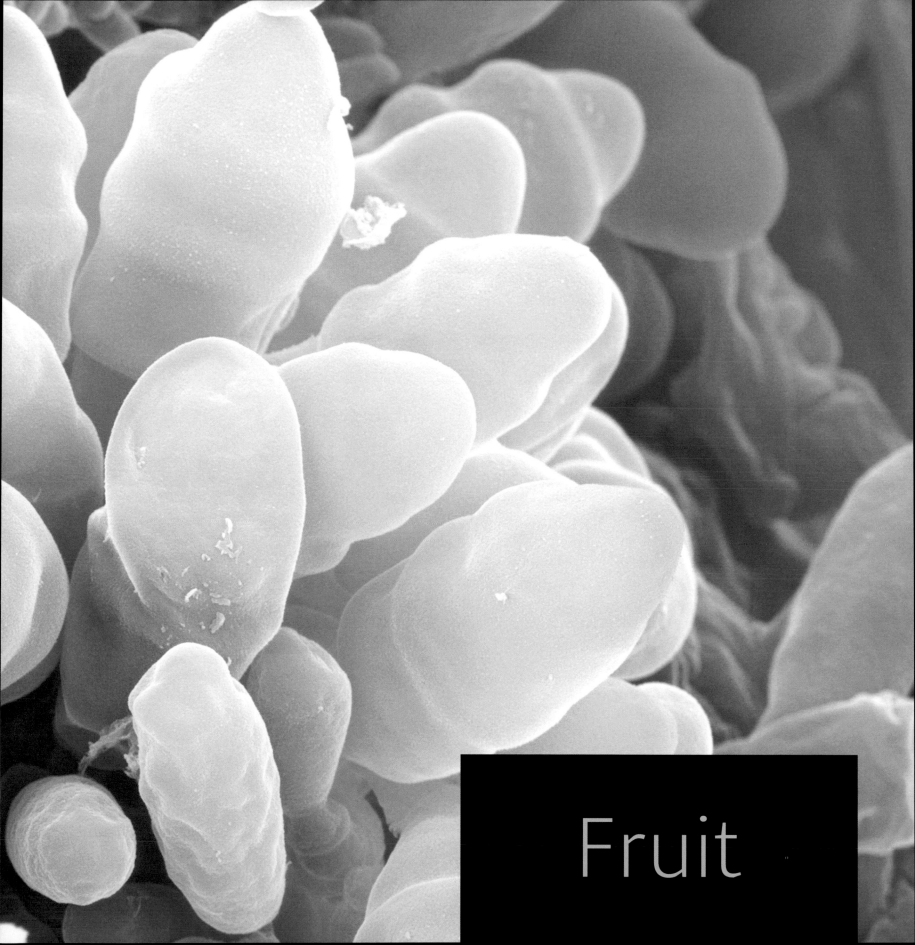

Fruit

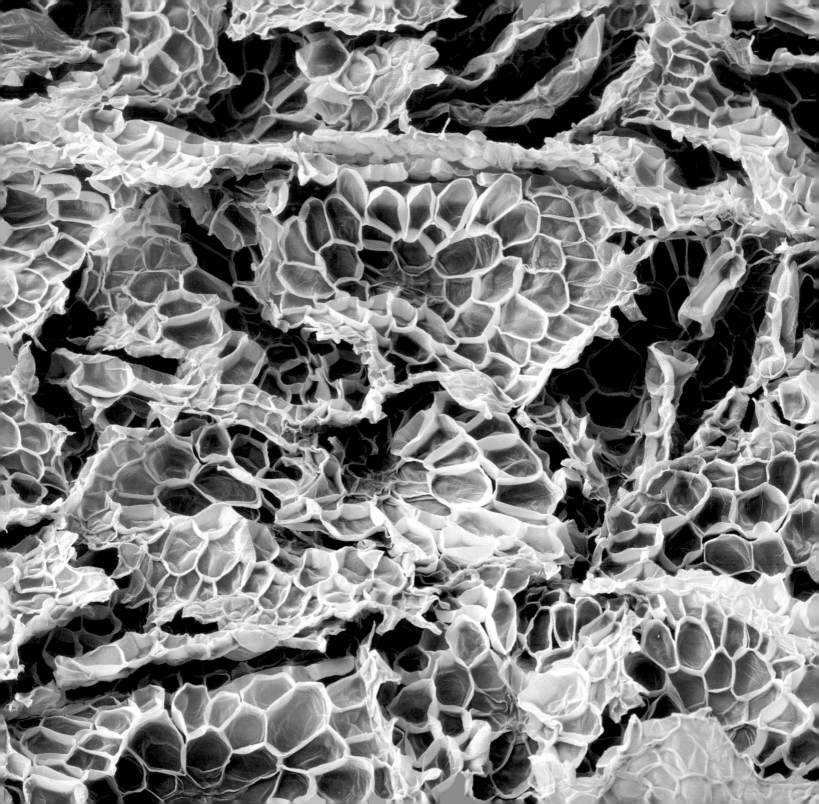

**Previous page: Apple tree fungus
(scanning electron micrograph)**

As the world's population grows, so does the
need to maximize agricultural yields. Yields are
affected by climate and a crop's resistance to
disease. Many crops attract specific parasitic
infections, such as this apple tree fungus, which
you can see here bursting out through a break
in the surface of a leaf. Infected leaves have a
reduced capacity for photosynthesis, which has
a direct, negative effect on the growth of the
tree and its fruit.
(Magnification x3200 at 10cm wide)

**Left: Pineapple leaf
(scanning electron micrograph)**

The word pineapple was originally applied
to what we now call pine cones. When the
fruit was discovered they thought it looked
just like a large pineapple and so named it.
This view is of the lower side of a pineapple
leaf. In some countries these fibres are mixed
with silk and polyester threads to manufacture
a stiff fabric used in formal clothing, table linen
and other items. The leaves can also be used
in papermaking.
(Magnification x175 at 10cm wide)

**Right: White grape
(scanning electron micrograph)**

In this image the closely layered fibres at the
top are the skin of a grape. Grape skin makes
a major contribution to the 'nose' – the smell
– of wine, and vintners prize thicker-skinned
varieties. The densely packed small cells within
give the grape its firm, springy structure and
also hold its juice. Some varieties have been
bred to be seedless, to improve the eating
experience. This is not a problem for the
reproduction of grape vines, which is usually
done by taking cuttings.
(Magnification unknown)

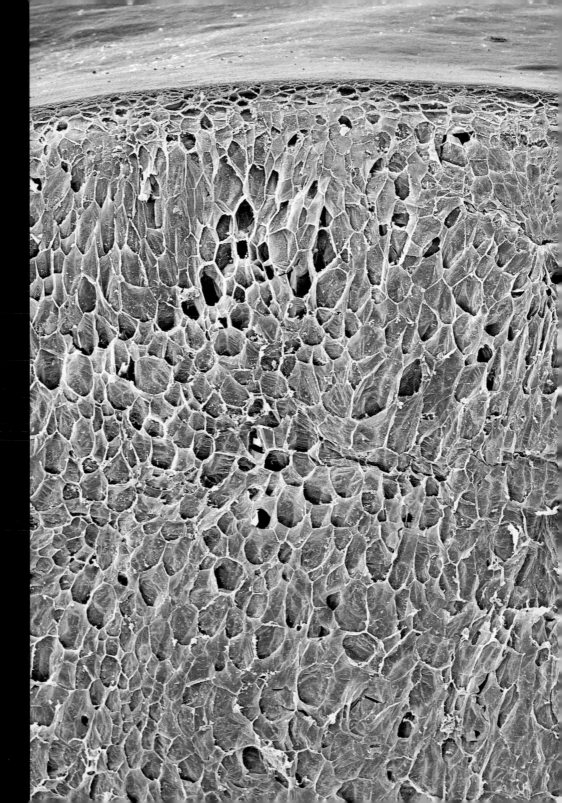

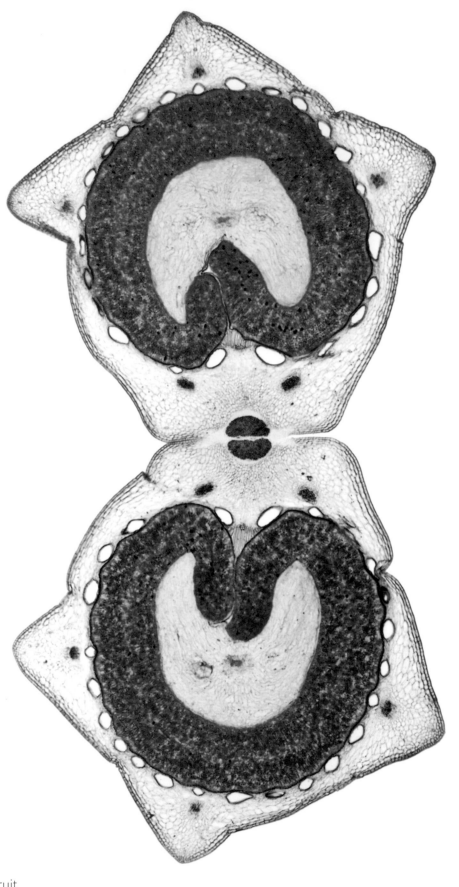

Left: Alexanders fruit (light micrograph)
The blanched stem of the Alexanders plant was a popular ingredient in the cuisine of ancient Rome, which helped to spread it to the furthest corners of the Roman Empire. It is only relatively recently that it has been supplanted by celery, whose taste it resembles. Its mature fruits split in half to reveal two seeds (here red) but they remain attached to the stalk (at centre, brown) until the wind blows them away. The five small brown dots just inside each rib are oil ducts.
(Magnification x5 at 10cm tall)

Right: Pear fruit stone cells (light micrograph)
Stone cells (botanically, sclereids) are the harder parts (but not the seeds) that occur in small groups in the cores of apples and the flesh of pears – they are the grittiness you taste when eating pears. Their function is to strengthen the fruit's structure. Stone cells (clustered here in red) have thick, woody walls that occupy most of the cell, in contrast to the loose, open surrounding cells (blue) that make up the soft body of the pear.
(Magnification x37 at 10cm tall)

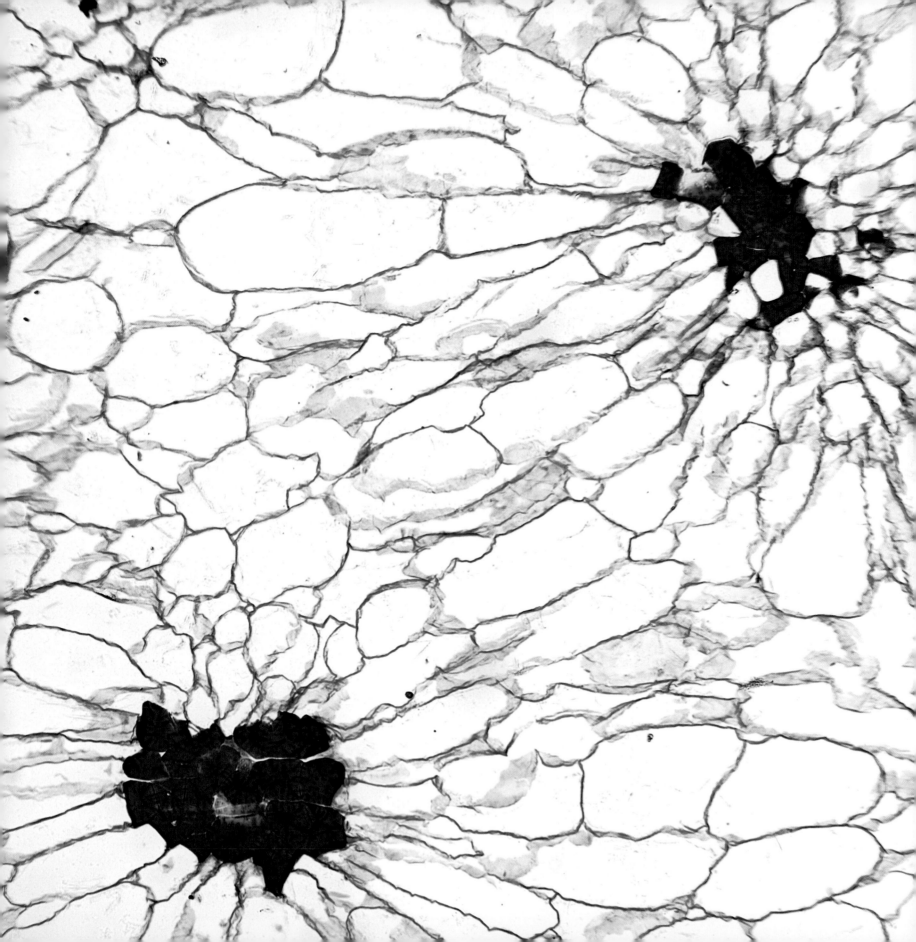

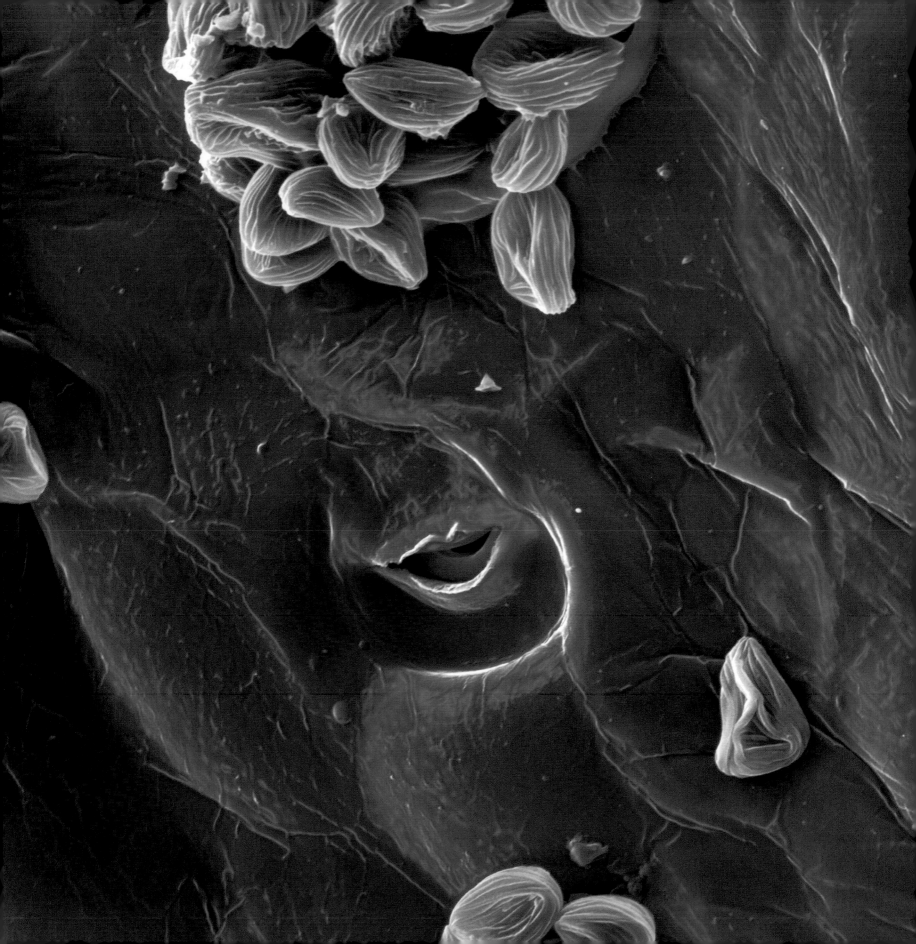

Left: Strawberry
(scanning electron micrograph)

Nothing about the strawberry is what it seems. For a start it is technically not a berry, because its flesh is an enlargement not of an ovary but of the receptacle, the part of the flower that holds the ovaries. And what look like little seeds on the outside of the strawberry (here yellow) are not in fact seeds, but ovaries containing seeds. The modern garden strawberry, although first bred in France, is not French but a cross between two wild varieties from North America and Chile.
(Magnification unknown)

Right: Tomato
(scanning electron micrograph)

In contrast to the strawberry, the tomato is a berry. It's one of many new plants that the Spanish introduced to the Old World after their sixteenth-century conquests in South America. There, the Aztecs had already begun the domestication of a smaller, native plant, to produce larger fruit. The walls of the tomato, which develop from the ovary in its yellow flower, enclose a number of seed chambers, easily seen if you slice the tomato horizontally.
(Magnification unknown)

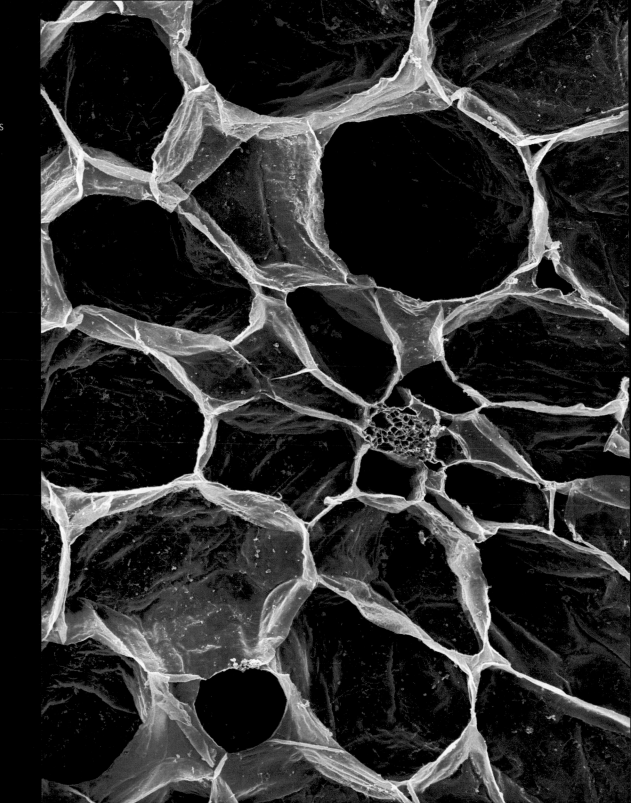

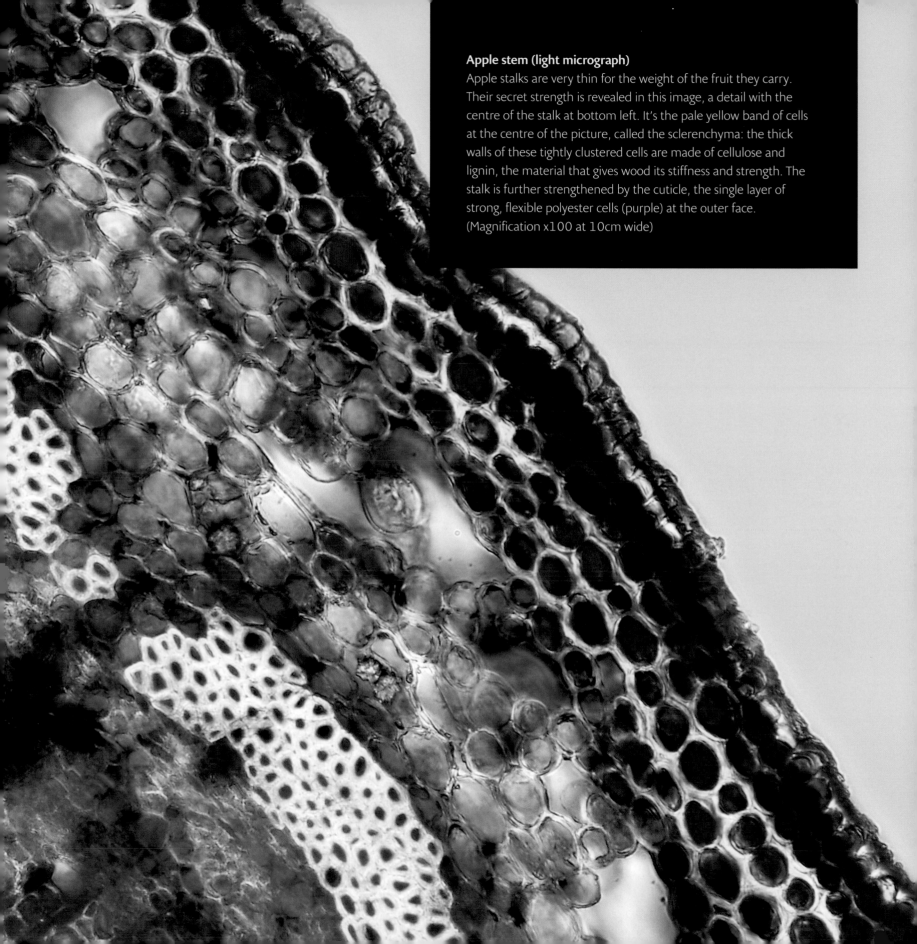

Apple stem (light micrograph)
Apple stalks are very thin for the weight of the fruit they carry. Their secret strength is revealed in this image, a detail with the centre of the stalk at bottom left. It's the pale yellow band of cells at the centre of the picture, called the sclerenchyma: the thick walls of these tightly clustered cells are made of cellulose and lignin, the material that gives wood its stiffness and strength. The stalk is further strengthened by the cuticle, the single layer of strong, flexible polyester cells (purple) at the outer face. (Magnification x100 at 10cm wide)

Index

Picture Credits